HUGH CASSON
DIARY

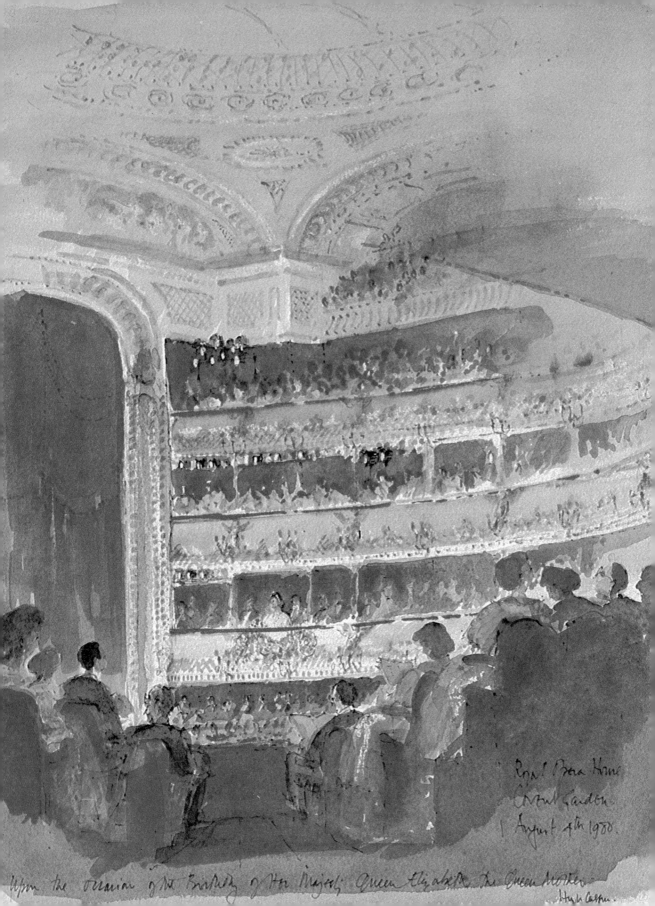

Royal Opera House
Covent Garden
August 4th 1980.

Upon the occasion of the Birthday of Her Majesty Queen Elizabeth the Queen Mother.
Hugh Casson

HUGH CASSON
DIARY

M

ISBN 0 333 31112 4

First published 1981 by
Macmillan London Limited
London and Basingstoke

Associated companies in Auckland, Dallas, Delhi, Dublin, Hong Kong, Johannesburg, Lagos, Manzini, Melbourne, Nairobi, New York, Singapore, Tokyo, Washington and Zaria

Produced by Rock Lambert
17 Albemarle Street, London W1

Reproduction by Martin Bragg Associates, Chalfont St Peter
Photosetting by ReproSharp Limited, London EC1
Printing by St Edmundsbury Press, Bury St Edmunds

ACKNOWLEDGEMENTS

The watercolour of the Royal Opera House (pages 2 and 92) is repro-
duced by gracious permission of its owner, Her Majesty Queen
Elizabeth the Queen Mother. I am grateful, too, to the Trustees of the
Royal Opera House for making available the separations of this, their
gift to Her Majesty Queen Elizabeth; to Laurence West for the loan of
the watercolour for a Windsor Festival programme; to Joanna Brendon
and the Friends of St John's Smith Square for the separations of the
watercolour (page 42) commissioned as the cover of their publication
Queen Anne's Footstool; and to the editors of *Punch*, *High Life* and the
Hotel Intercontinental *London* magazine for allowing me to quote
briefly from their pages.

My thanks also to Kathy Lambert and Tim Rock, who first conceived
the idea and format of this diary and who nursed it so enthusiastically
through to its completion; and finally to Meg Buckenham, Libby John-
ston, Sandra de Laszlo and Felicity Paton, for coping so admirably and
patiently with my manuscript.

CONTENTS

CONTENTS

PREFACE

A diary is seldom literature. Even less often is it a place in which great truths are discovered and discussed. This one is no exception. No profundities... no world affairs... no attempted assessment of the state of Art or the future of Architecture... no imperfectly remembered accounts of who said what... and, despite the experience of Samuel Rogers ('I have to speak badly of my friends', he wrote, 'or nobody listens to me'), the privacy of my friends has been respected.

The aims therefore are modest: to provide a brief, illustrated record of a full and fascinating year – 1980 – in the service of a great institution, The Royal Academy of Arts in London. The task is, I think, worth attempting, even at a light-hearted level, for few people realise that behind that calm, intimidating facade, which, like a 19th-century Genoese bank, commands the courtyard, is not just an assembly of silent, dusty saloons and dozing Victoriana, but a living mixture of university and art gallery, repertory theatre and department store, which without government support, each year welcomes over a million visitors.

Yet if the aims are modest, to keep a diary at all, it must be admitted, is not. Even if there are no intended self-revelations, there must be elements of self-regard. It is this seasoning of vanity (often unintended or unnoticed by the writer) that makes even the dullest diary more lively than an engagement book. This, plus the side-lights thrown upon the minor details of important occasions ('Yes, yes', said Proust, listening impatiently to a prosy account of the Paris Peace Conference, 'but what was the colour of the blotting paper?')... the twitch of curtains that normally conceal somebody else's professional life... the regular clink of the iron platitude that it's much easier to have ideas than to carry them out.

A postscript on the familiar problem of names – whether to put them in or, equally annoying sometimes, to leave them out. The device I have adopted throughout is to name public figures in full and to call my children, grand-children and friends – as in my life – by their Christian names. My wife is identified always by the capital M. There is no index.

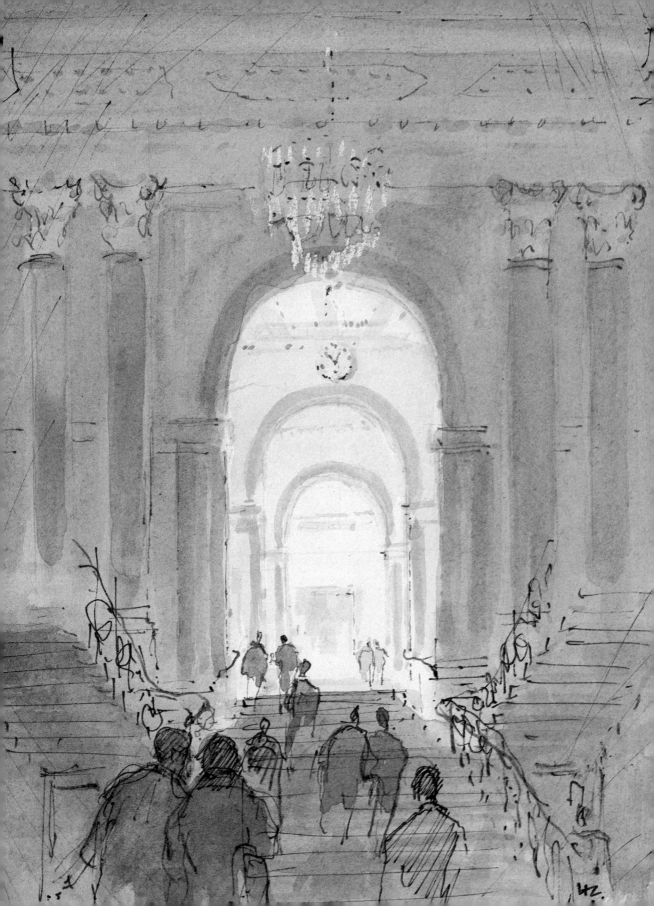

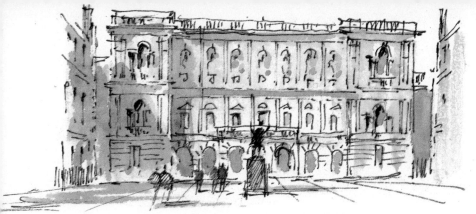

London – Canterbury – Castle Drogo – Leeds

Tuesday 1st/Sunday 6th: Solent, London

'Another year . . . another deadly blow' – so Wordsworth, but not so me. I enjoyed 1979 and expect to enjoy 1980 – my 70th on earth and my fourth as President of the Royal Academy (RA Presidential elections for the next year are held every December, and I have been about two weeks in office).

Resolutions? Two. First, to keep up this diary. My last attempt – a failure – was when, aged 11, I exchanged Charles Letts' School Boys'/ Girls' Diaries for Christmas with my cousin Angela. After I had completed the personal particulars – size of collar . . . size of boots . . . hobbies – I gave up. Angela persisted for one day. Her entry remains vividly in my memory. 'Shoped in morning', it read. 'Sick in afternoon'. Second resolution? To try not to cheat. Even in the Charles Letts days I had not been totally honest: my size in boots was accurate (it was written inside them), but my hobby was not in fact 'carpentry'. I hated it. But on the page it looked boyish. At the time I was sensitive about my small size, my tendency to faint before breakfast, and my timidity, and I was guilty, I fear as always, of a wish to please. So I resolve to stick to what happens and not to drag in more interesting events of previous years to make for better reading. Dull or enjoyably uneventful days exist and will be noted.

Today, for instance. Holiday over. The cottage by the Solent locked. Ashes raked from the fireplace, dustbins filled, beds stripped, cat basketted for the journey back to London. The house in Victoria Road is warm – God bless central heating and electric blankets – and as always a delight to enter. M found it by chance 30 years ago. It was built in 1897 and designed by Walter Shirley, almost his only work before he inherited an earldom, vanished to the Dukeries and presumably never picked up his T-square again. Stock-brick, white sash windows, a Gothic front door, wide, white-panelled corridors and landings, doors heavily made, as though by an estate carpenter – a huge, multi-level, sunny, happy house now sadly emptied of children and beginning to outstrip us. M, like a cat looking for somewhere to lay her kittens, is already beginning to notice estate agents' boards. After lunch take the Mini for fusspot visit to Burlington House (there is a Presidential car-perk in the courtyard) and up to the office. Not true

11

Secretary's Office.

Royal visit

really: I have no office at Burlington House. If the President lived away from London he used to have a small bed-sitter, but this for three years now has been somebody else's office. The Secretary, Sydney Hutchinson, has, and needs, a fine Burlington room, rich in red and mahogany. My secretary Meg – a lovely fortune inherited from the previous President, Tom Monnington – has a small back room overlooking a light well and shared with a colleague, and since it is on Meg's desk that the telephone calls and letters arrive, that seems to be the sensible place to sit – or rather perch. I look at the attendance figures for Post-Impressionism – just like a theatre manager – and they are excellent. Scramble through the post: a detritus of Christmas cards left by the Christmas tide, a complaint about the closure of the exhibition on Boxing Day, a commission to design a dolls' house – oh well – and a Valentine card – *already?*

Monday 7th

To Burlington House at 6 pm, to greet Princess Alexandra (Jean Muir printed silk and 'sweetly disordered' hair-do), Angus Ogilvy, son James and police inspector – all packed in a station wagon. Always difficult with distinguished visitors: some like to be escorted and have the pleasures picked for them; others, like the Ogilvies, prefer to rummage for themselves. I push them in and leave them to it. Always interesting to watch Royalty enter a crowded room unexpected and unannounced. They seem to drive, as it were, with dipped headlights. No blinding film star glitter, no eye glancing round in search of recognition or posher conversational prey. Yet within a few minutes the room is changed. The royal personage – polished perhaps by the daily passage of thousands of eyes – gives off a sort of radar that governs everybody's movements.

At 7 pm I leave Burlington House for the Greenwood Theatre at Guy's (why a theatre in a hospital?) for a recorded TV interview with Richard Kershaw. A breathless, rather scrappy half hour. He is running a temperature and, though friendly, is determined to get his prepared list of questions through and reluctant to let answers expand; but I enjoy myself in his expert hands, and hope by my answers I do no harm to the RA. To Chelsea to dine with Bernard Neville, an ex-Royal College colleague and textile designer, in his lovingly restored Philip Webb

house. Webb, a retiring but original and sensitive designer, was a pupil of George Street and a colleague-worker with William Morris. Everything, from light switches and curtain rings to bedspreads and tennis racquets in the hall-cupboard, is a genuine period piece. A real pleasure to see scholarship and a sensitive eye in harness. We are a party of 12. M and I are far the oldest and leave first.

Tuesday 8th

General Purposes Committee at RA, followed by Council. Routine agenda and dozy discussion but slight spurt of argument over a proposal to hold four lunchtime concerts during the Summer Exhibition. Nice idea, but will there be grumbles from non-music-lovers or even fewer sales to musically-distracted visitors? All painters, I've noticed, are nervous of distraction from any source. On to the National Theatre for Shaeffer's *Amadeus*. Foyer, as usual, agreeable, lively, active and humming – like the best sort of love affair, simultaneously relaxed and exciting. Sad the river is kept at arm's length.

Wednesday 9th

Two hours with a possible industrial sponsor: sales manager, PR consultant, technical director. Unpromising. What they want in return, reasonably enough – a say in what we show – is something we cannot really give. We disperse, promising to write. Lunch with Treasurer, Roger de Grey, in RA restaurant. Stand in queue next to visitor who sighs audibly for 'the old days, when it was such a quiet place'. Roger and I, who have spent, with M, a year on what we hoped was 'improving the place' – new furniture, crockery, manager and menu – keep cravenly quiet. Sit opposite two sweet-faced elderly ladies eating apples and cottage cheese . . . soft white hair, skin as palely brown and crinkled as the surface of a standing cup of coffee, powder drifting lightly into the lines, finely drawn from nostril to mouth. 'Aren't you going to Hilda's, then?' . . . 'Well, I *might* – it depends on Winifred' . . . a tiny gesture implying irritated resignation. How strange that in a couple of sentences a familiar world is created, its architecture, furniture and books, in which, thanks to a childhood shared with my sister largely in the care of kindly aunts, I would feel instantly at home.

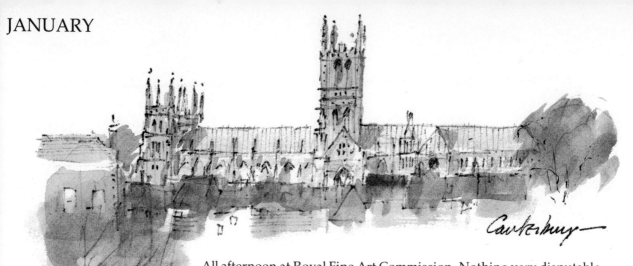

All afternoon at Royal Fine Art Commission. Nothing very disputable, but always nice to see what's going on, or will be. Then a brief TV interview with BBC on problems of patronage and sponsorship – sharpened by this morning's exchanges.

Thursday 10th: Canterbury

To Canterbury School of Architecture. Nostalgic for me as I was at prep school nearby, was confirmed in the Cathedral and once contributed my treble to a concert in the nave. Each housekeeping Thursday, I would accompany the headmaster's wife to Canterbury – a head boy's privilege – in an elderly Minerva with carbide-fed headlamps, which I was occasionally allowed to polish. (The chauffeur, Mr Westbury, became gardener at the Watts Gallery in Compton and his widow lives there still.) I lecture on Victorian Venice, and show my favourite 19th-century slides of Austrian gunboats on the Grand Canal and military English-made 'Bailey'-type bridges across it (nobody believes this). Lunch afterwards with students. Nice attentive lecture audience but notice slides being returned to boxes out of order (there's two hours' work correcting *that*).

Friday 11th: London

Day in the office with partners. Our firm, Casson, Conder and Partners, have been in practice together now for over twenty years – a marvellous, varied team of different talents, each with his own territory of expertise and responsibility. Our office is a converted builder's establishment alongside a Kensington mews (I'd resolved even as a student always to be able to walk to work, and up 'till now have managed it). Our total staff strength has ranged from ten to thirty as prosperity permits. The practice is mixed – much of it springing from competitions – and this morning's arguments over the drawing-board are, as usual, interestingly diverse. Our biggest project – new offices for MPs in Whitehall – has been patted on the head by the government and indefinitely postponed. Today we are dealing with smaller stuff: a students' hostel in Lambeth, a big house conversion at Windsor, an office block near Regent's Park. The first, a delicate piece of insertion next to Lambeth Palace. The second, what to do with a vast and hideous Edwardian mansion that looks like a hydro. The third, a job that's been trundling through the office for a couple of years, barking

35 Thurloe Place.

the Broadwalk.

its shins endlessly with the Camden planners.

Saturday 12th/Sunday 13th
Family weekend. Interview with dolls' house client (a retired doctor)... a preliminary sketch for a portrait of Mr Toad, commissioned by a Nottinghamshire vet... a brief article on Windsor Castle for an American publisher (cribbed from the Guide). A walk to the Round Pond and back.

Monday 14th
My first big meeting of the year: an assembly of heads or representatives of national museums to discuss the practicabilities of a Great Gothic Exhibition in 1984. Pamela Tudor Craig[1] and David Wilson [2] both in cracking form; Lawrence Gowing[3] apparently asleep throughout but always on the ball when challenged. Mr Turner (British Library) – eyes closed (in distaste?) – seems disapproving. I feel out of my depth in such a forest of learning, loud with knowledgeable (and often waspish) cross-talk that snaps underfoot like dry twigs.

All afternoon helping to assess a sculpture competition for Camden Borough. My colleagues are sculptor Philip King, Zuleika Dobson of Camden Arts Centre, 2 Councillors, an Arts Council observer. 35 entries – from artists who have to live or work in Camden. Pretty standard stuff, some of it I'd guess studio stock pushing in without regard to site or cost. (Artists sometimes stun with their arrogance.) Councillors at first audibly disappointed, but luckily a good short list emerges: one figurative, one witty oddball (my favourite), two worthy abstracts. Finalists must now submit *maquettes*. Drive home brooding over solemnity of modern public sculpture. Is it because it takes so long to do it's always so serious? We've abandoned the sweetness of Peter Pan and the absurd heroics of *Physical Energy*, but how often is the heart lifted by what has arrived since? I'm still backing my oddball favourite – a dancing child made of brightly coloured sheet metal.

Tuesday 15th
Young mother breast-feeding her baby while eating smoked trout at next table in RA restaurant. Nobody but baby pursing lips. Hooray! Could you do this at the Tate?

15

Round Pond.

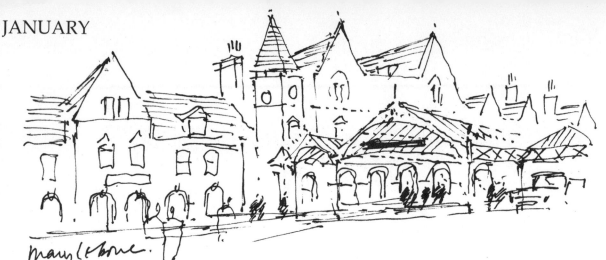

marylebone.

To Stock Exchange with RA Secretary and Treasurer for meeting with Chairman, Nicholas Goodison. Soft-spoken, thin, charming, diffident. Red-collared commissionaires... penthouse office... éclairs and China tea... am awed by this corridor of power, but there are no trip wires and he promises to help us with advice. We need it.

Wednesday 16th

BR Environmental Panel at Marylebone. Always a pleasure to visit this small, forgotten terminus – the only London station, Ronald Knox claimed, where you can hear bird song. The company, it seems, ran out of money when they reached London, so the train shed is tiny and unfinished... but it is fronted by the magnificent old Central Hotel, full of marble, mosaics, stained glass and gilded columns. (I once went to a tea dance in the ballroom.) Originally there was even a cycle track on the roof – all designed by the eccentric Colonel Edis, who wore his Volunteer uniform in his office but never got nearer to a battlefield than Brighton. The meeting begins with a slide show of recent station face-lifts. Excellent, lively, pretty... but BR will get no credit. Like British Leyland, it is doomed to be a public Aunt Sally.

Thursday 17th

Visit from ex-Ambassador with an exhibition project. Good subject but a doubtful runner with members and unquestionably a financial disaster. Prevaricate and escape home to draw for the rest of the day. In evening to London College of Printing to act as a dummy 'interviewee' on The Arts for a trainee TV student. Very professional set-up, but scenery collapses after four minutes. I would have been humiliated – student designer is totally unembarrassed. I choke back snarky crack. (Wish to please? Or not to be thought stuffy?)

Friday 18th

9. 30 am interview with architectural girl student writing a thesis on professional design attitudes in the 'thirties. Nice, serious questions, but feel as usual like a coelocanth. I don't remember *having* any design attitudes, and certainly spent no time in debating them. Nor now either, for that matter. Student packs up her notebook sadly. She is followed by a spectacular mink-clad beauty (a financial tycoon who is generously sponsoring our proposed exhibition of Andrew Wyeth)

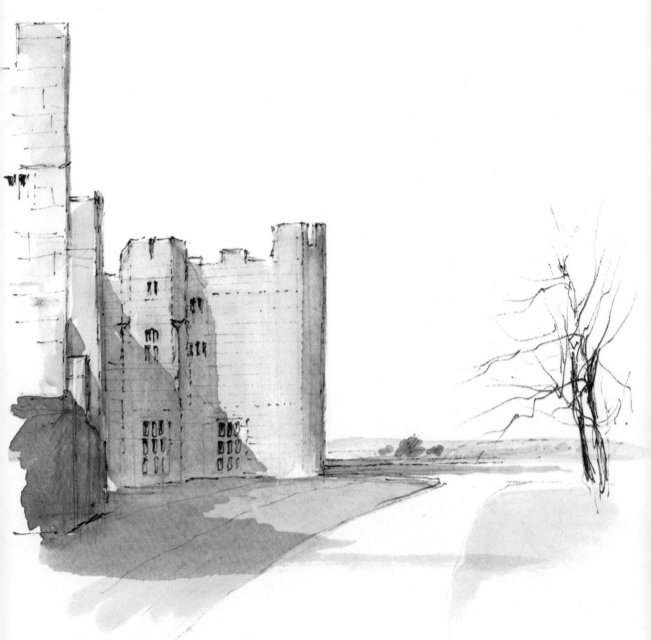

Castle Drogo.

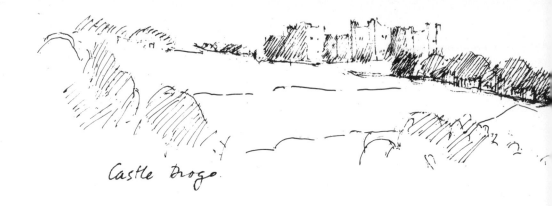

Castle Drogo.

plus her entourage. She wants to arrange a dinner party for 150 at RA in honour of Wyeth, to be attended by Royalty. We tread gently, but wealth has its persistence. I promise to do what I can.

Lunch with Moran Caplat[4], re possible Glyndebourne celebratory exhibition, followed by Museum of the Year assessors' meeting

Monday 21st
Chair meeting of Trustees of the Arthur Koestler Award, founded by ex-Spanish-Civil-War-prisoner Arthur to recognise and modestly reward creative work done in prisons and institutions: music (performance and composition), literature, visual arts, crafts and even technical workshop achievements. The Home Office helps to organise the submissions. The judges are unpaid; it's a wearisome, but I think rewarding, job.

Lunch with David McKenna[5] to discuss the possibility of a new sculpture at Euston.

Tuesday 22nd
A couple of short meetings . . . the rest of the day at the drawing board.

Wednesday 23rd
Miraculously, the same as yesterday.

Thursday 24th
Today makes up for two days to myself. Royal Fine Art Commission; Plunket Memorial Trust[6] meeting (the final wind-up of this one); RA Exhibitions Committee, with an agenda so long and controversial we scarcely get half-way.

Friday 25th
Memorial service at St James to Sheila Fell, one of RA's youngest and most talented members. Lawrence Gowing speaks well and sensitively about her. I read lesson. Church packed . . . Sheila's daughter – tiny, large-eyed – represents the family.

St James Piccadilly.

Saturday 26th: Exeter

M and I train to Exeter with Anne James of the BBC – a recce for a Lutyens programme on Castle Drogo, the last in a series we have been working on for over a year. Mist. Damp. Castle a sudden romantic silhouette above our hotel, which is comfy and crowded (*Good Food Guide* stuff). Deliciously bloating dinner of 5 courses.

Sunday 27th

Lovely low sun... long shadows... sparkling hedgerows. Castle Drogo was built for Arthur Drewe (of 'Home and Colonial'), mostly by two masons called Doodney and Cleare over some twenty years, and is now National Trust. A Drewe, still resident in a top-floor flat, gives us lunch, shows us round and regales us with anecdotes about his father and Sir Edwin. It is a house where the stairs, landings and corridors are spatially more thrilling than the rooms. The roofscape is stunning – Lutyens at his strongest and crispest. Return home elated.

Monday 28th: London

Harpsichord concert at V & A, sponsored by Mobil. Dinner in that fabulous Minton-tiled dining room. Sit next to Jean Muir, who eats like a bird and looks like a marmoset. She escapes early.

Tuesday 29th: Leeds

All day at Leeds Polytechnic examining ten students with fellow-architect Paul Koralek. Touching, as always, to sense the seriousness when threatened (impressed?) by contact with metropolitanism. Their subject of study is Les Halles in Paris. They defend their scheme, which they've lived with for months, passionately. Paul and I feel a bit like travelling medicine men armoured by client-sleeked experience, loaded with nostra and placebos, well aware of the superficiality of our comments – but at least they're from strangers. We reassure, question, comfort and dispute 'till, exhausted, we leave for London. Never easy to criticise toughly without murdering. It's not difficult to knock the heart out of a student – yet undiluted praise is equally dispiriting. (At Cambridge one visiting tutor would solve this simply by ignoring any design he thought unworthy of criticism, perhaps remembering Kenneth Clark's advice not to waste time and energy on commenting upon things you do not enjoy.)

19

Hartlebury

FEBRUARY London – Windsor – Hartlebury – Broadwell –

Friday 1st: London, Windsor, Hartlebury

A morning at Burlington House interviewing surveyors to replace Robert Hunt, who is retiring. Two possibles – a 'mouse' (who won't argue) and a 'dragon-fly' (who will). I vote for dragon-fly; buzzing enthusiasm is always warmer to work with than subservience.

Am picked up at Windsor by Libby J (plus an armful of papers) and on to Hartlebury through the Cotswolds. Cold, blue, winter's day. At teatime we arrive at the castle – a comfortably sprawling, pink-faced 18th-century house, its great 15th-century hall topped with a pretty lantern. We are greeted by the Bishop's wife, with a 3-week-old grandchild in her arms and two labradors and a corgi at her feet. She takes us into the hall, set aside for our project, *Royal Performance*, an expanded version of an exhibition of works by members of the Royal Family, which was most successfully shown at the Windsor Festival 1977. It begins with music by Henry VIII, embroideries by Mary Queen of Scots, includes fine drawings by George III, watercolours by Queen Charlotte, Queen Victoria and (unbelievably) Edward VII, and finishes with paintings by Prince Philip and Prince Charles, pottery by Prince Andrew and a table designed and made by Viscount Linley. The room is magnificent and icy cold.

Saturday 2nd: Windsor

Accompany Libby J, Bishop Woods' wife, grandchildren and dog round the moat before leaving for Windsor. Call in on Gordon Russell[1], chairbound, drinking sherry through a straw – his arms are paralysed too – but sparky as ever and full of plans for garden improvements. Would I be as philosophically courageous? I doubt it; I've never been averse to a bit of self-pity. Enlivened by this fleeting encounter – it was to be my last sight of this splendid, modest man – we make a diversion to Sezincote, which I've never seen before. It was designed by Cockerell for his rich ex-East India Company brother Charles, with the help of Thomas Daniell and Repton (who Indianised the Brighton Pavilion), and is a knock-out – even under scaffolding. It looks totally at ease in its quirky architectural fancy dress of onion domes and fretted cornices . . . sunning itself as if in Ootacamund and waiting for the pithhelmeted, pony-mounted Raj-tots to return with the syces. A lovely day from beginning to end.

The Great Hall.

20

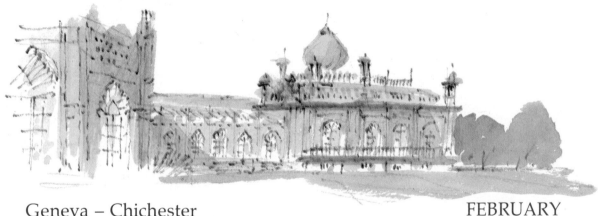

Geneva – Chichester

Szgincote

Sunday 3rd: London

Domestic Sunday. Draw all morning. M and the girls turn out cup-
boards all afternoon, with increasing ruthlessness. They divide our
possessions into four categories – Oxfam/Portobello Road/Bonhams/
Keep. I try not to look or interfere . . . but after they've gone do some
surreptitious re-sorting. Inevitably the 'keep' box becomes heavier.
The task is not made easier as we still don't know where – if at all – we
are moving to. Will it be to a cavernous mansion in North London with
plenty of rooms beneath the sagging cornices or an efficient little boxy
job in Fulham? I continue to be sulkily unhelpful.

Monday 4th: Broadwell

To Gloucestershire by train to record one of the BBC's *100 Best
Pictures* series. Met at Adlestrop-ish station by my BBC producer,
Andrew Corden, who drives me to Broadwell. Fog, dripping
hedges . . . Charles Addams Victorian house like a Home Counties
prep school. Wash before lunch in elderly lavatory hung with MFH
memorabilia. Lunch with Lord Ashton (sweet, leather-encased,
lively gnome with charming wife) and Andrew Corden. All after-
noon recording. The crew have set up in the room especially built in
the 'thirties for Constable's *Salisbury Cathedral*, both fine period pieces
and in top condition. It's not my favourite picture (though certainly
one of my favourite buildings) but there's lots to say about it. When it
was shown at the RA in 1831 critics dismissed it as 'coarse', 'vulgar'
and 'chaotic' and nobody bought it. Constable wasn't surprised. He
had other things on his mind: his wife had died leaving seven chil-
dren, his election to the RA (by one vote) had come too late to give any
pleasure, and he was in financial trouble. But he was proud of this
Salisbury Cathedral – one of many studies over his lifetime – and it's
found a good home in the house of a direct descendant of the man who
originally bought it (they've still got the receipt). Rhapsodise to the
camera – with a few fluffs – from 2.15 to 6.00 pm and train home.

Wednesday 6th: London

Banquet meeting (Ruskin Spear, Secretary, Assistant Secretary). Still
short of a principal speaker, but Mrs Thatcher in the bag. Decide to
pursue other guests first. Start with Ambassadors (whose turn this
year? Check our loan exhibition list to see which countries have been

*Gardener's House
Szgincote*

21

most cooperative – or we hope will be)... Third Worlds? (but they never seem to answer – regarding it perhaps a waste of energy?)... Government (a couple of Ministers perhaps, plus Leader of Opposition?)... Establishment (Bank of England, National Museums, Vice-Chancellors, Lord Mayor, Sheriffs)... the Law, the Church, Medicine, the Services. Files are consulted for who came last time and for persistent refusals. Nice that the numbers of ladies invited (without husbands) has been continually rising over the years. Quite right too. Although the RA was liberal enough to accept women members in 1768, they didn't have women banquet guests (who have to be professionally distinguished to qualify) until very recently. Finally the real fun begins – artists, poets, scholars, writers, musicians, the media. The stage is usually a write-off – good actors and actresses are always busy in the evenings. (When William Armstrong, of Liverpool Rep, told his aunt he was going on the stage she said 'I wouldn't, Willie dear, you'll find it cuts into your evenings'.) Film stars tend to cry off at the last minute. We all plug our favourites and try to fill the gaps or avoid the overkills (all the best women novelists, the files say, seem to have been asked in the last four years). Who won the Booker Prize this year? When did Laurie Lee or Ted Hughes last come? It's like doing a sort of private Honours List and enormous fun. At last a rough list under categories is compiled, a refusal percentage of 25% assumed and possible stand-ins listed. Private recommendations from members are yet to come. These can be difficult sometimes, but it's their banquet. Decide who needs a personal wheedle – what a pleasure it was to persuade Cardinal Hume two years ago to speak – and break for lunch. Secret self-hug at seeing long queues in the courtyard.

To Ove Arup's[2] office in the evening to talk about attitudes to conservation. Polite, attentive audience of his staff, mostly engineers, and good questions. Ove himself gentle and impressive as ever, like the archetype of a Nobel prizewinner.

Thursday 7th

Long, busy, tiring day. Start with two hour tele interview in main galleries, discussing personal choice of twelve pictures from Post-Impressionist Show, our exhibition secretary, Norman Rosenthal, giving me a list of his 'most important', scholar John House another. We

all agree only on Annah, Gauguin's thirteen-year-old mistress/model who, enthroned on a blue chair, commands Gallery 3. This must challenge Forain, Bonnard, Gwen John, Whistler, Vuillard and Pellizza, who are among my other favourites. Everything has to be done in the crowded galleries with clapper boards and floods and eavesdropping public who – depressingly – seem to find a TV crew in action more exciting than seeing 19th-century painting. The interviewer is amiable, nervous, voluble, reluctant to permit silence, to allow pictures to be *looked* at and not just chatted about.

Break for Valuers' annual lunch at Savoy Hotel. Three hundred plus in big, splendidly absurd ballroom – presentations, three speeches (including mine). Very agreeable table-mates, but as usual with these affairs we do not escape until after three. My usual survival recipe is to keep to two courses, exclude meat and never drink more than one glass of wine. How do people do this every day of their lives and still get any work done in the afternoon?

Just in time for Joyce Grenfell's Memorial Service. Westminster Abbey packed to the doors. What a well-beloved lady she was; she had what the Zulus call 'shine'. How typical of her that she always referred to the side-duties of a celebrity – charity openings, bazaars and lunches – as 'fringe benefits' and worked as hard at them as her professional work. 'The lines', she used to say, quoting the Psalms, 'are fallen to me in pleasant places'. Bernard Levin and I (we the undersized) crouch behind two of the largest men I have ever seen. Bach, Mozart – her favourite composers – modest, touching tribute from her local vicar, a reading – disappointingly unmoving – from Paul Schofield and then the rush for the West Door, waspishly envying those who seem entitled to chauffeurs (eg Peter Hall and Permanent Secretaries). Heavy establishment top-dressing but lovely to see so many less famous faces. Memorial services may be disliked by those they honour, but to those left behind they serve as a sort of surrogate encounter with death.

Friday 8th
All day at BBC in cutting and dubbing rooms with Anne J, two charming young experts and an oversized Airedale. We trim and adjust and

23

Poets Corner

Portmeirion.

re-arrange and re-record. The Airedale snores. Making a film (this one is Portmeirion) is like writing a school essay. The bits you took most trouble over in the end (as the form master used to advise) have to be discarded, as they are nearly always self-conscious and overweight for the fabric of the rest. The casualty today is my reading of the account of Mrs Haig, the original tenant of Portmeirion, reading the burial service over a dead pet terrier and then leading the mourning howl of all her family of forty dogs, who sat obediently round the grave in a lethargic circle scratching and snapping at the flies. She was a strange old girl who died (as did her dog man) in horrible circumstances. The local doctor told me he had to shoot his way up the overgrown drive and through the starving pack, to find them both dead – a melodramatic tale but out of key in the film, says Anne J. My dramatic rendering drops coiling and wriggling like a half-killed snake into the bin...

Saturday 9th/Sunday 10th
Weekend of drawing interrupted by more cardboard boxes and decisions. The girls are tireless and invaluable. Jo P comes to help pack up books. M and I still trying to assemble balanced set of fellow guests for an official RA lunch. How busy everyone is; I seem to remember when people were almost always free for lunch.

Lovely concert at St John's, Smith Square in the evening.

Tuesday 12th/Thursday 14th: Geneva
Three days in Geneva for Aga Khan Award[3] steering committee meeting. Blue skies, wind-pleated lake, aconites, snow mountains. I am met at airport and driven first to the hotel – old-fashioned, comfortable, as I remembered Swiss hotels sixty years ago. (We used to take a primus stove to make tea on the parquet floors of our bedrooms.) Huge lever door handles, espagnolette bolts controlling lofty French windows, balconies wreathed in ironwork. Lake steamers, canvas caps pulled over their funnels, sit out the winter at their moorings and the promenade is deserted. The lake, in which Ruskin complained (in 1869) that he could scarce see his own blade a fathom deep, is the colour of steel; the Rhone – subject of one of Ruskin's most famous poetic descriptions ('how I envy the fish', he said) – looks as glassily solid as a glacier.

Hotel window

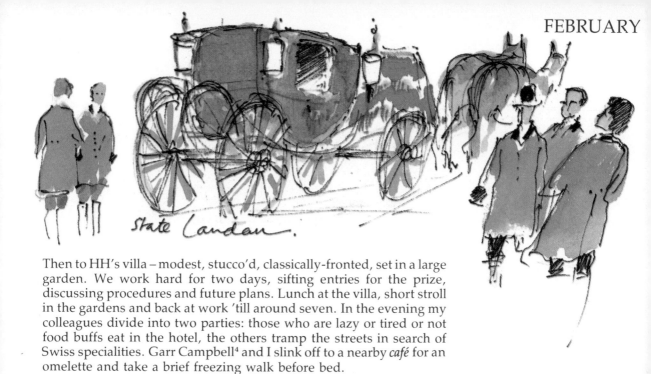

state Landau.

Then to HH's villa – modest, stucco'd, classically-fronted, set in a large garden. We work hard for two days, sifting entries for the prize, discussing procedures and future plans. Lunch at the villa, short stroll in the gardens and back at work 'till around seven. In the evening my colleagues divide into two parties: those who are lazy or tired or not food buffs eat in the hotel, the others tramp the streets in search of Swiss specialities. Garr Campbell[4] and I slink off to a nearby *café* for an omelette and take a brief freezing walk before bed.

At Geneva Airport chaos reigns. The computer has seized up (in *Switzerland?*) and nobody can book in. At last, somebody suggests it's done by the counter clerks as it used to be, by hand. Things get moving again and we are not much delayed. Tube home in a trance.

Friday 15th: London
Annual PRA audience with HM at Buckingham Palace. Accompanied by Secretary and an armful of documents, we drive into the quad-rangle. An 18th-century scene, with State coaches gleaming in the sun. Hatless footmen in full-length scarlet coats stand around and lean gossiping against coach wheels. We are conducted by kilted attendant to Oval Drawing Room. The new Mexican Ambassador is presenting his credentials and the room is full of supporting *attachés* chattering like animated parrakeets. The Ambassador's party process out, the new Governor of Belize and wife enter. Footman squints through keyhole to assess progress. A buzzer sounds and they vanish. Buzzer sounds again and we enter, halt, bow, shake hands. HM (pleated printed silk) signs documents, then, formalities over, asks about our affairs, including the Japanese Exhibition and possible problems of Japanese royal patronage. We are the last official visitors of the morn-ing and the atmosphere is very relaxed. We bow out and whisk the Mini self-consciously out of the courtyard gates.

Saturday 16th/Sunday 17th: Windsor
Weekend at Royal Lodge, due 6 pm, but punctuality *angst* – endemic to royal occasions – gets us there at 5.30. We park under a tree among the rabbits to await arrival of other guests. The sermon in church next morning is briskly phrased: 'This view of Christian charity simply isn't *on* . . .'. At drinks afterwards the Chaplain, a famed butterfly expert,

Foreman.

*Gatewn
Royal Lodge*

tells us of an annual phenomenon in the East Mediterranean: each March a 'flying carpet' of scarlet butterflies moves up from Egypt towards Turkey, travelling along about 5 inches from the ground (this, he thinks, could have been one of the plagues in the Bible). Afternoon stroll in Frogmore and leave for home after dinner.

Monday 18th: London

Architect members' lunch meeting at Burlington House. We go through nominations book, discuss with some despair the problem of 'exhibiting' architecture as pictures on a wall. Long, interesting discussion and lots of ideas, film shows, slide theatres, mock-ups. All take space/time/money and will probably not be popular with colleagues. Richard Rogers suggests an excellent new election procedure for assembly discussion. I am pessimistic of support.

Brief ceremony at which Unilever present us with the famous Millais *Bubbles* on indefinite loan. A tiny child model called Christina – white socks and a fringe – patiently pirouettes before press men for half an hour and then for the photographers sits briefly on my knee while I make stilted conversation about Ribena. Nice to have the picture but the PR circus takes the edge off the occasion, forcing everybody into artificial behaviour. Obediently we point, grin, shake hands, gravely consider, look thoughtful, point again... 'just one more please'... until Christina, wise girl, shows signs of restlessness.

Evening at National Theatre *(Death of a Salesman)*. Excellent, unsentimental, but dispiriting. As usual get lost in the foyer, where the staircases follow you about in a funny way.

Tuesday 19th

Royal Mint Committee. We meet in the Centre Room at Buckingham Palace. (How tempting to 'appear' behind that familiar balustrade, but surprised to find the view down the Mall totally blocked by Queen Victoria memorial.) Two new members this morning, sculptor Elisabeth Frink and Professor John Hale. Main subject: Birthday Crown for Queen Elizabeth. Prince Philip arrives sharp at 10.30, shakes hands, sits down, makes brisk work of minutes and off we go. Before us are some 30 designs (anonymously prepared by a score of artists).

Frogmore

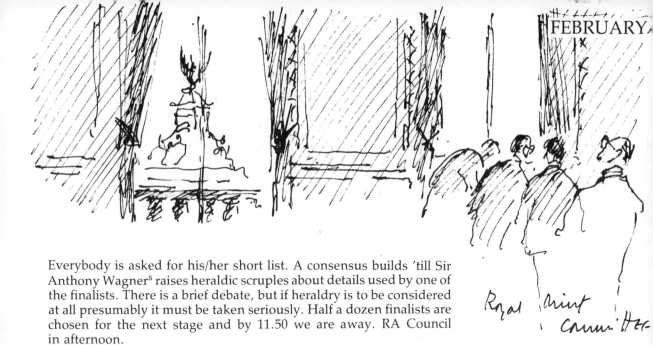

Royal Mint
Committee

Everybody is asked for his/her short list. A consensus builds 'till Sir Anthony Wagner[5] raises heraldic scruples about details used by one of the finalists. There is a brief debate, but if heraldry is to be considered at all presumably it must be taken seriously. Half a dozen finalists are chosen for the next stage and by 11.50 we are away. RA Council in afternoon.

Wednesday 20th

Brief site meeting at office, with Aga Khan in cheerful and decisive mood. Briefer meeting with partner Michael C on office building and back to RA. Lecture at Royal Society of Arts by Marina Warner on *Queen Victoria's Sketchbook*. Rapid speaker, pointed features, excellently succinct and lovely slides. All over, including questions, in 50 minutes – a good example to others, particularly me.

Thursday 21st: Chichester

Arrive late, after dentist, at National Trust Executive Committee. Nose and cheek paralysed, which leaves me uncharacteristically quiet. Long meeting 9.30-12.45 . . . as always, high level of debate and splendid variety of topics. Emerge to find car has been towed away. Momentary panic as due for lunch with Thelma Cazalet[6] to meet Queen Elizabeth. Just make it. Am encouraged to give my imitation of King of Italy proposing a toast – a performance pinched from Sir John Balfour[7], and demanding strong knees.

To Victoria for Chichester, with two days' correspondence to read in train. Cold, dark site meeting to discuss floodlighting of the Cross: very difficult problems, most of them left unresolved . . . including the main question – do you light it from *outside* (like a bollard), or from *inside* (like a lantern). I am a lantern man and firmly against the use of colour.

Friday 22nd: London

At 9.30 Prince Philip arrives for skateboard round Post-Impressionist Exhibition. Buys books on Whistler, varnish, paintbrush, primer at shop, then over coffee gives us advice on appeal procedure. Rest of am settling ruffled scholars (over Mediaeval Exhibition[8]) drafting 500 words for Kokoschka obituary tribute. Then home, weekend of water-colours ahead.

27

Chichester / Cross

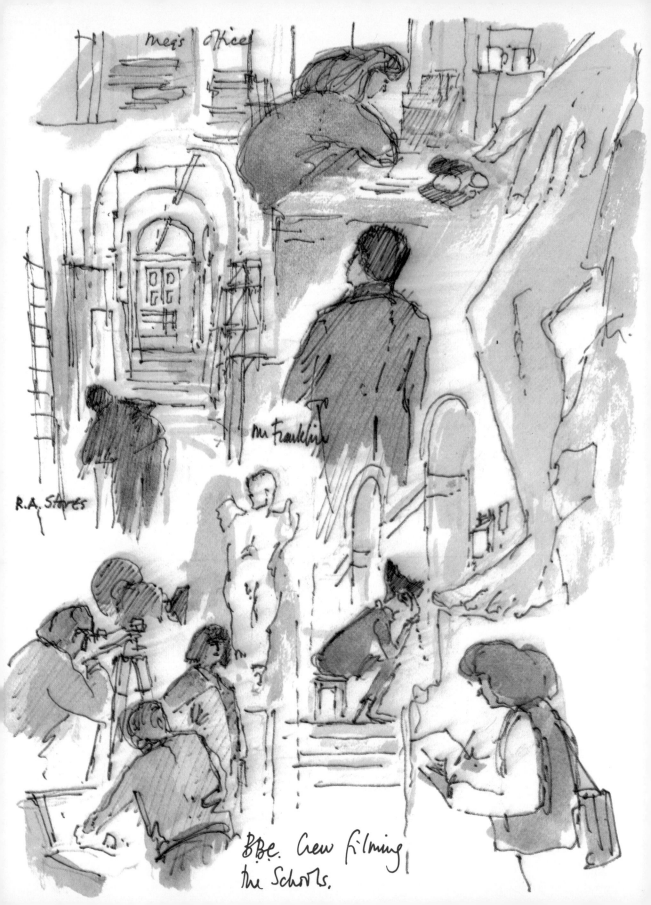

meg's office

R.A. Stores

mr Franklin

B.B.C. Crew filming
the Schools.

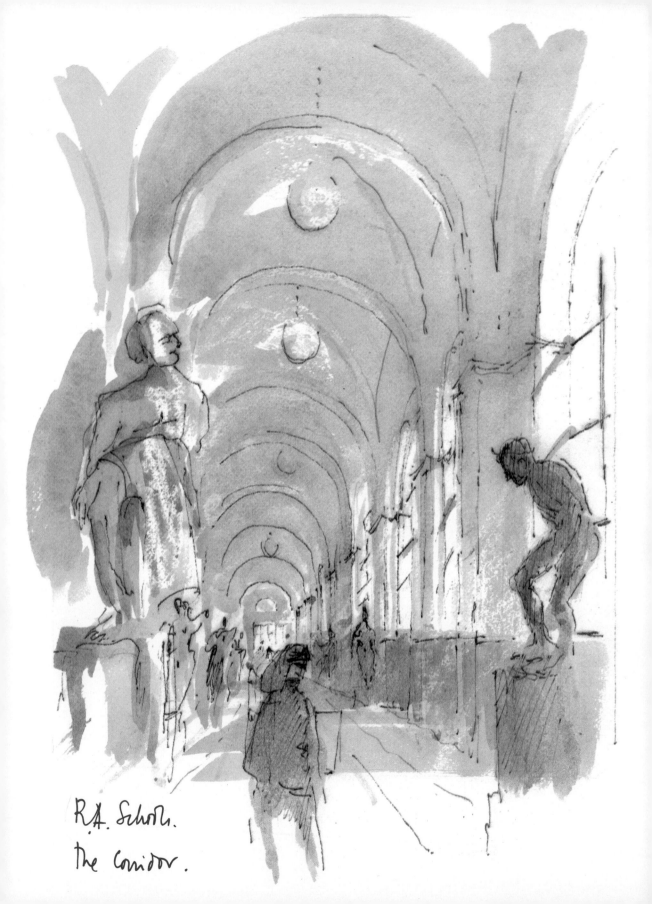

R.A. Schott.
The Corridor.

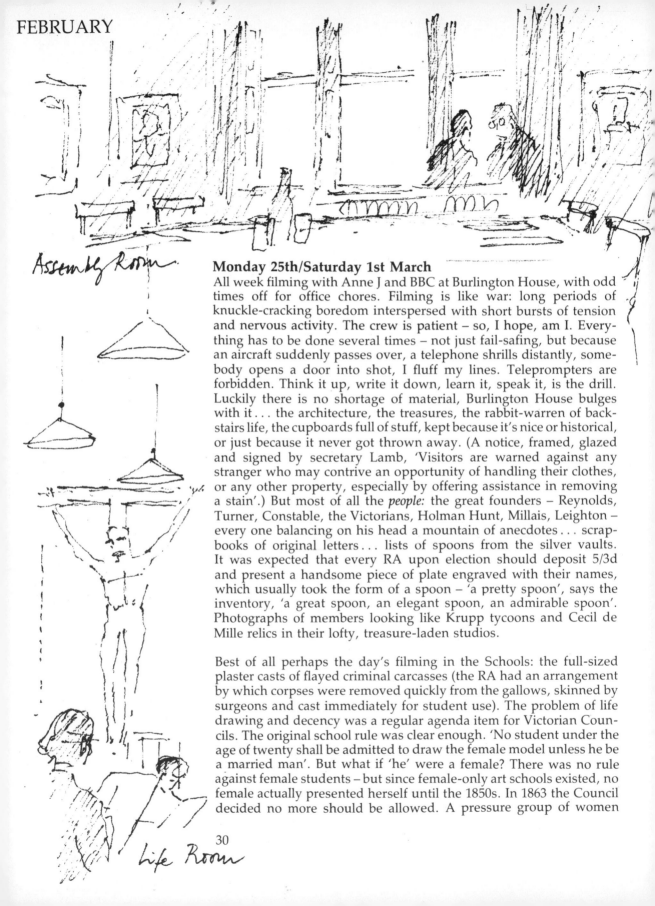

FEBRUARY

Assembly Room.

Life Room

Monday 25th/Saturday 1st March

All week filming with Anne J and BBC at Burlington House, with odd times off for office chores. Filming is like war: long periods of knuckle-cracking boredom interspersed with short bursts of tension and nervous activity. The crew is patient – so, I hope, am I. Everything has to be done several times – not just fail-safing, but because an aircraft suddenly passes over, a telephone shrills distantly, somebody opens a door into shot, I fluff my lines. Teleprompters are forbidden. Think it up, write it down, learn it, speak it, is the drill. Luckily there is no shortage of material, Burlington House bulges with it . . . the architecture, the treasures, the rabbit-warren of backstairs life, the cupboards full of stuff, kept because it's nice or historical, or just because it never got thrown away. (A notice, framed, glazed and signed by secretary Lamb, 'Visitors are warned against any stranger who may contrive an opportunity of handling their clothes, or any other property, especially by offering assistance in removing a stain'.) But most of all the *people:* the great founders – Reynolds, Turner, Constable, the Victorians, Holman Hunt, Millais, Leighton – every one balancing on his head a mountain of anecdotes . . . scrapbooks of original letters . . . lists of spoons from the silver vaults. It was expected that every RA upon election should deposit 5/3d and present a handsome piece of plate engraved with their names, which usually took the form of a spoon – 'a pretty spoon', says the inventory, 'a great spoon, an elegant spoon, an admirable spoon'. Photographs of members looking like Krupp tycoons and Cecil de Mille relics in their lofty, treasure-laden studios.

Best of all perhaps the day's filming in the Schools: the full-sized plaster casts of flayed criminal carcasses (the RA had an arrangement by which corpses were removed quickly from the gallows, skinned by surgeons and cast immediately for student use). The problem of life drawing and decency was a regular agenda item for Victorian Councils. The original school rule was clear enough. 'No student under the age of twenty shall be admitted to draw the female model unless he be a married man'. But what if 'he' were a female? There was no rule against female students – but since female-only art schools existed, no female actually presented herself until the 1850s. In 1863 the Council decided no more should be allowed. A pressure group of women

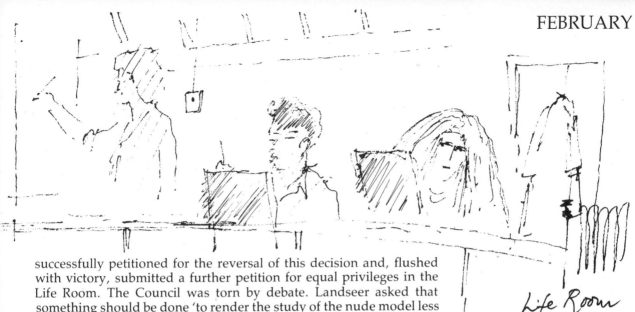

Life Room

successfully petitioned for the reversal of this decision and, flushed with victory, submitted a further petition for equal privileges in the Life Room. The Council was torn by debate. Landseer asked that something should be done 'to render the study of the nude model less offensive to decency and morality'. A sensible decision was reached by deciding – according to the minutes – that as a general principle 'it is desirable that the model in the Life School should be undraped, and that any partial concealment for considerations of decency would rather tend to attract attention to what might otherwise pass unnoticed'. Beautifully put. Meanwhile the girls fought on – not being granted Life Room equality 'till 1893. Even then it was ruled the male model must wear bathing drawers, over which a light material, measuring 9 foot by 3 foot, was to be wound and secured by a leather belt. The girls made good use of their modest victory, Frith recording that he was 'delighted' with their proficiency.

The drawing school is a marvellous, evocative room. High, a cold north light falling as it plays on the plaster corpse of James Legg, a Chelsea pensioner hanged for murdering a fellow pensioner. The semicircle of benches and board rests around the model stage with its portable heater, a traditional layout that hasn't changed in centuries . . . a theatre in reverse, where the audience does the work and the principal actor on the stage has only to keep awake.

The longer I work in this place and explore its space and corridors the more it seems to hold on to its original image of a gentleman's mansion, with its posh gilded rooms, its library and its dining room, its butler's silver vault, its cellars and attics crammed with old furniture or sheltering the odd retainer who has worked there for ages, who knows the family and their eccentricities. Such a place could easily become as dusty and forlorn as an abandoned stately home. What keeps it alive is the nursery wing – the Schools and students with their independent, self-preoccupied lives. (Joe Lyons and Heath Robinson were students here; so was Mr Morse, who invented the Code.) The Schools are physically part of Burlington House, but separate – they have their own entrance down a cobbled alleyway from the back, their own canteen. The crew seem totally fixed by this place and hard to extract on Saturday.

School Alleyway

31

Parliament Buildings Ottawa.
The South West Tower.

Sainsbury Centre

Norwich – London – Ottawa – Southampton – Eastbourne – Longleat – Manchester – Coniston MARCH

Monday 3rd: Norwich

To Norwich with M to open an exhibition of mediaeval sculpture in Norman Foster's celebrated Sainsbury Centre – my first sight of it. In the train I read the criticisms in an old architectural magazine and count the adjectives... 'cool, authoritative, fascist, obsessed, dramatic, a masterpiece, a milestone, a sardine can, classical, simple, technically complex, spectacular, heroic, boring, fetishist, noncommittal'... Clearly, since one applauds plurality and passion in architecture, as in most things, it cannot be anything but admirable to arouse such debate. The Vice Chancellor's car takes us the long way round. Leaden skies, sodden meadows and suddenly there it is, smaller and greyer than expected, not a glittering monster, just a quiet silver shed. Once inside the light takes over, clear as water. Humming machines, grey floor, white walls, silver slatted ceiling. Two end windows frame and command the view. Drinks, speeches, lunch. The Sainsburys are there, blissfully hugging the place to their hearts. A girl in the lift nurses (on purpose?) a plastic bag carrying the message 'it's always fresh at Sainsbury's'. The art? Well, the objects are precious and mostly small. Surprisingly they don't look trivial: the space is vast, but it doesn't bully. Some critics dismiss this building on the grounds that anything big can't avoid being impressive ('Size', wrote the Victorian John Emmet', 'is the easiest way to attain the sublime'), and that anything sufficiently isolated (like an egg-cup in an art gallery) can't avoid acquiring significance. True, and of course the Sainsbury Centre is both large and lonely. But it is also in its way a romantic masterpiece – even to me who cannot master the intricacies of a 3-pin plug. Does it matter that it's already dated, that its objectivity is mythical and that the arrangement of uses is not as flexible as it appears? (No.) Does it matter that the residents work permanently by artificial light? (It would to me.) Is it unfair to say that any space that can be comprehended in a single glance ceases, after repeated visits, to amaze? (No. Look at the Pantheon in Rome or King's College Chapel, Cambridge.) My misgivings are for the future. All buildings decay from the day they are finished (weather, dilapidation, human wear and tear). The streak of rust, the jammed louvre, the bashed-in skirting – endurable in a conventional building – are unendurable in a structure where precision and immaculacy are all. Am bowled over nevertheless by the conception, the consistency, the workmanship. Banish as irrelevant niggling

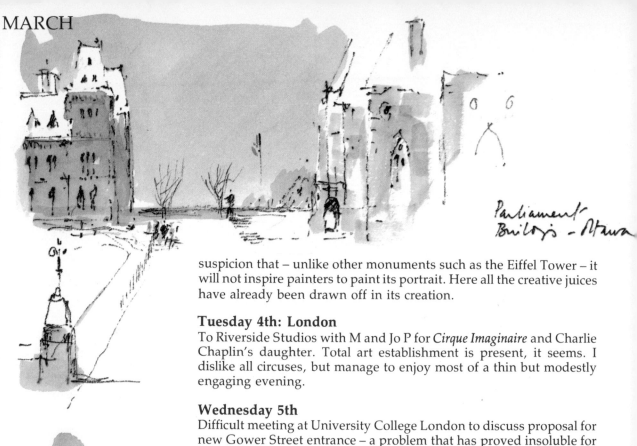

Parliament Buildings – Ottawa

suspicion that – unlike other monuments such as the Eiffel Tower – it will not inspire painters to paint its portrait. Here all the creative juices have already been drawn off in its creation.

Tuesday 4th: London

To Riverside Studios with M and Jo P for *Cirque Imaginaire* and Charlie Chaplin's daughter. Total art establishment is present, it seems. I dislike all circuses, but manage to enjoy most of a thin but modestly engaging evening.

Wednesday 5th

Difficult meeting at University College London to discuss proposal for new Gower Street entrance – a problem that has proved insoluble for over fifty years because it is so conspicuously placed. Any 18th- or 19th-century architect and patron would have solved it satisfactorily in twenty minutes. Today we are all desperately self-conscious, lacking in confidence, wary of committal, nervous equally of 19th-century repro and 20th-century dynamism. We push the problem around for a couple of hours and retire to consider. As an ex-student I know the place well and came long ago to my private convictions: that the view through from Gower Street should not be blocked; that the buildings should be terminated as politely and exactly as the existing designs demand; and that two huge trees should be planted outside the gates to announce the presence of the planted quadrangle behind, to help screen Waterhouse's angry-faced hospital when seen from within and to bring some greenery into the flat facaded length of Gower Street. (John Summerson once dismissed Fitzwilliam Street in Dublin as 'one damn Georgian building after another'.) The big tree near Queen's College in the High at Oxford is as important as any building. This is the sort of problem where the parameters (client's requirements, building regulations, budget) must yield to the image.

Thursday 6th: Ottawa

To Ottawa for two days to attend the centenary celebrations of the Royal Canadian Academy – a lively institution similar in many ways to our own in its stormy history, sometimes triumphant, sometimes scandalous, sometimes moribund, and now boldly receiving photographers, designers and craftsmen into its membership.

Wellington St Ottawa.

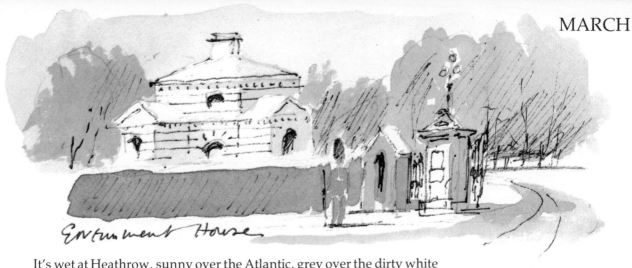

Govmment House

It's wet at Heathrow, sunny over the Atlantic, grey over the dirty white grid pattern of Ontario, a blizzard at Ottawa. I am met by an English RA, Jennifer Dickson, given supper and taken on to the National Gallery reception. Packed and clamorous; Premier Trudeau's speech inaudible. Scream inanities into hospitable ears for an hour then walk back to hotel through air that burns the nose linings.

Friday 7th

Morning seminar (same old problems . . . membership . . . money . . . election procedures . . .) and an afternoon walk over Parliament Hill: sunny, crisp, white-carpeted. Lovely to be back here (in the 'sixties I came here four times a year on a job), a dramatic promontory above the river Ottawa chosen by Queen Victoria in 1857 – to the horror and disbelief of all Canadians – as the site of their capital city. She was right. Ottawa may or may not be dull to live in but it's splendid to visit. The Parliament Buildings complex that today crowns the hill was supposed to be built in 'a plain and substantial style'. The architects – quite rightly – took no notice. The result is a triumph and as pretty and determined as a picnic party of dottily behatted and sternly corsetted Victorian ladies. I enjoy an hour of their company (Anthony Trollope praised 'their beauty of outline and nobility of detail') before retiring to the ceremonies. Presentations at Government House – the Governor General has soft brown eyes and speaks in Ukrainian to one of the honorands; above his head hang two astonishing royal portraits, as 'primitive', stiffly formal and uncompromising as Grant Woods (who was the larky patron I wonder?); a banquet; more presentations and speeches, all well-organised and enjoyable.

Saturday 8th

Conference, official lunch, tea with the UK High Commissioner in his north Oxford villa perched above the frozen river. Below us groups of fishermen crouch over ice-holes like *New Yorker* cartoons. At six I leave for the airport and chaos. Another blizzard is raging, Toronto is closed, Montreal threatened. I am double-booked. Tired of my whining, Air Canada pushes me into a taxi and we hustle off into the snow-flaked swirling darkness. Two hours later we are in Montreal. I arrive at the desk at take-off time to find I've left my ticket at Ottawa. The girl, fearing hysterics no doubt, gaily waves me through. The passengers

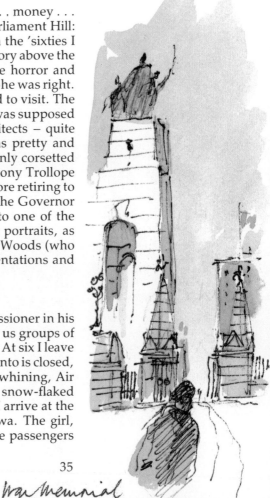

War Memorial

are on board but take-off is delayed, and I'll make it if I run. Pounding feet, pounding heart . . . I sink into the last empty seat as the door shuts. Is this what it feels like to be David Frost?

Tuesday 11th: London
Simple and moving ceremony to unveil the memorial tablet to my PRA predecessor, Tom Monnington, in St Paul's Crypt – unpretentious, honest and sturdy as Tom himself. Fifty or so old friends, including Annie, the aged Burlington House cleaner. No address, familiar hymns. A touch of fantasy is provided by the Breughel-like faces framed in the grating in the nave floor above my head. Amazed as always by the confidence of the memorial statuary in the transepts – including a monster effigy of Turner, a shabby, prickly genius, transformed by the sculptor into a pompous Victorian statesman.

Council all afternoon. Poor attendance, so all important items postponed. Rush back to change for Oxford and Cambridge Club discussion dinner. Friendly engineer chairman, about 60 guests and wives. I'd never been inside before. Impressive, confident architecture, but clubs are really not for me. Years ago I tried one of the nicest ones – the Garrick – where the company was excellent and the architecture and pictures a pleasure to see, but I resigned after a year or so as I found I never went there. Feel guilty when I remember Kingsley Amis' remark. He likes going to his clubs, he told me, 'not to get away from my own wife but from other men's wives'. Brood over the truth of this and wonder if Kingsley's remarks have for me a reverse truth.

Wednesday 12th
Royal Fine Art Commission morning, enlivened by brief press conference and debate on our role, effectiveness, and future as aesthetic watchdog. Vatican of taste? Toothless compromisers? Certainly we are serious, dedicated and unpaid. Afternoon, judging four finalists for Camden Sculpture Competition – one figurative, one solemn, two more lively, of which one is quickly chosen by fellow assessors.

Brief whisk round Japanese Exhibition at V and A. As always excellent, not too big, well shown, exquisite pottery and witty toys. Pass up raw fish and pinball games. Back home to change for dinner with Prince

36

1 RFAC.

2 Carlton Gardens.

and Princess Michael of Kent at Kensington Palace.

Thursday 13th

British Council all morning, miserably discussing cuts. Do we close some outposts (in order to strengthen survivors) or leave unsubsidised toeholds so that we are not forgotten? Board helpless in such a situation, which must inevitably be judged country by country with in-field information. Lord Goodman makes his usual and wittily phrased appeal for us to refuse to accept cuts, as being arbitrary and unsupported by evidence of need or study of consequences.

Meg-work 'till brief Publicity Committee – thence to Covent Garden. *The Seasons* is beautifully danced but (for me) boring music. First performance of Kenneth Macmillan's *Gloria* (Poulenc) with splendid choral singing, simple effective setting, imaginative choreography. Polite rather than wildly enthusiastic reception. It is followed by *Concert*, witty and pretty as ever. Designer takes his curtain call chewing gum. Unforgivable. Hope he is given a sharp rebuke.

Friday 14th: Eastbourne, London

To Eastbourne College to open new art school, a pilgrimage of a kind. When I was there in the late 'twenties it must have been one of the most boring and narrow-minded of minor public schools, deeply philistine and revolving round the rugger field. I loathed it, despite the help of one or two lively teachers. The art room was something of a refuge, totally deserted, of course, and presided over by a lovely old man in a blue, belted raincoat called Allom. He had once had a picture accepted at the RA and gave me a photograph of it. It depicted two young 19th-century fops on the arm of a bonneted beauty and was called inevitably *Two Beaux to her String*. He left me alone and treated me as a fellow student. He knew the school regarded him and his rooms as a waste of time, space and money, but he kept a sort of chirpy spirit among his stuffed birds and fly-blown still-lives, and I enjoyed the odd hours in his company. I spent most of the rest of my time – and who does not at school? – doing things I wasn't any good at. I had an undistinguished career, being bad at all games, left without regret, and have not visited it since. (How lovely to go to school and know you can be home again the same day.) Great changes now of course. Met by

Covent Garden Opera House.

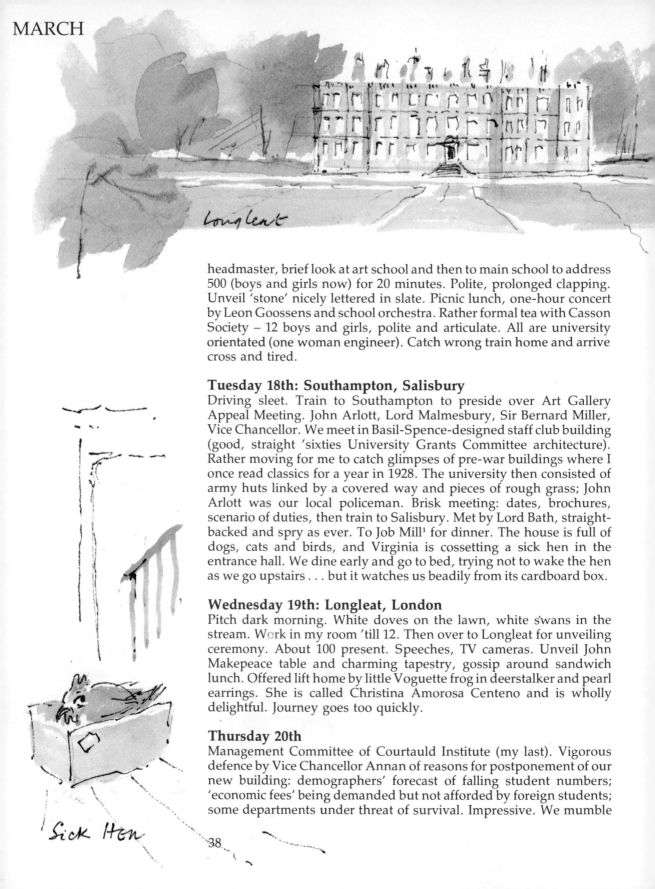

Longleat

headmaster, brief look at art school and then to main school to address 500 (boys and girls now) for 20 minutes. Polite, prolonged clapping. Unveil 'stone' nicely lettered in slate. Picnic lunch, one-hour concert by Leon Goossens and school orchestra. Rather formal tea with Casson Society – 12 boys and girls, polite and articulate. All are university orientated (one woman engineer). Catch wrong train home and arrive cross and tired.

Tuesday 18th: Southampton, Salisbury

Driving sleet. Train to Southampton to preside over Art Gallery Appeal Meeting. John Arlott, Lord Malmesbury, Sir Bernard Miller, Vice Chancellor. We meet in Basil-Spence-designed staff club building (good, straight 'sixties University Grants Committee architecture). Rather moving for me to catch glimpses of pre-war buildings where I once read classics for a year in 1928. The university then consisted of army huts linked by a covered way and pieces of rough grass; John Arlott was our local policeman. Brisk meeting: dates, brochures, scenario of duties, then train to Salisbury. Met by Lord Bath, straight-backed and spry as ever. To Job Mill[1] for dinner. The house is full of dogs, cats and birds, and Virginia is cossetting a sick hen in the entrance hall. We dine early and go to bed, trying not to wake the hen as we go upstairs . . . but it watches us beadily from its cardboard box.

Wednesday 19th: Longleat, London

Pitch dark morning. White doves on the lawn, white swans in the stream. Work in my room 'till 12. Then over to Longleat for unveiling ceremony. About 100 present. Speeches, TV cameras. Unveil John Makepeace table and charming tapestry, gossip around sandwich lunch. Offered lift home by little Voguette frog in deerstalker and pearl earrings. She is called Christina Amorosa Centeno and is wholly delightful. Journey goes too quickly.

Thursday 20th

Management Committee of Courtauld Institute (my last). Vigorous defence by Vice Chancellor Annan of reasons for postponement of our new building: demographers' forecast of falling student numbers; 'economic fees' being demanded but not afforded by foreign students; some departments under threat of survival. Impressive. We mumble

Sick Hen

and mutter and pass on to the future of Seilern collection. Temporary or permanent home? Somerset House? RA? Prince's Gate? Surprising and, to me, welcome swing away from strict conservationist attitudes. 'Art', says chairman, 'is pretty tough'. (Try and persuade some gallery directors of that.) Long meeting finishing at 6.30; whiskey all round.

Friday 21st: Manchester, London
To Manchester to take part in Art Questions Panel in aid of the Friends of the Whitworth Gallery. Travel up with M and Joanna Drew[2] – opportunity for long, valuable gossip on art scene. Picked up by Bill Mather[3]. Tea, change, black tie scene. 200 hundred people. Join Edward Montagu[4] and Marina Vaizey[5]. Very impressive answers by my colleagues, thoughtful and informed. Feel greatly outranked in knowledge and indeed sense. Huge dinner afterwards, complete with raffle and auction. Sit one away from splendid old lady whose father was a friend of Ruskin's; enjoy myself totally. Travel back to Euston next morning by early train. Clear blue sky, frost, splendid Italianate warehouses and chimneys and blackened churches, canals, stone bridges like a landscape designed for a toy railway.

Monday 24th
All day at Arts Council judging Holborn Underground Station Competition. About 100 entries, some difficult to interpret, but all lively and larky. Usual conflict of ideas on jury, and arguments about maintenance. (A lovely long love-knot in neon, for instance. How do you service it?) Settle on about a dozen finalists and finally four main prize winners – most of them professional artists.

Tuesday 25th
RA Committees all day. Club dinner in evening. Lord Amory in chair. Caccia[6]/Inglefield[7]/Adeane[8]/Robert Armstrong[9]. Entertaining and gossipy. I feel genuinely honoured to be a member and embarrassed by my irregular attendance. I wish I could enjoy dining clubs.

Wednesday 26th
Judging again, this time Mobil posters in the Big Room at Somerset House. Always a pleasure to visit the place where the RA lived happily and scrappily for 2 years – I suppose it's London's largest classical

39

Roof finial.

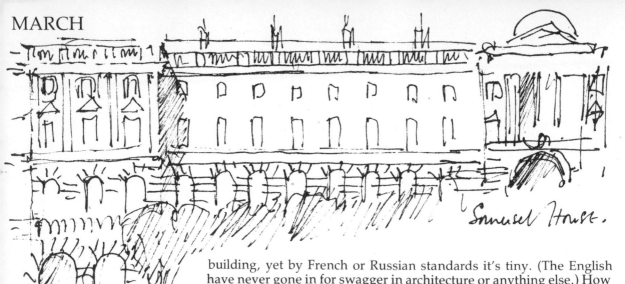

Somerset House.

building, yet by French or Russian standards it's tiny. (The English have never gone in for swagger in architecture or anything else.) How sad you can't walk along the river terrace: buildings always try harder with their toes in the water. The architect Chambers, a Swedish-born, French-trained ex-sailor, knew that anyway. The brisk professional jury takes two hours. There are 80 entries, 3 finalists. Mobil seems pleased with the results.

Thursday 27th

Royal Mint Committee, unusually close after the last one. Peter Scott[10] joins us for the first time. It lasts only an hour, as Prince Philip has to helicopter off to Cambridge. Then to RIBA to judge Architect or Artist Exhibition (325 entries). Strange how architects, however *avant garde* on the drawing board, return in their spare time to the familiar subjects of amateur sketchbooks – harbour scenes, picturesque windmills, stranded yachts, Cotswold barns. The sculpture entries are unspeakable (how shocked Ruskin would have been).

To Italian Embassy to receive – with great pleasure – an Italian order. Two other recipients, RA Secretary and an Italian scholar. Citations, handshakes, scroll, ribbon round neck, champagne – all over in half an hour. Policeman outside – who is obviously in the know – gives me a facetious salute.

Lively, argumentative dinner with friends before auction pre-view of Turner's *Juliet and Nurse*. Deeply disappointing to me, over-worked and unmoving, but nice to see a Turner that I don't for a second covet.

Friday 28th: Ulverston

Take midday train with M and Anne J to Ulverston. Intercity to Preston, then change for two-carriage buzz-train. Rain sluicing down, windows steamed up. Saturday shopping bags, wellies, glimpses of mudbanks, waders, abandoned estuaries. Smell of wet wool and Smarties. Book into small commercial hotel in town centre. Grey/white/ black stone and street cobbles, good lettering. Irish feel, boarded up old drapers, gift shoppettes, gossipers at corners, collapsing stables and backyards. Scampi-type dinner beneath rustic props. How country pub decor and food has been elaborated in the last few years.

The Navy Staircase
Somerset House.

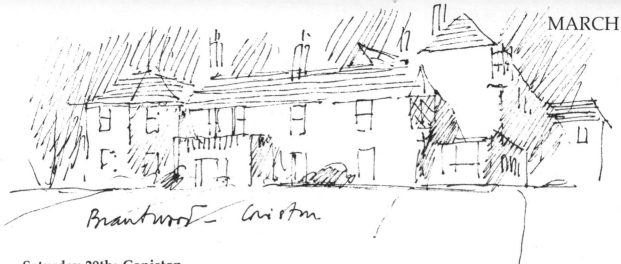

Brantwood - Coniston

Saturday 29th: Coniston

Sunny and cloudy. My first real sight of the Lake District. Snow on peaks, silver flashing lake, winding road. Go first to Coniston, where we winkle out Mr Bilton, curator of the Ruskin Museum in town centre. Am shown Ruskin's grave, snowdropped, then go on to museum at back of gabled Victorian Insitute, a massive turnstile of clanking cast-iron. Room like a school gym, but a treasure house of watercolours, mementos, photographs, sticks, fossils, letters, diaries – my ideal museum. Then across to Brantwood, where Ruskin spent the last twenty or so years of his life, a rambling, white, inconsequent house, turretted and be-hatted. Few bits of original furniture, but exquisite watercolours. Ruskin's boat – *The Jumping Jenny* – and his coach are still in coachhouse. A quick circuit to inspect *Gondola*, the beautiful old steam launch now being resuscitated by the National Trust and then long, slow drive back into the sunset. Empty roads, empty sands, blue-rimmed horizons. Drive down to mouth of old canal, abandoned and melancholy. Slimy posts, mud, dribbling tide. Silence.

Sunday 30th: To London

Sunny again. Join tiny empty train in charming dilapidated station. Sunday quiet, shelduck, sheep on salt flats, distant sea 'with waves fiddling and small', as Stan Holloway's song put it, 'and nothing to laugh at at all'. Transfer to bus at Carnforth, then train to Lancaster, Preston and Euston.

Monday 31st

Recording all pm at BBC – a feature programme on the Crystal Palace. Not my script, but I do my best for a subject I've always been interested in. The young producer hardly believes me when I tell him I attended an organ recital as a child in the Crystal Palace, and years later watched it burn to death.

Boathouse Coniston.

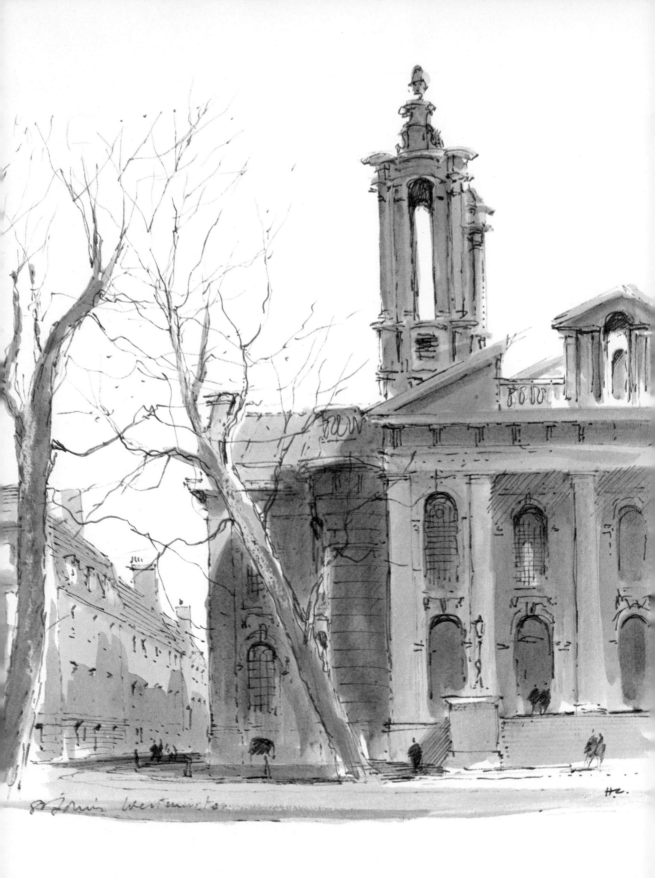

St John's Westminster

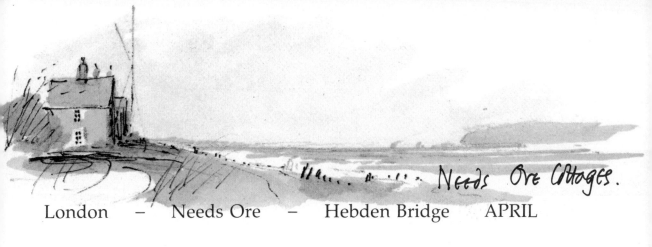

Needs Ore Cottages.

London – Needs Ore – Hebden Bridge APRIL

Tuesday 1st: London

Brief recording in Francis Kyle Gallery for *Kaleidoscope* on Paul Hogarth's masterly drawings of architecture. Nobody to touch him for catching a building's likeness – dead right without a trace of laborious correctness. Paul and I first met in Peking in the early 'fifties. (On the way out over Russia and Mongolia I discovered in the airport waiting-room at Ulan Bator a copy of a novel by Angela Brazil. There's a short story for somebody there.) In those days Paul was hooked on the dignity of labour and the magnificently lined face-landscapes of aged peasants. Now it is the eccentricities of Miami or Tufnell Park that hold him captive. Enjoy myself hugely before returning to RA.

Wednesday 2nd

Two art competitions today. Invalid Children's in the morning – my fellow judges fail to arrive so I'm spared argument, and rightly or wrongly the work is swiftly done. After lunch to the Serpentine for the annual *Art into Landscape* – almost my favourite exhibition of the year.

Finish the day at St John's, Smith Square. All-Bach Concert, my favourite composer and favourite concert hall. Supper with Joanna Brendon – a refugee from Covent Garden – who wants a brief architectural history of the church written by the end of the month. She'll be lucky . . . but then she usually is.

Thursday 3rd

Meeting about our hostel project with Lambeth Planning Officers, patient and helpful, as is also the receptionist in the entrance hall. Yet I am shocked by the presence of one unwrapped white loaf and a packet of detergent on her desk. You wouldn't get that (I know and she knows) at Mobil or de Beers – why not? and does it matter? Extraordinary how these seams of personal conservatism are suddenly and unexpectedly laid bare, as if by a geologist's hammer. Blimpism? or irritation that the chief executive doesn't notice, or worse still, has noticed and doesn't dare rebuke?

Friday 4th: Needs Ore

Good Friday. Drive down to cottage. Blazing sun. Blinding traffic. Pass a Toyota carrying a sticker 'Bly Blitish'.

The Beach Needs Ove.

Saturday 5th

Children and grandchildren arrive. Cold wind, hot sun, blue sea. Read Ruskin, walk on the beach, play snakes and ladders. Feel well blessed. What did Thomas More say to his children? 'I have given you, forsooth, kisses in plenty and but few stripes . . . If ever I have flogged you 'twas but with a peacock's tail' . . .

Sunday 6th

Continue happily to read Frith's diary. Frith says it was a toss-up whether he became an artist or an auctioneer. 'Pity he lost the toss', said Whistler. Good joke but poor judgement. The diary is packed with splendid anecdotes on the strange ways of Victorian painters, rifling the classics for 'subjects' or 'titles'. They seem more like telescript writers than artists – swopping stories, getting colleagues to put in the 'difficult bits', looking for 'correct' models. (They all complain of the scarcity of genuine beards.) Their industry was as breathtaking as their output. The architects, too: Norman Shaw designed Cragside while the house-party was out on a day's shooting; Charles Barry worked from 6 am to midnight; Street dealt with all his correspondence before breakfast; the hours in Pugin's office were 6 am to 8 pm.

Tuesday 8th: London

Unilever dinner party of Dutch/English nobs in honour of Leverhulme Exhibition, with the Duke of Gloucester as principal guest. Exhibition looks absolutely splendid. Full marks for designer Ivor Heal, but I question its profitability. We shall see.

Wednesday 9th

To University College London Committee. Warm reception to our preliminary sketches. Open an RIBA exhibition of models and drawings. Then RFAC till 6. Agreeable, run-of-the-mill afternoon: motoring junctions, ruined farm buildings, provincial supermarkets, street lighting, an abbey bookshop, an eccentric architectural statement in Hull with yards of explanatory gobbledegook. I have always enjoyed attending the RFAC in Carlton House Terrace. Even when the agenda's not exciting, the setting always is. Indeed, my peak of visual drama in London is not Westminster Bridge, nor the famous view of the Horse Guards from the footbridge over the lake, but the top of the

Duke of Yorks Steps.

Selection Committee

Duke of York's steps overlooking St James's Park – both the creation of that magical spacemaster John Nash. Spare a glance, incidentally, into the shrubberies at the tiny tomb of Giro, pet dog of Herr von Ribbentrop, whose Embassy was here, and at the railings. They were placed there, I've been told, on the orders of Gladstone, to avoid a repetition of the incident when he personally prevented two ladies in a run-away carriage from plunging down the steps. Prime Ministers these days seem to live more sheltered lives.

Thursday 10th
Long morning at RA with Membership Committee. Familiar arguments for expansion of numbers *vs status quo*, the possibility of abandoning two-tier membership... Dispiriting. Sense granite behind courteously listening faces. Lunch at Knight, Frank and Rutley. My neighbour, a director, reveals himself as a keen church organist.

Friday 11th: Beaconsfield
All day at Beaconsfield. Site inspections, meetings with officials all spouting 'Section 52 application' jargon. Dreadful lunch at posh restaurant. Forty minutes' wait for speciality, much waving of napkins and changes of empty plates, but no food. Eat two rolls, gobble a trout in final seven minutes left to us. How I loathe pretentious restaurants.

Monday 14th: London
Selection Committee first meeting, with Peter Greenham, Iain Stephenson, Colin Hayes, Ruskin Spear, Leonard Rosoman, Paul Hogarth, Roger de Grey. About 13,000 submissions to get through – the same number as usual – so the pace is necessarily fairly brisk. Virtually no dissent – unanimity perhaps predictable, since only two votes needed to survive first round. Not many portraits or abstracts, lots of suburban streets and flat beaches. At lunch go with Libby to Old Battersea House by the river. Huge 18th-century mansion beautifully restored, packed with magnificent Victorian paintings – Orchardson, Hughes, Holman Hunt, Millais, Brett, Moore, Tissot – and lovely ship models. Owner is 28-year-old millionaire son of American called Forbes. It's a private house, open to view only by special arrangement. We find some special stuff for our purpose, Hartlebury Exhibition of works by royal artists: a doodle by Prince Albert and a joint painting by

Student Porter.

Monkton.
Edward James
House.

Queen Victoria and Prince Albert, bearing signatures of both. More selecting after lunch, narrow squeaks in turning down friends, RA students, potential candidates. Student porters efficient and good-tempered, but it's exhausting work.

Tuesday 15th
Overheard in Knightsbridge: 'There are some days when I simply can't *face* Sloane Street'.

Wednesday 16th
Discover a door at the RA this morning which is marked 'Private' on *both* sides. Selecting 'till noon, then to RFAC for Aga Khan press lunch. Good and high quality turnout and lively questions in informal setting. HH sharp as a pin.

Dinner with friends in honour of old friend, Muriel Murphy, just arrived from New York. Host complains that American guests always telephone too much. 'In America', he is told gently, 'guests have their own private 'phone'. Host defeated.

Thursday 17th
Selecting 'till 3. Record brief interview with Edward Lucie-Smith on Dali. In the late 'thirties when working as the only assistant to Kit Nicholson – my dearly loved ex-tutor from Cambridge – we worked closely with Dali on a Lutyens house in Sussex belonging to Edward James[1], a charming, sensitive and dandyesque figure who seemed to me to be the ultimate in sophistication (hats from Naples, shirts from Nice, a German chauffeur). Our office was over a chemist's shop in the Fulham Road. James and Dali would arrive in a Mercedes and the morning's work would begin. Dali's first instruction was that the main living room should be made to resemble the inside of a not-very-healthy dog. This project – to be achieved, we hoped, by lining the room with flock-sprayed sheet-rubber concealing compressed air ducting, to ensure walls that expanded and contracted unevenly (the dog, after all, was ill), was thwarted by the Munich crisis, but Dali's other devices – sculptured blankets hanging from the bedroom window cills, a chimney stack shrouded in a plaster dust sheet that also contained a dial telling the days of the week (each day had a different colour

Selecting

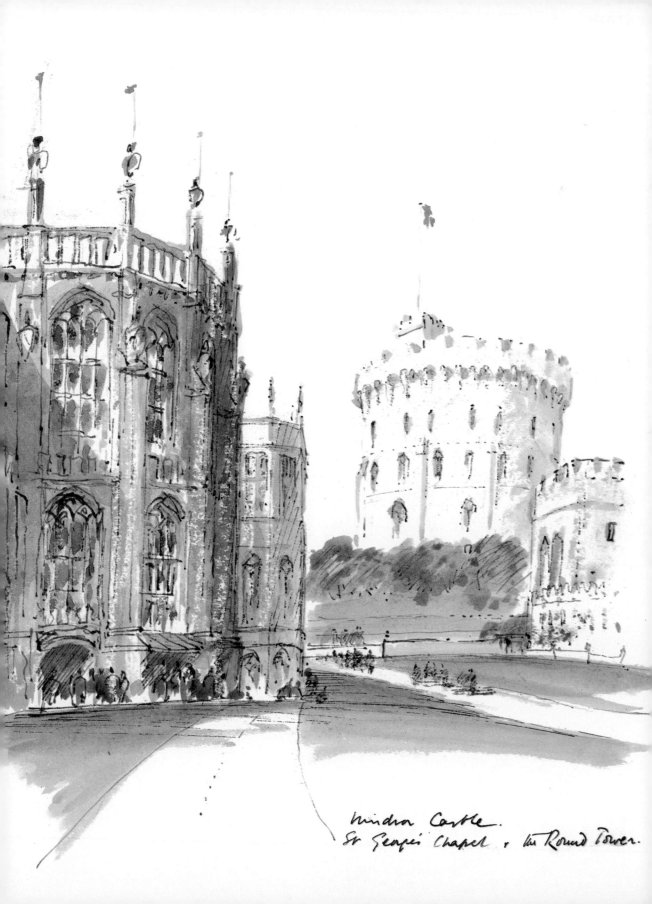

Windsor Castle.
St George's Chapel & the Round Tower.

- Hills r Mills.

personally mixed by Dali on my drawing board), and a stair carpet patterned with the paw prints of Edward James' Great Dane – were all accomplished and for all I know are there still.

Photo session with *Sunday Times*. Then return to finish selecting at 5 pm. Watercolours, drawings, prints generally high quality – higher than oils – but we are tired and perhaps a bit perfunctory. Author Ved Mehta to drinks, just back from India making a film about his penurious uncle. What other blind man would think of making a film? As always astonished by his freedom of movement – up steps, around tables. He is guided, he tells us, a great deal by temperature, obstructions giving off tiny waves of heat or cold. I once saw him walking down 73rd Street without a hesitation at kerbs, passers-by, hydrants or steps. Film-maker John Bulmer and sculptress Angela Conner join us and take him off to House of Commons.

Friday 18th
2 pm to Painter Stainers' Hall for their annual prize giving. Robes, chains, beadle, processions. What do the students in their sneakers and windcheaters make of it? They are polite and puzzled.

Saturday 19th
Draw all morning. House-hunt round Bayswater all afternoon.

Riverside Studios for one-man show by Eleanor Bron. Sit with Jo P and Cedric P, who leads the claps. Two or three moving or funny sketches, but she doesn't quite hold the evening. Is it a handicap on the stage to be an intellectual? I guess so.

Sunday 20th
Afternoon sketching in Eton/Windsor for future Festival Programme cover. Too cold to get out of the car, and I find to my shame that if I leave the engine on I get a very seductive trembly line.

Monday 21st: Hebden Bridge
Long and curious day. Start by catching 6.45 am train from King's Cross. St Pancras Hotel glowing as pink as a lampshade in early morning horizontal sun. Work (over BR kippers) on RA banquet

48

Painter Stainers Hall.

Hebden Bridge

speech 'till Leeds, then change for Hebden Bridge. Met by young ex-RCA film student, Meyer, and taken to 'location' on a main road above Hebden Bridge. Cost decrees (Arts Council grant) that the crew is restricted to three, Camera/Sound/Clapper-Assistant. As always puzzled and irritated by clumsiness of film-making equipment – huge boxes, three types of microphone. There are the usual snags: a broken cog, a missing unit (nine minutes instead of three to change a film). There are also the usual hazards: aeroplanes, distant tractors, curious bystanders, fluffs on my part. The first take – about 500 words to learn – is on a main road. Each attempt involves stopping traffic, apologising, asking for engine to be switched off. Camera man and clapper boy race in all directions. A fluff or a noise and we do it again. The boys are polite, patient, anxious. I am torn between sympathy and rage. Sun shines, sky is blue, moors are beautiful, architecture stern, stony and direct. Why am I grumbling?

Next for a disused mill, now an 'archaelogical museum'. A forgotten railway, a drained canal, an abandoned magnificent stone building full of elegant and robust textile machinery. Curator, bearded, sandalled, bespectacled, enthusiastic, lays on cheese sandwiches and tea. The architecture is totally splendid. Next to a weaver's cottage with the first floor converted to take spinning jennies. On again to two more examples (a two-storey weaving shop above a house and a farmhouse where the weaver-owner went straight from farming to weaving into a mill). Minor brush with cottager, who emerges to say 'I suppose you know we had a funeral this morning?' We can think of no appropriate comment, so apologise and strike tents. All these places are miles apart up and down hills, past rank upon rank of raking roofed cottages, deserted mills, boarded-up shops, huge town halls, sudden brave-facing flashes of prosperity. Oldham is ruled and divided by two huge red-faced mills called 'Rome' and 'Athens'. Chimney stacks, square, octagonal and round, spout from fields with no buildings (even ruins), in sight. By 6 I am tired and sulky. Already I've missed the 6.30, which means catching the 7.10, changing at Crewe (oh well). Sausage and chips at Crewe buffet (excellent), where white-haired matron rebukes crowd of booted skin-heads, who cringe beneath her sharp tongue. (Memories of Gran? Just imagine if I'd complained of their noise.) Greeted by Harold Wilson in buffet car and rumble on home.

49

Mill

Tuesday 22nd: London

9.30 photo session with Tony Snowdon in his charming little turreted villa. Two hours, about 50 'takes'. Relaxed, humorous, enjoyable. Always a pleasure to encounter true professionalism. Rest of day with Hanging Committee at RA. Good progress. A couple of private views. Instructive supper with RA ex-Secretary, Humphrey Brooke.

Wednesday 23rd

Early am meeting at RA followed by Mobil prize-giving at Somerset House. Large press turn-out and posters look fine. Exhibition Committee discussing ideas – sent in or our own – costs, backers, timing, vacancy slots. It's like running the Palladium: getting shows in and out quickly, tickets, posters, publicity, the gamble in success or failure, the sudden unexpected demands. (Can we accommodate a retrospective of X, or a suddenly available offer from France of 19th-century lithographs? Is it time for a revival of, say, Brangwyn or Meredith Frampton? Anyone for Tissot?) We sort out schedule and pencil in dates.

Thursday 24th

John Skeaping[2] memorial service at St James' Piccadilly. Fine music, fine words. How sad that, living in France, John was such a rare visitor to Burlington House. I never met anybody who burned with such energy and zest. You could warm your hands at him.

GLC Historics Buildings Committee (very difficult and contentious, my fellow advisers (John Summerson, Osbert Lancaster, John Betjeman) and I are allowed to advise but not to vote. Impressed as always by the expertise and knowledge of the technical officers.

Friday 25th

Budget meeting on our proposed Modern Painting Exhibition. Could hardly look worse. Then Youth and Music Press Conference with Richard Baker. Excellent response. Down to BBC for private showing of three *Great Pictures* films. Pictures look fine and BBC pleased with my script.

Monday 28th

Invalid Children's Exhibition opened by Norman St J Stevas. A mov-

Tony Snowdon's house.

ing and desperate occasion. One of the prize-winners, sitting in his chair like a piece of crumpled-up paper thrown into a wastepaper basket, emits regular whoops of (I hope) pleasure. The pride of the parents, teachers and helpers in the achievement of their charges brings tears to the eyes.

Go through architects' submissions for the Summer Show and rescue a few corpses from the discards. On to BP office for interview on their new office interiors. Then to Victor Pasmore's Private View. The art-span today – from handicapped children through RA and corporate sponsorship to Victor Pasmore – has been a wide and at times a disturbing one.

Tuesday 29th
Letter today from a Friend of the Academy:
> *'Dear President, Are your chandeliers by any chance made of soup?*
> *Yours sincerely, . . .'*

Stung, I go on to the landing and look. He's right and we arrange to remove them for cleaning. Amazing for how long one can fail to notice sluttery in one's own house. Usually it comes to the surface when you are trying to sell it. 'Is this your *living* room', potential buyers ask incredulously, as they gaze at the chipped paint, torn paper and book-laden window-cills.

Wednesday 30th: Hounslow
Meeting all am on Hounslow Library Inquiry; solicitor, planning officer, architects. Only half my mind on it because of the afternoon ahead. After lunch with M and Jo P go to crematorium for Michael P's funeral. Usual sort of building: style vaguely Byzantine, lots of brick and polished oak, scent of flowers and floor polish. The manager – pale, young, deferential – asks me to wait in the office, just the same as any other, and, I suppose, why not? Filing cabinets and tea-cups, and typists' tat . . . holiday postcards and joky slogans about productivity ticky-tacked to emulsioned walls . . . two cheerful clerks typing and sorting. I sit on in quiet despair. The chapel is packed – and no wonder, for Michael was a lovely and much beloved man. The service is short, there is no priest and we bring our own music. I speak briefly and with difficulty. Should there be funerals? Yes, because they are final.

Inspecting
the chandeliers
Burlington
House

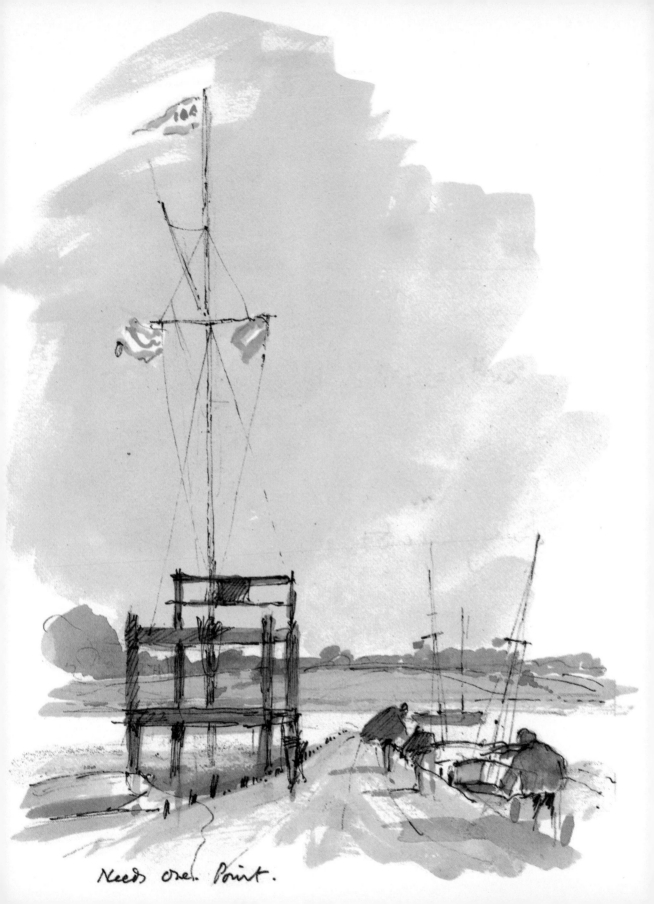

Needs one Point.

London – Needs Ore – Isle of Wight – Brighton – Chichester – Cambridge

Solent.

MAY

Friday 2nd: London

Council Takeover Day, when we all walk round all the galleries re-assessing the selection and the hanging, and finally and formally 'accept' it. Desultory start at 10 am. Six galleries finished, but the rest still *en deshabille* (the legacy of prolonging Post Impressionism). No real dramas. An argument about somebody's hideous, shiny frames ('don't let's upset him'), a disconcertingly bright royal portrait moved to a more shadowy corner, a few rumoured complaints about somebody's wife's painting being hung too high. (Once, in the days when the RA was housed in a wing of the National Gallery, the Secretary was felled unconscious by a blow from an angry member complaining about the placing of his painting.) The sculptors, as usual, have the hardest job: heavy stuff, in all shapes, sizes, materials and colours, difficult to arrange, since each piece needs space to breathe. The architects are 'arranged', but not hung. We leave two volunteers to complete the unfinished rooms – the fewer people, the fewer argu-ments – and drift off to Council. This drags on through lunch. We return to the galleries at 3 for final approvals. Fatigue and impending Bank Holiday are good ingredients for quick decisions.

Saturday 3rd: Needs Ore

Up 7 am, pack and get ready to leave. No traffic to speak of and we are at Needs Ore by 12. Ours is one of a row of coastguard cottages, each sash-windowed, sturdy-walled, planned tightly as a lighthouse. Tiny gardens behind white-paled fences, a shared washhouse – snugly perched behind a turfed, protective *bund* and backed by fir trees. I discovered it by accident nearly 60 years ago when with two equally inexperienced friends we ran our half-decked dinghy aground on a mud-spit and found the cottages empty except for a kindly old man who drove us in his Arrol Johnston to Beaulieu and civilisation. (We came back for the boat later.) After the war we rented one of them for summer holidays – oil lamps but piped water – and finally became tenants. It's all more sophisticated now. Electricity arrived (no more airing of blankets in front of the fire), the water-meadows have become a bird-sanctuary with notices, the old coast-guard boathouse on the point is now a tiny yacht club alive with the tintinabulation of wire shrouds on aluminium masts . . . but off-season it is still a wild, lovely, bird-haunted and magical place.

53

Beaulieu River.

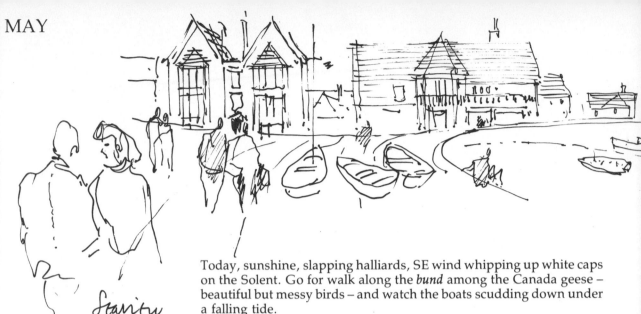

Stanton I.o.W.

Today, sunshine, slapping halliards, SE wind whipping up white caps on the Solent. Go for walk along the *bund* among the Canada geese – beautiful but messy birds – and watch the boats scudding down under a falling tide.

Sunday 4th
Dinner with neighbours. You can see the house across the Beaulieu river, but it's nearly a fifteen-mile drive to get there. It's the only large modern house I've ever been in (no wonder architects are under-employed) – spatially adventurous in section, beautifully built and finished. Hateful paper games after dinner. Do badly as always. Drive home beneath Japanese-sized moon over the silver Solent.

Monday 5th/Tuesday 6th
Sunny, windy, beautiful. Work most of the time in the garden: a Waitrose store, a Sainsbury supermarket, a small museum. A nice change to think and draw uninterruptedly.

Wednesday 7th: London
My 'London' stamps out on sale today. Queues round the block in Trafalgar Square, I am told. Wish I was prouder of them. Draw all morning (Sainsbury's Chichester store) and all afternoon (Beacons-field's Waitrose). A little nearer the solution perhaps.

RA chores after lunch. Then to Salters' Company for Civic Trust press conference. Good speakers but I try to extemporise and flail about miserably. Escape, blushing, to hear the last words of Asa Briggs' lecture at Royal Society of Arts, followed by hilarious supper party.

Thursday 8th
A day that brings out the worst in me: too many things done too quickly to be done properly. Letters 9.30-10. Visit from publisher's editor about possible children's book. Top-and-tail sixty letters for an ex-students' appeal; do a drawing (a farewell present for the retiring surveyor), and design and draw poster for Royal Tournament Court-yard Concerts. Each occupation interrupted by visitors and telephone calls. Afternoon NPG Trustees' Meeting. Very enjoyable as always (Henry Anglesey a welcome new trustee). Then GLC Historic Build-

Bembridge

ings. Long complicated, difficult, wordy.

Home to inspect possible new house off Ladbroke Grove. Nice but maybe too tiny?

Friday 9th: Isle of Wight

Up early. With M and Anne J to Waterloo/Portsmouth/Ryde. Blazing sun, cold wind, blue sea. Hire car to Seaview; delicious fish and chips on front. Thence to Bembridge School for 2 hours in Ruskin museum – a private collection of watercolours, drawings, and manuscripts assembled by a Ruskin fan called Whitehouse and presented by him to the school he founded. Some of Ruskin's most delicate and observant work – including a ravishing portrait of his beloved, Rose la Touche.

Tea with Headmaster and on to Susan C's cottage for dinner and bed after a brief walk along the beach. IoW, as always, a winner for landscape, architecture and character. It has hardly changed in a hundred years – low, clay-coloured cliffs merging into multi-coloured farmland and the swelling downs, and all to miniature scale. Everything about it – its Gothic vicarages and toy town-halls, villas and cliff walks, pierettes and forgotten signal boxes – miraculously preserved. There are some horrid suburban outcrop areas to be found, of course, but they too are small and buried in shrubs, and the shoreline is as varied and beautiful as ever.

Saturday 10th: Whippingham, Osborne

A peerless day. Apple blossom, plum-coloured brick, white paint in the foreground, and in the distance, beyond what Auden called the 'pluck and knock' of the tide, the shoreline of England – so clear you can almost tell the time of the clock on the tower of Portsmouth Town Hall. Pack up and drive slowly over the downs to Osborne, calling first at Whippingham Church, with its dotty little spirelets, pretty glass candleholders and magnificent monument to Albert. (He is supposed to have designed it.) It's a lovely place, perched above ill-kempt meadows tumbling down to the Medina river below, but it's recently been placed on the tourist circuit, and as you enter, a recorded commentary on the church booms authoritatively across the silent pews. On to Osborne itself, one of my favourite spots on earth. Metropolitan

Candle holders – Whippingham..

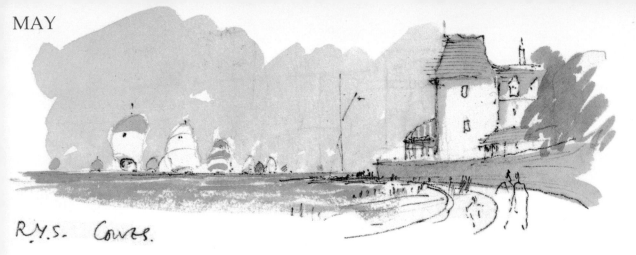

R.Y.S. Cowes.

Water Board architecture by Albert and Thomas Cubitt, state-rooms cluttered with Victoriana (childrens' limbs sculpted in marble, furniture made of antlers, portraits of favourite dogs – Scamp, Noble, Minnie and the rest), the room where Queen Victoria died shuttered against the sun, left undisturbed since the day she died, Albert's sword lying significantly on her bed.

We have a brief encounter with an old student friend, Gontran G, convalescing (with twenty-five others) in the old courtiers' wing. It's comfortable, he says, run like an officers's mess – formal and unglamorous. The lawns, embroidered with Victorian flowerbeds, slope away to the sea and Queen Victoria's old high-wheeled bathing machine. We sit and gossip until lunchtime, while fellow convalescents, scarved and be-sticked, creep over the gravelled paths like ancient insects. Susan C's late husband was a member of the Royal Yacht Squadron and we are taken there for a delicious lunch. French Baronial architecture, empty flock-papered rooms, deferential staff. It's Saturday and the Solent is crowded; coloured spinnakers race past the windows in a force 5 wind. We feel like aristocrats besieged in some revolution, as the brilliant colours billow and crack at us fiercely, like banners brandished by the mob.

We catch the tea-time ferry and watch Gilbert Scott's spire of All Saints' Ryde, one of his best, drop astern. A totally enjoyable day.

Sunday 11th: London
House hunting. Elgin Crescent, W11. Could it be? A vast, lofty, peeling, terrace house, pillar-porched and balustraded, with a garden giving on to a curving, communal garden behind. The rooms are coarsely corniced, the windows have shutters, and the air of grand gentility is touching. What captivates us is the garden-level basement room – a casual, rambling space – for it is all one, back to front, with the staircase descending into it and at the back, a garden room extension, low-ceilinged, with romantic views. The condition of the house is appalling.

Monday 12th
Early start for official visit to Burlington House by Dutch President of

Osborne House

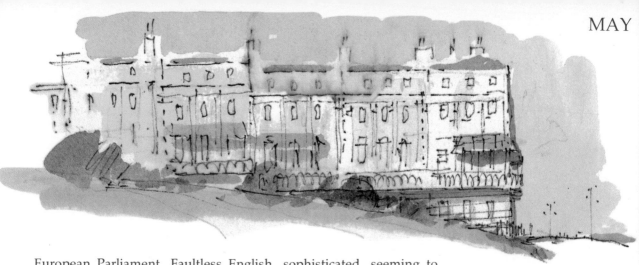

Brighton.

European Parliament. Faultless English, sophisticated, seeming to know everybody from Alma Tadema to Ruskin Spear. Push him (plus large entourage) out and then do quick tele interview with Russell Harty. Posh lunch at Hammerson Group's headquarters in old Dudley mansion, Park Lane, magnificently restored by Basil Spence.

Chores 'till 4.30 and Publications Committee, then to National Theatre and *The Wild Duck.* Splendid performance by Michael Grant.

Tuesday 13th
Office 'till 12, working on Watford, Beaconsfield, Cambridge. More drawing all afternoon cancelling trip to Brighton because of rail stoppage. These unexpectedly rescued hours are a great pleasure and bonus. Sun continues to blaze. M's negotiations over the house reach sparking point.

Wednesday 14th
All day RFAC. No sign of that building slump. A dozen huge, important building projects, including Liverpool block warehouses and James Stirling's new Tate extension. The Commission membership – equally divided between architects, engineers and 'informed laymen' – enjoy the usual argument about conservation standards and financial realities. Architects perhaps over-conscious of the latter, historians of the former. The chairman keeps an amused balance.

Thursday 15th
Press conference on the projected Burlington House Fine Art Fair. Gets off to a warm start, I think, At Thurloe Place office 'till dinner, and draw 'till nearly midnight. Time was when I did this several nights a week . . . but no longer.

Friday 16th: Brighton, Chichester
To Brighton for Festival Committee meeting. Rather subdued, for takings are down, despite good performances. I suggest that fringe (very successful) has taken over and our 'official' job (to stimulate) is therefore done.

Train on to Chichester to see Sainsbury site. Unspeakably dull. Only

Brighton Beach

Supermarket Site
Chichester

saving grace (its low level) ruined by filled-in gravel pit. A real design problem.

Saturday 17th/Sunday 18th: London
Domestic chores and house-hunting. Cousin Andrew arrives with silver birthday mug from my 19 first cousins. Touching that they should bother. I'm luckier than Sydney Smith, who said he wished all his cousins were 'once removed'.

Monday 19th
RA chores 'till 11. Then take the chair at National Film Theatre for press conference on Southampton Art Gallery Appeal. Middling response, I'd guess. Afternoon off to inspect the office-designed bridge across the lake in the Savill Gardens (looking fine), and the Plunket Memorial Pavilion, still miraculously free from graffitti. Beautiful day, long light, lake, moorhens, rhododendrons, polo lawns.

Tuesday 20th
Ambrose Congreve[1] Award for Architecture ceremony. Two winners: the Bykker Wall at Newcastle and the Sainsbury Centre. Neither, I suspect, greatly to the liking of the generous donor, but he congratulates all of us, committee, jury, winners. We wolf our *canapés* while we discuss alternative administration proposals. Prize by nomination (like Nobel?) But how would we be sure we'd seen everything? Calling in entries at last minute if field is poor? Would look like a judge's rig-up. As always, the best is the enemy of the good – we should recognise excellence but not necessarily the most excellent. All judges in all competitions fret as much about their own reputations as they do about the candidate; nevertheless John Summerson, Philip Dowson and Bute have done well to get this award on to such an authoritative and credible basis.

Back to RA for brief Council meeting. No sparks. We dine at the Larsons, a fabulous Edwardian house in Airlie Gardens, splendidly restored and covered in pictures by painter grandfather, Olivier. He was an official war artist in 1914 war, mostly portraits: generals meeting in chateaux round maps and green baize, King George V descending from his Daimler to greet pince'nez'd General Nivelle. ('Could you

Savill Gardens Bridge

perhaps', says a Buckingham Palace note, 'insert the Maharajah of Patiala somewhere – coming round the car bonnet perhaps?')

Wednesday 21st

Assembly lunch and election meeting at BH. Sun pours through skylight and I begin to question my defence of natural daylight for pictures – some of them look a bit skin-tired in the blaze. Sit between Jean Cooke and Robert Buhler, both old RCA colleagues, and gossip away about former days. William Brooker, Ann Christopher, John Partridge (painter, sculptor and architect) are elected. It all takes ages, so clumsy is our mechanism of check and countercheck, but nice to get a cross-section of new ARAs. Artists are not the easiest of audiences. Their minds are elsewhere, and when meeting in a gallery of pictures, they find it hard not to study them instead of bending to the task of election. As always, our votes are capricious to start with – friends gossiping to each other as they consult the papers – but in the end some order prevails. A few questions on finance (touching, the artist's belief that you can always make money by showing pictures), on the restaurant (not yet good enough). All over by 4.30. As always fairly irritated by our failure to get any agreement to increase our number. Perhaps tomorrow.

Dine and speak at the Chelsea Arts Club, a traditional PRA occasion in a familiar building. I started my professional career over the chemist's shop 50 yards down the road; my secretary of those days still lives next door. M and I lived out a month or two of the Blitz 'till our landlady, Miss Rose, a sweet little tiggy-winkle crafts patron of the 'thirties, decided she couldn't be bothered with the clattering glass and the nightly bangs. We left for a week in the Regent Palace Hotel. This was an extraordinary experience, where guests slept in the corridor like shoes put out to be cleaned.

Thursday 22nd

Election day No 2. Only one nominee today – Anthony Whishaw – who waltzes through after his near-victory the day before. Procedure, as always, deeply unsatisfactory. Many members have gone and by 3.30, when debate begins, only around 20 survive to argue about increasing the size of membership (a fairly even split of opinion) and abolishing

70th Birthday
Party.

the Associateship. Both subjects have been annually debated for nearly 100 years. There were no Associates in 1768 – they were introduced later, partly because it was the view then that consistency of performance needed a period of time to get established. Those were the days when average election age was under 30. Now, when it is 50 plus, consistency is there and, in my view, to keep such probationership for a mature painter is a little insulting. Others differ. Some, like prefects defending fagging, 'I went through it, why shouldn't they?', others, because traditions, however daft, should not be lightly overthrown, one or two, illogically, on the grounds that an ARA is as distinguished as (and implies more liveliness than) a full RA. Ruskin, giving evidence in the 1860s, remarked, perhaps rightly, that the whole issue was of such monumental triviality that it was unworthy of debate. A show of hands, however, shows a wish to preserve the practicalities.

The increase of numbers is far more complicated, and signs of scratchiness appear. We end inconclusively, having given a few minor byelaw amendments our fatigued support. Suppress the irritation one always feels at the imperceptible movement, democratic procedures permit. Sigh for the achievements possible, no doubt, if it were all left to the officers to deal with. Wonder again at the deep conservatism of artists. (We think of ourselves, I suppose, as rebels and iconoclasts – but so few of us are – and the RA perhaps is not the proper place for them anyway.)

Nevertheless a flattish afternoon. Home and then back to BH with M to pick up some friends for dinner – to be greeted with an explosive surprise. Grandchildren in the foyer, who dash ahead like puppies to conduct me to Gallery III, transformed into a huge buffet drinks scene and 250 or so of our dearest friends of the last 50 years gathered to celebrate my 70th birthday, all organised in totally successful secrecy by M and the girls. A birthday cake, piles of telegrams and cards, a huge book of messages from those there or regretting absence, a warm-hearted eulogy from Huw Wheldon and embraces all round. It is like swimming in golden syrup for 2 hours. Touching and warming to be greeted by friends from as far away as Monte Carlo and Northumberland, relations and friends not encountered for over twenty

years. Leave exhausted and tearful with pleasure at 9 pm.

Friday 23rd
My birthday. RA at 11. Correspondence 'till service at 12. I read the
lesson (St Paul to the Ephesians). Archbishop Coggan and wife to
lunch, then despatch them off round the show. At 3, announce various
awards: Anthony Gross the main winner; runners-up Ruskin Spear,
Carel Weight, Ralph Brown. Off to Thurloe Place, where office has laid
on a birthday tea of strawberries and champagne, and then to family
dinner, where I am given by the children a lovely present – a huge pine
box carved in *bas relief* with the facade of No 35 and containing a
collection of drawings and photographs of that lovely house.

Saturday 24th: Cambridge
From Liverpool Street to Cambridge for nobby lunch with Jack Plumb
at Christ's College, hardly visited since we failed to get our extension
scheme accepted by the college way back in the 'fifties. (Denys Lasdun
rightly succeeded.) Delicious lunch, lovely house, nice company.
Trundle back to Liverpool Street full and cheerful.

Tuesday 27th
RA in morning, for two meetings: an abortive and rather embarrassing
one with an ad-agency presentation, followed by a discussion on the
BP office job. Last-minute agonies over banquet. Florist's horrors, as
always, to be removed out of sight, timing and guests' drill to be
arranged. Lunch and home for change and rest.

Arrive at 6.30, lovely sunny evening. Joshua Reynolds in garland,
courtyard swept. Lord Hailsham, like a crumpled teddy bear, arrives at
6.50, other guests at 7.10ish. Lots of friends. Distant brass band, a bit
too near. At 7.20 Prime Minister (black taffeta dress to the ground, *crêpe
de chine* white rose on shoulder) looks handsome, as also does Denis.
Sidney bears them off. At 7.21 Princess Margaret arrives in white silk,
embroidered with silver and pearls, looking beautiful. She destroys
our careful plans immediately by asking to see Michael Noakes' por-
trait of Queen Elizabeth, before evening starts. Administrative panic
since it involves threading our way through busy waitresses still put-
ting out wineglasses, but all goes well. We then ease into the mob,

Birthday Cake

RA. Banquet

where she sees a number of friends. Before sitting down to dinner, Mrs T, with an experienced gesture, turns the mikes away to face outwards – she is not risking being overheard. Dinner is painless. HRH drinks mild whisky, makes a brief, clear and witty speech. Mrs T is purposeful and serious: 'I like speeches with meat in them, otherwise it is not worth going to listen to them'. She quotes Apollinaire: 'Come to the edge . . . it's too high they said . . . we shall fall they said . . . but they came . . . he pushed them and they flew'. (Anthony Powell is so moved by this that after dinner he asks to be introduced, and I leave them together.) Tom Stoppard witty but not, I'm later told, everywhere audible. A shame. My own speech is cut to 11 minutes – quite long enough. Party disintegrates into drinks and greetings. A few pictures are bought, but mostly they are ignored. PM and HRH hang on 'till 11.50 and disappear in flurry of waves and smiles. Sink exhausted into Mini. Nice evening, but feel drained and battered by responsibility. Can't get used to letting the organisation carry me along.

Wednesday 28th
A couple of meetings, thank-you letters. Routine. M and I go to lecture by Noel Annan at National Theatre – beautifully phrased, timed and spoken. (Obviously an actor-manager *manqué*.) Amusing dinner afterwards.

Thursday 29th
Summer Exhibition private view day. Drive up Piccadilly at 9.45. Queues down the pavement outside and across courtyard. Never seen such crowds since Pompeii. Nice but alarming. Is everybody furious? Luckily no: fight in past very good-tempered crowds. Surprisingly cool and not too disastrously packed inside; pictures selling like an Oxford Street sale. Encouraged, alarmed, buffeted, leave lunch-time to go home and draw.

Friday 30th
Last night's sale figures nearly £200,000, but this figure artificially lifted by Victor Lownes, who came in early and bought 500 works, putting them all on sale again at slightly higher prices, the difference going to charity – a generous device which arouses much sucking of teeth. But what's to do? All pictures are for sale and somebody could presumably,

HRH. arrives.

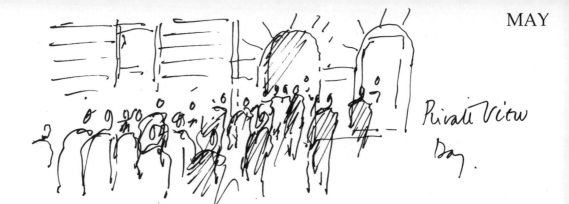

Private View Day.

if they liked, buy the whole lot in the first hour. It's ridiculous to put a limit on the number anybody can buy at one go. What should that limit be? And why?

Saturday 31st
Pouring wet, so spend morning turning out old files (three sackfuls). Old lectures, old correspondence. Malta/Vienna/Nebraska/Ankara/Texas/Toronto. Photographs, visiting cards, facetiously inscribed menus, speech notes, the *débris* of a professional life. Heigh ho. Draw all afternoon.

Turning out files.

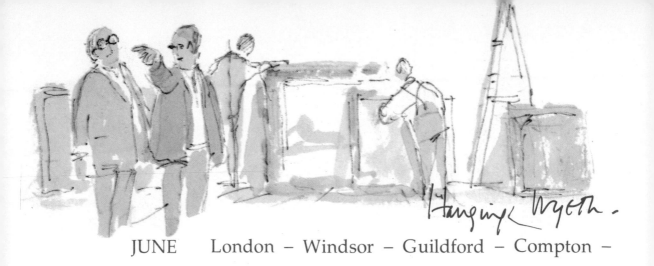

Hanging Wyeth.

JUNE London – Windsor – Guildford – Compton –

Decorating the Staircase

Monday 2nd: London

Wyeth week. Starts badly with a wet day, Leverhulme Exhibition hardly cleared, and hangers demanding more wall space to allow pictures room to breathe. The extra room asked for was set aside for a coffee shop and several hundred quid a day, but we have to yield in interests of the show. Some of Wyeth's finest works – but it all remains a gamble. Although top of the pops in the USA, he is almost unknown in England. Critics tend to suck their teeth over him. We shall see.

Huge evening party given by Annenbergs at Claridges: Royals, Cabinet Ministers, Duchesses, 500 'Beautiful People'. The Ballroom (I remember it being built) is still in tip-top 'thirties condition. How sensible of Claridges to keep it so.

Tuesday 3rd

British Council morning. Anthony Kershaw speaks rather sharply about his visit to the Far East. We look down our noses as if somebody has fainted in Church. Chairman, as always, a funny courteous, efficient lightning conductor. AGM of the Artists' General Benevolent Institution. Fantastic and moving total of £60,000, assembled mostly from artists for their less fortunate colleagues. Brief despairing meeting over a Somerset House Exhibition project. Good idea, lovely place, lots to show, government indemnity promised, but no sponsors and an estimated deficit of £60,000 at least. Decide RA shouldn't pick up this tab and agree to withdraw unless . . . Chatsworth exhibition is also in sponsor trouble. All conversations at RA seem to be about money.

Look in on students' preview before going home and on to American Embassy dinner given in honour of Wyeths. A few Claridges survivors there. Sit next to Mrs Brewster and Mrs Wyeth and have a lovely time.

Wednesday 4th

'Don't feel so bad today' (as ex-RCA colleague, Freddie Sansom, used to say) . . . 'feel worse', so decide to stay in bed husbanding strength for tonight's Wyethry. Its Derby day (as usual, I get through it without knowing who won). Boiling hot sun – not the weather for sheets and

Oxford – Glyndebourne – Glasgow – Winchester

Adelaide Cottage
Home Park.

pillows. I report in at 5 pm. By 6.30 the florists finish turning BH into an Alma Tadema tepidarium: roses in garlands, fountains of flowers. Brewsters arrive early and unannounced. Prince and Princess Michael of Kent on the dot in amiable and hard-working mood. Party hums along. Much the same as Monday but not quite so grand. Royals stay on 'till nearly 9 (instead of 7.45 as billed) so the Safras are pleased. Three hours standing in the heat is exhausting but tonight the Safras (plus Wyeths) are the real hosts, so my responsibilities lighten and I feel less flogged.

Thursday 5th: Windsor, London

Quiet, boiling day sitting in a garden at Windsor writing speeches. 9 pm to Annabel's and Safra-land again – glamour clamour from 9-12. Sit next to ravishing young French jeweller, who is wondering whether or not to marry a Venezuelan, which means going to live in Caracas. I advise on former, but against Caracas, though I've never met him nor seen it. Wonder what will happen. How comparatively easy it is to settle other people's lives. Perhaps being an architect, and expected to be a semi-expert on anything from child psychology to indoor plants, nourishes this fatal belief.

Friday 6th: Guildford, Compton

By hire car to Guildford to see a possible new job. It is Sutton Place – ex-Getty owned and now belonging to a modest young American called Seeger. He wants to restore it closer to its Tudor original, and to improve the gardens. My escort is his PA, Penelope Midgley, a dynamic and obviously efficient girl who puts me in the background *en route*. (Seeger himself has rung to apologise for his absence: he has heard the lilies in Monet's garden at Giverny are at their best and he has gone off for the day to see them. I find this a wonderfully encouraging start – at least the client's values are well balanced.) Sutton Place – Tudor-chimneyed and mullioned without, tapestried and timbered within – is not really my sort of house, but on its plate of green lawns it looks magnificent. The park (canal, watermeadows, willows) is nicely relaxed, and the gardens empty and quiet.

65

Home Park
Windsor.

looking up-river from 'St Peters Wharf.

A quick tour of the house, a quicker lunch, and I go on to Compton for a preliminary look at the Watts Gallery, my next BBC programme. Buried in foliage, its roof pulled over its ears, it looks like an abandoned gipsy encampment. Inside it is enchanting – sunny, empty, casual, with huge Watts pictures dozing on the walls above a sleeping cat. Anne J, who meets me there, is thrilled with it.

Saturday 7th: Oxford

Jubilee lunch at Dorset House School of Occupational Therapy, Oxford. For 20 years I was chairman of the governors of this school founded and run by my formidable doctor aunt Elsie. She was a beautiful, compassionate, strong-minded and public-spirited woman with a most individual dress-sense. (I remember at the age of nine being conducted, rebellious and humiliated, across Paris, together with my equally embarrassed sister, by Aunt Elsie wearing a full-length black evening dress and a straw hat and carrying an alpenstock.) Lots of old pupils and staff at the lunch and my speech received indulgently.

Sunday 8th

Lovely day to myself at the drawing board. Funny how guilty one feels about feeling buoyant – something to do, no doubt, with the traditional belief that high spirits are a sign of superficiality, that pessimism is the true mark of the serious thinker, that ill-health is an essential ingredient of genius. 'Genius?', I remember an aunt saying to my mother about a clever little cousin, 'nonsense dear, he's as strong as a horse'. Draw on happily, putting Blake and Haydon behind me and thinking instead of Bonnard and Turner and Matisse.

Take an hour off for the RCA Annual Degree show, always a nostalgic occasion. Memories of late-night working, picnic baskets, smell of size, the rattle of staple guns, the anti-climax of opening, the hot shuffling crowds of visitors on private view day. They were sad occasions... saying goodbye to another clutch of students, sensing their alarm at a new world ahead without studios, equipment, patrons or critical fellows. A questioning (Freddie Sansom again) as to whether we, as teachers, have only been alchemists in reverse – turning gold into dirt.

Crossing Paris

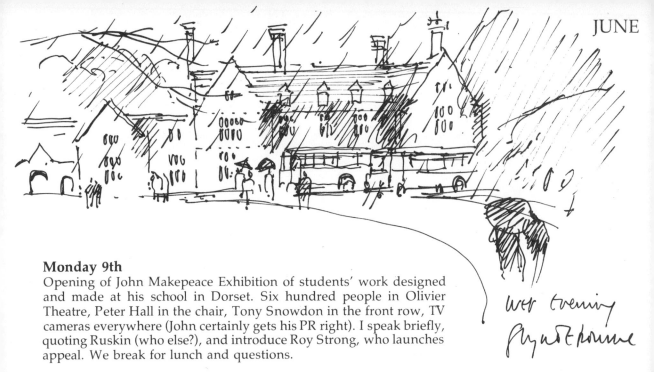

wet evening
Glyndebourne

Monday 9th

Opening of John Makepeace Exhibition of students' work designed and made at his school in Dorset. Six hundred people in Olivier Theatre, Peter Hall in the chair, Tony Snowdon in the front row, TV cameras everywhere (John certainly gets his PR right). I speak briefly, quoting Ruskin (who else?), and introduce Roy Strong, who launches appeal. We break for lunch and questions.

I return to BH for difficult meeting on future of Rome Scholarships in Fine Arts. These are under threat and my painter sculptor colleagues are indignant. I am in two minds. Obviously no artist could fail to profit from a year in Rome, but is 'Art' being too narrowly interpreted? How about landscape, conservation, film making, jewellery? We disband rather grumpily.

Tuesday 10th: Glyndebourne

Quick nip into the office to pick up post and cheer partners (work is a bit thin on the ground). Brief meeting at BH with sponsors on possible Venetian Exhibition. Scale? Budget? Scenario? One Thousand Years of Venetian History? The English and Venice (Corvo, Ruskin, Turner and Sargent)? We toss it around, decide on our scholar and pencil in a date. We guess it will cost nearly £750,000. Wyeth doing very well, but at expense of Summer Exhibition. Decide to issue combined tickets and check results. Over the road to watch BBC's first preview of Edwin Mullins' *100 Great Pictures* series. Informative, passionate, unpretentious.

Home to change for Glyndebourne and *Il Seraglio*. First visit of season. Grey drizzle, drenched trees, bedraggled pigeons. Train full of Germans, a party from Deutsche BP on a trip, but as DBP have sponsored the opera they deserve every seat. Spot George Harewood trying to conceal the fact that he happens to be reading a book on Colditz. Would you find a trainload of British BP executives trailing off to the opera black-tied in mid afternoon in, say, Munich? Possible. Would British BP help pay for an opera in Frankfurt? Doubtful.

Glyndebourne veiled in cloud like the setting for an old B who-done-it movie: huge chimneys, lattice windows, lowering trees. Make a self-gratifying survey of watercolours in foyer (all sold) and take seats in

Picnic Place.

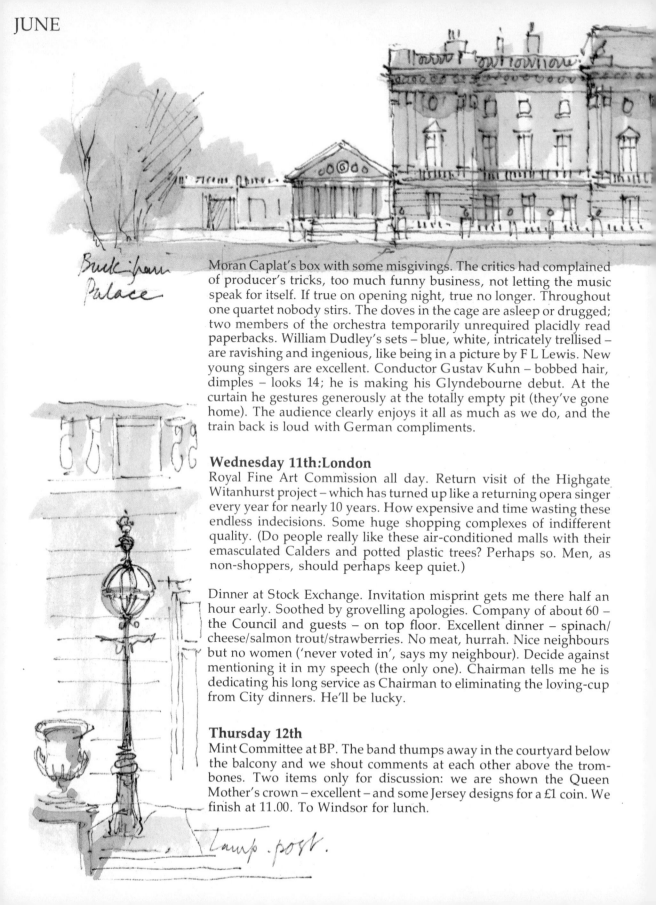

Buckingham Palace

Moran Caplat's box with some misgivings. The critics had complained of producer's tricks, too much funny business, not letting the music speak for itself. If true on opening night, true no longer. Throughout one quartet nobody stirs. The doves in the cage are asleep or drugged; two members of the orchestra temporarily unrequired placidly read paperbacks. William Dudley's sets – blue, white, intricately trellised – are ravishing and ingenious, like being in a picture by F L Lewis. New young singers are excellent. Conductor Gustav Kuhn – bobbed hair, dimples – looks 14; he is making his Glyndebourne debut. At the curtain he gestures generously at the totally empty pit (they've gone home). The audience clearly enjoys it all as much as we do, and the train back is loud with German compliments.

Wednesday 11th:London
Royal Fine Art Commission all day. Return visit of the Highgate Witanhurst project – which has turned up like a returning opera singer every year for nearly 10 years. How expensive and time wasting these endless indecisions. Some huge shopping complexes of indifferent quality. (Do people really like these air-conditioned malls with their emasculated Calders and potted plastic trees? Perhaps so. Men, as non-shoppers, should perhaps keep quiet.)

Dinner at Stock Exchange. Invitation misprint gets me there half an hour early. Soothed by grovelling apologies. Company of about 60 – the Council and guests – on top floor. Excellent dinner – spinach/cheese/salmon trout/strawberries. No meat, hurrah. Nice neighbours but no women ('never voted in', says my neighbour). Decide against mentioning it in my speech (the only one). Chairman tells me he is dedicating his long service as Chairman to eliminating the loving-cup from City dinners. He'll be lucky.

Thursday 12th
Mint Committee at BP. The band thumps away in the courtyard below the balcony and we shout comments at each other above the trombones. Two items only for discussion: we are shown the Queen Mother's crown – excellent – and some Jersey designs for a £1 coin. We finish at 11.00. To Windsor for lunch.

lamp post.

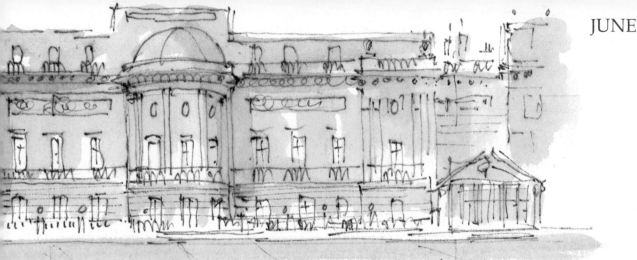

After supper Dick Guyatt brings plans for the RCA extension and relates his latest troubles: pressure to give tenure to all teachers, which we agree would be disastrous for students, and a request, apparently serious, from the Film School, that 50% of all future entrants, irrespective of ability, should or indeed must be women. True, it's easier to spot women than talent, but this proposal sounds like a relic from the 'sixties, when all standards of ability were regarded as authoritarian and excellence was to be deplored as élitist. My standard response to students who asked at final exam time who was I to decide upon their quality, was to remind them that I (with my colleagues) had once chosen them from 30 applicants to come to the college and that my judgment had presumably been acceptable then.

Friday 13th

9.30 meeting with Unilever directors on their art buying policy. They want to buy more – not just for the directors' floor – but for corridors, canteens, typing pools and lift halls. They are putting money aside and wondering about the next step. Do you hire the equivalent of a Duveen? Have a small committee of fine-art shophounds? Leave it all to the personal taste of an interested member of the organisation? Trust the architect? We debate the issues and I promise to write. Back to BH to record interviews with American and BBC reporters on Wyeth Exhibition, which is doing magnificently well, and give lunch to a party from Association for Business Sponsorship of the Arts, who have spent this morning touring the attics, cellars, library and schools of Burlington House, to their evident pleasure. Short speeches. Another Wyeth interview, then home and down to the country in hot sunshine. Next week looks like being worse.

Monday 16th

Both secretaries back from holidays. It's like the sun coming out again. What a luxury they are, sort of patient, elegant, responsive out-trays into which you push everything . . . income tax demands, airline bookings, difficult appointments, cross 'phone calls. Two hours at the office with Michael C on the John Lewis supermarket, no easier to resolve.

On to the Museum of the Year lunch. Sit between Martin Charteris, who makes a confidently worded speech about the National Heritage

Needs ore Road.

Group Photograph Glasgow.

Fund – his first public statement – and Norman St John Stevas, who today is silent. James Bishop (Illustrated London News) is in the chair, and the museum world is there in strength. As chairman of the judges I have to announce the awards – a gaggle of excellent examples of enterprise and thrift. The winner (for the first time) is a national museum – the Natural History Museum. (Often they are too nervous to enter.) Mixed reactions to the news: a national museum is regarded by smaller institutions as madly rich and the prize (£2,000), looks like disappearing into the petty cash account. But it is deserved; let's hope it will be imaginatively used.

Exhibitions Committee at BH more scratchy than usual and agenda more controversial. Finance, dates, subjects, scholars. Then down to Fulham to open a tiny new gallery with drawings by Philip Sutton. How inspiring to see such courage and private enterprise.

Tuesday 17th: Glasgow

Up early. To our pleased surprise meet Neville C and wife Susan (*en route* to Edinburgh) in the shuttle lounge. Peaceful trip so write my preface to the Antiques Fair catalogue. (Strange how one's style adapts to the problem. I expect most leader writers could write 600 words on anything, but not a word less or more.) Catalogue prefaces tend to be bland and boring. Thanking people – however justified – is always a yawn for those not being thanked. Finish the last sentence as we approach Renfrew. Not raining, thank goodness.

Professor Willett awaits us and whisks straight to the museum, where we meet architect William Whitfield for brief tour. A great success: nice modest scale, beautifully detailed, good light, handsome floors, wonderful Whistlers. Lunch with Chancellor, Principal and other academics in ingenious mezzanine suspended from Gilbert Scott's metal girders. Boiling hot. At 2.30 we move back to museum. Brief speech. Key fits at first go into handsome Paolozzi door – which is more than happened at the opening of the Bodleian Library, when key broke as King George V inserted it. Photographs, drinks, euphoria.

Buzz back to hotel (near airport) for brief feet-up before changing for dinner with my fellow honorands – a musician from USA, a law

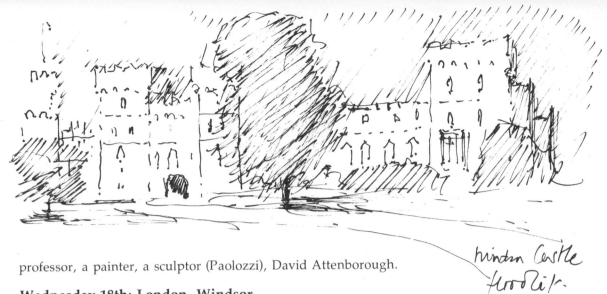

Windsor Castle floodlit.

professor, a painter, a sculptor (Paolozzi), David Attenborough.

Wednesday 18th: London, Windsor
8 am breakfast and mini-cab ride back to Glasgow. David A and I have no white ties. He insists on trying to find one, and after energetic shop flitting acquires two brilliant white clip-on velvet cotton jobs, to the cheers of fellow travellers. We robe up, receive our orders, process into Chapel. Velvet, fur, scarlet and purple. Chains and medals. One kilt. Moving roll-call of university benefactors, including Oliver Cromwell and Andrew Carnegie, a couple of hymns and prayers. Coffee in the cloisters, more instructions, process into Great Hall – another piece of magnificence in iron and granite and oak. One by one we are called up and gracefully flattered while we sit in the famous Blackstone chair, black, polished, icy cold (the bottom is warmed by the time it's my turn). All smooth and dignified. Chancellor tops you with a velvet hat, a bedell encircles you with a hood, a leather cased scroll is placed in your hand and it's over. A glass of sherry and a group photograph on the lawn. Formal lunch for about 300. Brief masterly speeches by the Clerk, David A and the American musician, who speaks rapidly and wittily for 10 minutes without a note. 3.30 and the shuttle is at 4.15. Slight panic, car cannot be found, luggage gone to the garage, but officials are calm and soothing and we reach Renfrew at 3.50 in time to catch our breath and remove my plastic-teeth-coloured tie.

Taxi home. Bath, change and down again past Heathrow to Adelaide Cottage. Delicious dinner. Convoy up in sunset dusk to floodlit Castle for birthday celebrations for the Queen Mother. Princess Alice, Duchess of Gloucester and the Duke of Beaufort – the eighties party. HM The Queen and Prince Philip receiving (HM dress with an ivory embroidered top, wide skirt, Prince Philip in Windsor coat, scarlet collar and cuffs, The Queen Mother also in white with tiara). Off through rooms crowded with people, pictures and wonderful flowers. Joe Loss in white suit, greying thatch on top of face like an old money wallet, seamed and brown and familiar, bashing out old 'thirties tunes. We enjoy ourselves hugely and dance 'till senseless with fatigue.

Thursday 19th: London
Early morning meeting of partners at Thurloe Place. Money? Jobs?

The Queen's Ballroom

71

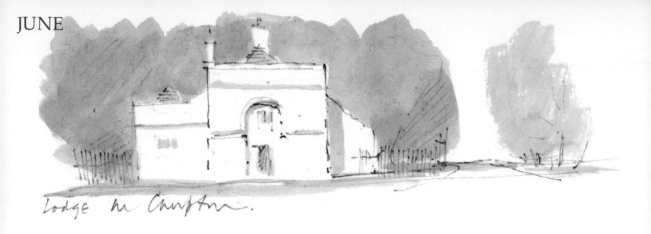

Lodge in Compton.

Staff? Redundancies? Depressing. Leave them at it for National Trust Executive. As always a nice varied meeting: an island in N Ireland, a piece of Welsh industrial archeology, a bit of downland, publishing policy, shop assistants' salaries.

A scrappy afternoon of interviews, indecisive meetings, then home to bath, change, and to Lloyds for banquet. Long traffic block outside Albert Hall, but a nice place to be kept waiting. M and I worked for two years on the redecoration of this building and grew to love it. Queen Victoria on her first visit said it was like the British Constitution, robust, portly, flexible, willing to welcome anything from requiems and ping-pong to the Women's Institute and hairdressing contests. How nice that after such a financially unstable start it is now as solid as it looks. One of the devices for raising money was to sell the freehold of individual seats, which caused lots of difficulties. Two such owners – the famous Miss Murchisons – who owned seats 894 and 895 in the amphitheatre, refused permission for a dance floor to be built over their property, so that if they wished they could sit, as it were, in a manhole while Victorian society waltzed around their heads. Dine in nice setting, no speeches, agreeable companions.

Friday 20th: Winchester, London
By now Wednesday's dance is beginning to tell on me. Brief meeting on Stanley Spencer poster, then rest of morning judging Kelloggs' children's art. Not difficult, for this year has produced an outstanding winner – a girl from Glasgow.

Correspondence solidly 'till 4.30 when leave by train for Winchester, a date planned carefully to coincide with a weekend, but now rather unwelcome to-and-fro trip. Architect Frank Chippendale meets me and takes me up to Castle for buffet with preservation society. Charlotte Bonham-Carter loyally in front row. Speak for 30 minutes – a bit of the old gramophone record I fear, but it provokes some good questions and evasive answers. Train at 9 pm. Still blazing sun for tonight is the shortest night.

Monday 23rd: Compton, London
Sunny and showery morning. Pleasant drive through sunny lanes to

The Graveyard. Compton.

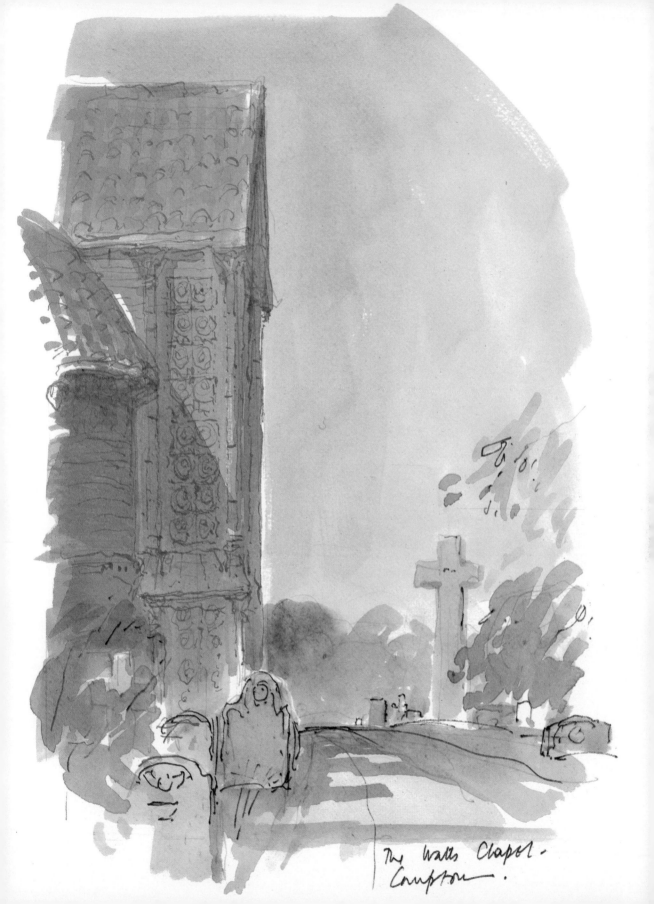

The Watts Chapel.
Compton.

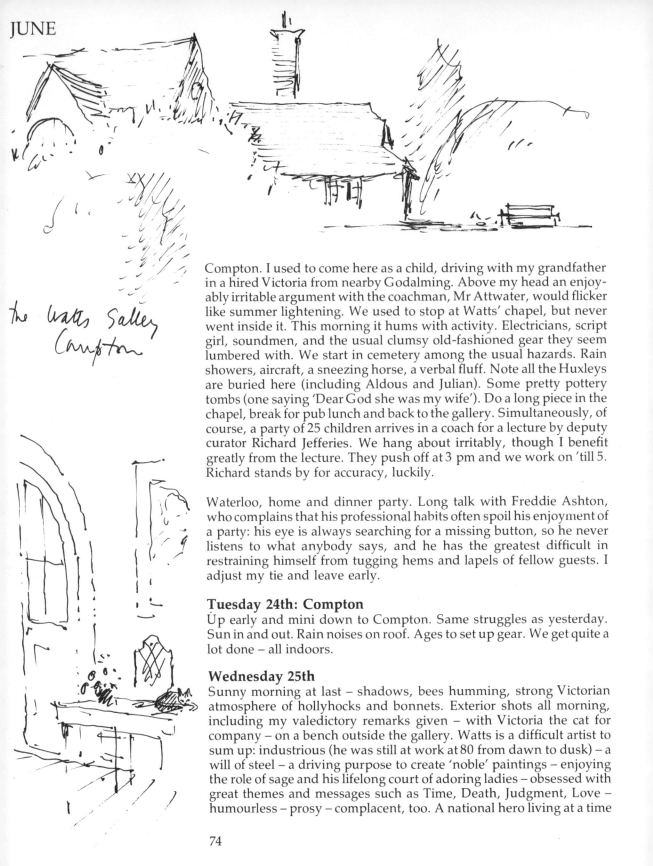

the Watts Gallery
Compton

Compton. I used to come here as a child, driving with my grandfather in a hired Victoria from nearby Godalming. Above my head an enjoyably irritable argument with the coachman, Mr Attwater, would flicker like summer lightening. We used to stop at Watts' chapel, but never went inside it. This morning it hums with activity. Electricians, script girl, soundmen, and the usual clumsy old-fashioned gear they seem lumbered with. We start in cemetery among the usual hazards. Rain showers, aircraft, a sneezing horse, a verbal fluff. Note all the Huxleys are buried here (including Aldous and Julian). Some pretty pottery tombs (one saying 'Dear God she was my wife'). Do a long piece in the chapel, break for pub lunch and back to the gallery. Simultaneously, of course, a party of 25 children arrives in a coach for a lecture by deputy curator Richard Jefferies. We hang about irritably, though I benefit greatly from the lecture. They push off at 3 pm and we work on 'till 5. Richard stands by for accuracy, luckily.

Waterloo, home and dinner party. Long talk with Freddie Ashton, who complains that his professional habits often spoil his enjoyment of a party: his eye is always searching for a missing button, so he never listens to what anybody says, and he has the greatest difficult in restraining himself from tugging hems and lapels of fellow guests. I adjust my tie and leave early.

Tuesday 24th: Compton
Up early and mini down to Compton. Same struggles as yesterday. Sun in and out. Rain noises on roof. Ages to set up gear. We get quite a lot done – all indoors.

Wednesday 25th
Sunny morning at last – shadows, bees humming, strong Victorian atmosphere of hollyhocks and bonnets. Exterior shots all morning, including my valedictory remarks given – with Victoria the cat for company – on a bench outside the gallery. Watts is a difficult artist to sum up: industrious (he was still at work at 80 from dawn to dusk) – a will of steel – a driving purpose to create 'noble' paintings – enjoying the role of sage and his lifelong court of adoring ladies – obsessed with great themes and messages such as Time, Death, Judgment, Love – humourless – prosy – complacent, too. A national hero living at a time

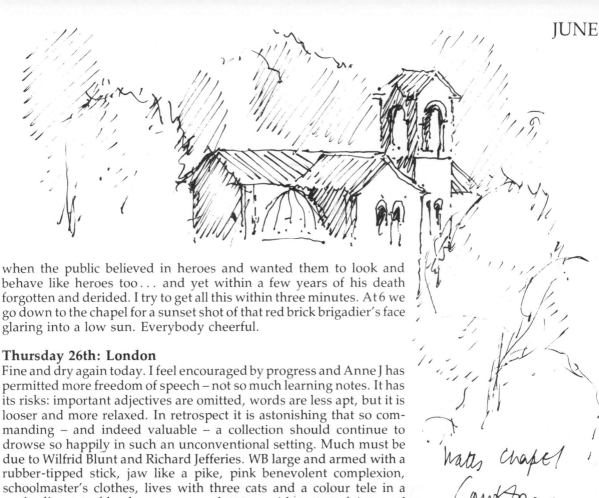

Watts Chapel
Compton

when the public believed in heroes and wanted them to look and behave like heroes too... and yet within a few years of his death forgotten and derided. I try to get all this within three minutes. At 6 we go down to the chapel for a sunset shot of that red brick brigadier's face glaring into a low sun. Everybody cheerful.

Thursday 26th: London

Fine and dry again today. I feel encouraged by progress and Anne J has permitted more freedom of speech – not so much learning notes. It has its risks: important adjectives are omitted, words are less apt, but it is looser and more relaxed. In retrospect it is astonishing that so commanding – and indeed valuable – a collection should continue to drowse so happily in such an unconventional setting. Much must be due to Wilfrid Blunt and Richard Jefferies. WB large and armed with a rubber-tipped stick, jaw like a pike, pink benevolent complexion, schoolmaster's clothes, lives with three cats and a colour tele in a squirrel's nest of books, papers, and notes, with traces of Arts and Crafts detailing in the farmhousey cupboards and dressers. The garden is charming – benevolent neglect, sweet disorder, birds. WB pads through his galleries like a housemaster on the dormitory rounds, with a sharp eye open for anything amiss. The gallery is filled with fresh flowers; books lie about casually. The notices are hand written and personal: 'Please do not lean on this table. It stops the clock'.

At 3, I am released and mini back to London in time for first Cushion Concert at Burlington House arranged with Youth and Music (a sell-out). Philip Jones Ensemble, finishing with a wildly successful Blues March. Robert Mayer sits delightedly enthroned.

Friday 27th: Sutton Place

A day saved, miraculous. Letters, drawings, office 'till lunch. Picked up and driven down to Sutton Place. This time Mr Seeger is here, grey-streaked beard, quiet, shy, sensitive, funny. We stroll round the house and garden, establish the problems. He is clearly a man of great taste, did two years of architecture before becoming a musician. After tea a helicopter lands on the lawn to take me back to London. We clack into the sunset playing the architect's game of spotting familiar buildings from the air.

JULY London – Billingshurst – Loughborough –

Tuesday 1st: London
British Council all morning. Chairman has successfully wooed Prime Minister and clawed back some of our money, but some hard decisions made on cuts. Moura Lympany concert at BH in the evening is a sell-out. She has a Queen Mother radiance and obviously enjoys herself too.

Wednesday 2nd
RA all day 'till 6. Drinks at a St James' Street club. Usual problem in finding the right one. Clubs pride themselves on having no nameplate up for some silly reason – the Americans would call it 'preppy'. Intimidation of non-members perhaps? It continues inside. Can I wait by the fireplace? Am I allowed upstairs? Where is the gents? Is that alcove restricted to members over 60? The whole business gives me the creeps. I can't believe I am alone in disliking clubs. I feel so insecure, dreading equally the deference of the staff and the bonhomie of the bar. It may be a relic of school: that flight of steps forbidden to new boys, the exclusive jargon or apparel of prefects, the tedious rituals and traditions in which the male sex seems so incurably embedded. Nevertheless the party is agreeable, the pictures nice and the architecture splendid.

Thursday 3rd
Lunch at Macmillan over this diary. Their enthusiasm for it is warming but I have to do the work and it begins to weigh. Keeping notes is not that difficult – it's the translation of those notes into something faintly readable that is so alarming – no inside stories of rows in the Cabinet... no back-stage gossip... no gripping yarns of hazardous travel adventures... no Lady Cunard.

Charming young pianist, Michel Beroff, at second Cushion Concert at BH. Full house again. This series, a joint enterprise with Sir Robert Mayer and Youth and Music, I hope will become an annual event.

Friday 4th
Family Rejoicing Day: granddaughter Emily's birthday and M's honorary Degree at the Royal College of Art. Arrive RCA around 11. Old friends, robes, bustle, photographs, sherry, procession, trumpets.

Clubland.

Graningford Farm
Sussex

Leicester – Glyndebourne – Salisbury – Sudbury JULY

Speech Day hats, scarlet/silver/black/lilac. Colin Anderson[1] gloriously handsome in the Chair – as usual wearing half-amused half-puzzled expression as to what to do next (after thirty years he still can't remember the drill). Dick Guyatt[2] reads a sober report of the year's events, pretty deadly stuff to write, to read or listen to. Normally a witty and relaxed man, Dick today is stiff and nervous. The public orator takes the lectern, and introduces the other honorands – designer Colin Chapman and Huw Wheldon. Some nice affectionate jokes for M, who looks ravishing and is clearly a popular choice. Huw, a born actor, is totally at ease, quoting Proudhon and E M Forster in his reply. 'Do not regret', he quotes William Cory, 'the hours you spent on much that is forgotten... the shadow of lost knowledge protects us from many illusions...'. (Second time in a month I've heard the forgotten Cory quoted in public.) The students follow – jeans and pink winkle-pickers under alpaca and rabbit fur – but temporarily a little less confident than usual.

Over to Emmy's birthday – six little friends, games. Sit at the back observing, ashamed of my idleness, remembering the slogging work such parties are. Organising prizes... music... settling quarrels... comforting losers...

birthday Party

Saturday 5th: Billingshurst
First bathe of the year in a friends' pool, alone in a field watched by a rabbit. M opts out of this. John and Aline S we have known since student days. (Aline was the only girl in the Cambridge School of Architecture and treated us all with equal *hauteur*). They have built a bungalow in the corner of their old farm estate and seem blissful and contentedly relieved from the hassle of farming.

Sunday 6th: Haslemere
Hosts vanish and we drive off to lunch with friends for whom M had designed a house near Haslemere. It looks splendid and they are still quite rightly delighted with it.

Monday 7th: London
Minor rumpus at RA over hanging of George Clausen show in Diploma Galleries. The Art Historian would have us put the drawings and

studies – however small – alongside the finished oils. The Artist accepts the literary interest of this technique, but holds that the result is visual disaster. As it's the RA, the Artist wins. Ruffled feathers settle down and the works are re-hung. What a remarkable painter he was... and how underestimated. At his best better than Millet, and everything infused with his own strongly personal – almost dotty – spirit.

Attend (briefly) a private party in the Assembly Rooms and a question and answer session between around 300 RA Friends and the Hanging Committee. The latter defend their choice bravely against criticisms: 'too many abstracts'... (you take the best of what's submitted, figurative and abstract)... 'the dominance of the Hanging Committee over the Selection Committee'... (they are the same people)... 'the unnecessarily high proportion of members' works... (oh well). Atmosphere amiable rather than waspish; the temperature never rises. Perhaps we need an *agent provocateur*.

Tuesday 8th

All day at RA. Short agenda so we dribble on into a post-mortem on the Summer Exhibition... the uncomfortable crowds on private view day... the glamour of one 'event' versus the discomfort of too many people there and the loss of sense of being 'a guest'. The criticism that persists – as it has done for over a century – is that for the Members to send in six works is too self-generous. Members argue, justifiably, that the weight and quality of their work – with few exceptions – sets the standard for the show, that the total of Members' work never exceeds one third of the whole show, that reducing it from six to four, say, would only let in another 100 outsiders. True, and yet one remembers with genuine distress the number of good paintings not hung for lack of space; discomfort remains.

I interview two schoolgirls (A-Level Art History) (16), who for their Duke of Edinburgh Award project have decided to explore Burlington House and its activities. They are bright, amusing, impressed. Push off home for the half-filled packing cases and bare walls of home, to find a totally exhausted M. And no wonder. For the last two months – I am ashamed to say – she has handled virtually single-handed all the house

selling and buying procedures: bridging loans and insurance, party wall agreements and building societies... Estate Agents, Planning Officers, Bank Managers, Surveyors and Lawyers... as well as all the preliminary hunting and the final sorting and packing at No 35.

Wednesday 9th: Leicester, Loughborough, London
University car from Leicester to Loughborough and a quick tour of Nick Phillips' astonishing laser labs – where definition improves almost weekly. (He was one of the brilliant team behind an RA Laser Exhibition four years ago.) Lunch with Chancellor (Lord Pilkington). Robe up, photographs, procession. Handel on the organ. Public orator to which I reply – I am only honorand today. The campus is huge, workmanlike rather than beautiful, but splendidly landscaped, well-maintained and the new Octagonal Library by Faulkner Brown is going to be a startler. Ease off back to Leicester and home. Grey miserable day. How nice that all the students – or over eighty per cent – are certain of jobs... banking, modern languages, physics, electronics – and how happy they all look.

Taxi to RA in time to catch Prince Philip at the Wyeth Show.

Thursday 10th
To Whitechapel Art Gallery for Holborn Station design judging. Five finalists: two electronics/lighting proposals, one ceramic, one collage (four of them ex-RCA). All lively and enterprising. Each artist is given 15 minutes to explain his ideas but all take longer and we are left with only 15 minutes for discussion. Unanimous decision for the winner, subject to practicalities. I escape having to do the report and we disperse. It's a Royal Garden Party day and the drive back to RA takes 40 minutes. Call in at Clarence House, to find Mrs Mulholland up to the ears in what looks like Selfridges. They are birthday gifts from citizens to Queen Elizabeth – touching, loyal and difficult to deal with. Baby clothes. Self-portraits. Hand-painted pillow slips. Rag dolls... Mrs M remains calm but puzzled. Feelings are hurt if gifts are sent elsewhere, but what can anybody of eighty do with a child's smocked pinafore? I leave her to it and go to National Portrait Gallery, to arrive late... but not too late to vote on purchases – always fun.

79

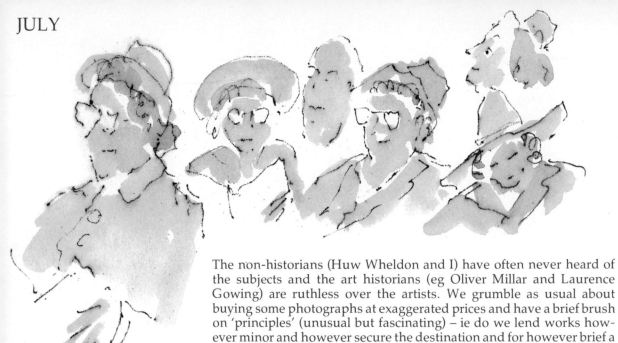

Royal Staff

The non-historians (Huw Wheldon and I) have often never heard of the subjects and the art historians (eg Oliver Millar and Laurence Gowing) are ruthless over the artists. We grumble as usual about buying some photographs at exaggerated prices and have a brief brush on 'principles' (unusual but fascinating) – ie do we lend works however minor and however secure the destination and for however brief a period, to private citizens? The Trustees (except one) are adamant in saying 'No', National Trust 'Yes', The Duke of Omnium 'No'. I sulk a bit, believing that we exist also for individual citizens and our refusal of the case under discussion to be unreasonable, but no doubt my experienced colleagues are right. I always dislike finding reasons for not doing something.

Back to RA for quick 6 pm meeting with Nicholas Goodison[3], who is generously advising us on our rocky finances, and at seven descend with Drogheda and the girls to meet Prince Charles for our third Cushion Concert. King's College Choir, Byrd, Bach and Britten programme. A sell-out. Prince C in cracking form, talking to everybody, warm and witty. He disappears into a summer lightning storm of camera flashes.

Friday 11th

Anne J calls at 9 am for Ealing, where we sit through her rough-cut of the film we have been making together for the BBC on Burlington House. Compose linking bits for later recordings, which we do at Lime Grove. Takes rather long to balance voice (films) with voice (shots) in style and volume, and I get a bit restless. A note pinned to the desk in my little recording cell, signed by the TGWU says 'Boycott the Staff Club' and 'Sack the Management Committee'. How nice it's not an argument I've got to join in. We pass along corridors from every door of which recordings yell and gibber and squeak beneath loving and attentive fingers.

Drive back through suburbia drenched in roses. It's the suburbia of Edwin Muir's poem, 'when the idle doors stand open and the air flows through the rooms fanning the curtains' hems . . .'. Are those housewives polishing the windows or mowing the lawnettes unhappy and

neurotic, as we are always told, or perhaps earning naughty pin money, or even keeping a mongol child chained in a cupboard under the stairs? Doesn't look like it.

Saturday 12th/Sunday 13th
Packing and sulking.

Monday 14th: Windsor, London
Pick up Libby at 11.30 and drive up to Castle. Try equerries' door. Locked. Try next one. Pull handle, distant jangle. Footman emerges carrying two cases with jumbo labels, 'The Queen', to put in station wagon. Page descends to tell us we are to see The Queen before she leaves for London. We are received in the Oak Room, and the re-decoration problems are explained (it's the State Guest Room, huge, high, dark, on the axis of the Long Walk, and formally if rather uncosily furnished. Colossal pictures, including a vast Frith of Edward VII's wedding, every face recognisable for miles back into the recesses of St George's Chapel). After lunch, with Prince Philip's help, Libby and I sort out some of his pictures for *Royal Performance* at Hartlebury.

Evening at Covent Garden. *Romeo and Juliet* – almost my favourite ballet. Georgeous if a bit overweight. Georgiadis sets and costumes, gold/brown/beige/coffee/cream/burnt orange. Baryshnikov, the guest star, is alas injured, but his stand-in does well and Lesley Collier moves and looks twelve years old.

Tuesday 15th
Queen Mother's Birthday Celebration Service. M sorts hats desperately for ten minutes, then we leave, labelled and posh, at 9.20 for St Paul's. Smooth journey down Mall between puzzled crowds lining the route. Park 100 yards from West Door. Place half full already . . . 'We must be the opposite side from Mummy', cries a Sloane Ranger in a housefly hat. Lovely seats under the dome just behind royal house-hold and next to Tony Snowdon and his mother. Lots to watch. Cabinet Ministers past, present – and future? Tele cameramen in red and white button holes (I remember Penelope Gilliatt's story of the Snowdon wedding . . . a cameraman's bloodshot face peering beneath a thicket of lilies, experiencing disbelief at a rebuke from an official:

'Get back please . . . your breath will brown the blossoms'.) Alongside us a covey of royal housemaids in bright coats and shining shoes cluck over the passing hats. Distant cheers. Procession of clerical notables, including Bishop of London in his new 'architectural' robes, which look very handsome. Minor Royals plus their tots, blue, yellow, lilac (do they, I wonder, telephone each other beforehand?) The Queen (in gold), Queen Elizabeth (in plumbago blue), Prince P as always searching the congregation for a familiar face. More trumpets, hymns, lessons, a relaxed man-to-man address from the Archbishop (he lacks the jowls and fruity tones of a prince of the Church and wisely keeps a light hand on the scene). Processions, robes, wigs, swords, halberds. Distant cheers and National Anthem from the streets outside. The Church grandees – having seen off the royal guests – process back with crosses, robes, mitres. 'Is this an encore', whispers Tony – and why not? A shame it all goes by so quickly. We struggle off under ushers' batons to the West Door . . . a way is cleared for Harold Macmillan and Ted Heath. By 1.30 we are safely back at RA.

Wednesday 16th: Glyndebourne
Thurloe Place – first time for days. Pay shamefully scrappy attention to design problems as no time to consider them properly. Change and catch train to Glyndebourne and *Der Rosenkavalier*. Sun emerges as we reach Lewes. Looking forward to the Erté experiment – a bold piece of patronage which has met with mixed reception. The drawings in the programmes are pretty enough – if a bit flat in form – but Act I is visually a slapping disappointment, a mixture of Dunlopillo and Ivor Novello. Act II worse, like a flash hairdressers' in Kampala or Baku. Too bad it gets a round of applause. The ceremonial staircase which looks elegant enough in the drawing is too high; the doors are flimsy, the drapes pinched. Moral? Be careful of giving 2-D designers 3-D problems. The last act redeems itself and the Marschallin looks fabulous. No wonder we leave the theatre thinking of her and not the happy young lovers. The last 20 minutes can only be described as totally exalting: complicated, sharp, pointed, difficult music faultlessly sung.

Thursday 17th
Trustees' Meeting, Natural History Museum. No excitements. Drive down with M to Glyndebourne for dress rehearsal of *Fideltà*, a revival

The Pantiles
Tunbridge Wells.

of last year's production, which I had so much enjoyed designing. Composed by Haydn when court musician to Count Esterhazy, the story is the usual silly tangle of amorous misunderstandings, partings, reconciliations, set in Arcady. John Cox, the producer, had decided to counter its absurdity by treating it as 'an opera within an opera' – as an afternoon diversion acted out by a bored house party on a hot afternoon in the Esterhazy gardens, the guests singing the principal parts with rudimentary costumes, masks and props handed to them when needed for an aria or a duet by servants/chorus. There are three acts: by a gazebo, in a glade and on the shore by a great lake, from which, in the final scene, a marine monster rises dripping to devour the lovers before being transformed into the figure of Diana, who from aloft smugly puts everything right for the finale.

Scenically, I had treated it romantically – wet and freely drawn watercoloury backcloths (with a faint hint of Glyndebourne itself). All the costume colours were cream, ivory, beige, caramel and brown. Greatly helped in these by Joyce Conwy Evans, an ex-student, ex-member of staff who can turn her hand with equal ease to the detail of a manhole or an altar frontal, and whose knowledge of where to find things in a hurry is so bewildering it's tempting to put it on test daily. (She found a stuffed crow in an East Anglian shop within a hour of being asked for it.) The highly experienced technical team – electricians and milliners, hairdressers and carpenters – and the generous rehearsal time always allowed saves the amateur designer from the worst mistakes, while good lighting rescues all. Robert Bryan lit *Fideltà* magnificently . . . long shadows, golden syrupy light, though the 'monster' started by giving trouble (its 'face' didn't always drop off as intended at the touch of a switch revealing Diana enthroned).

Different cast from last year and some costume problems, but all goes reasonably well. Tea with Moran C in interval. Post-mortem at 7 pm: Celia's hairstyle, Nerina's shoes, Peruchetto's handkerchief, the boat painter (as usual) hanging overboard. Again one finds oneself in merciless mood. 'Those collar-bones simply won't do . . .', 'Can we raise the skirt hem and risk a look at those ankles?' Brief drink with Christies and the cast, icy lonely picnic in the garden and home by 12.

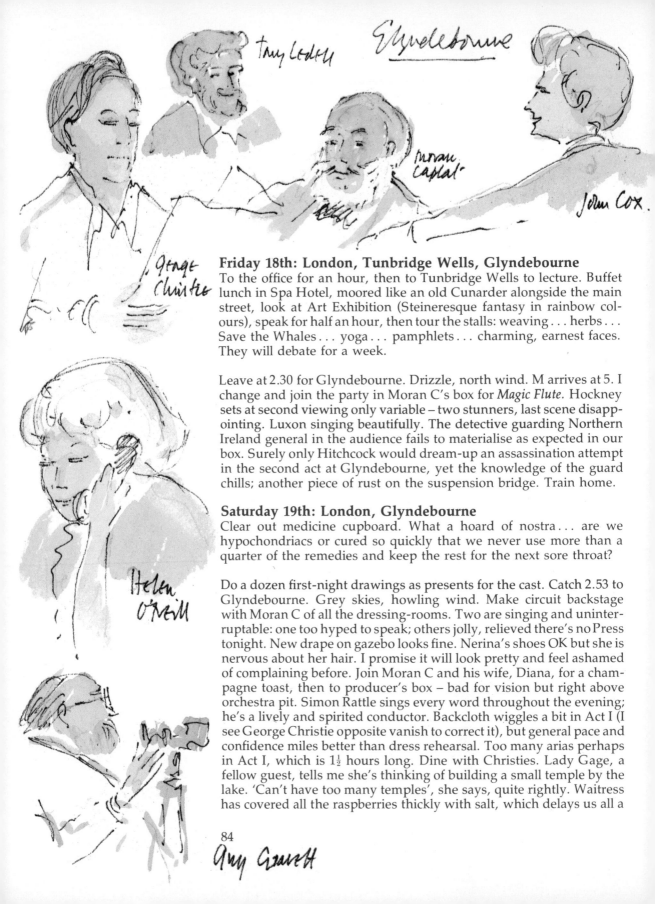

Tony Ledell

Glyndebourne

Moran Caplat

John Cox

George Christie

Helen O'Neill

Amy Grazett

Friday 18th: London, Tunbridge Wells, Glyndebourne

To the office for an hour, then to Tunbridge Wells to lecture. Buffet lunch in Spa Hotel, moored like an old Cunarder alongside the main street, look at Art Exhibition (Steineresque fantasy in rainbow colours), speak for half an hour, then tour the stalls: weaving . . . herbs . . . Save the Whales . . . yoga . . . pamphlets . . . charming, earnest faces. They will debate for a week.

Leave at 2.30 for Glyndebourne. Drizzle, north wind. M arrives at 5. I change and join the party in Moran C's box for *Magic Flute*. Hockney sets at second viewing only variable – two stunners, last scene disappointing. Luxon singing beautifully. The detective guarding Northern Ireland general in the audience fails to materialise as expected in our box. Surely only Hitchcock would dream-up an assassination attempt in the second act at Glyndebourne, yet the knowledge of the guard chills; another piece of rust on the suspension bridge. Train home.

Saturday 19th: London, Glyndebourne

Clear out medicine cupboard. What a hoard of nostra . . . are we hypochondriacs or cured so quickly that we never use more than a quarter of the remedies and keep the rest for the next sore throat?

Do a dozen first-night drawings as presents for the cast. Catch 2.53 to Glyndebourne. Grey skies, howling wind. Make circuit backstage with Moran C of all the dressing-rooms. Two are singing and uninterruptable: one too hyped to speak; others jolly, relieved there's no Press tonight. New drape on gazebo looks fine. Nerina's shoes OK but she is nervous about her hair. I promise it will look pretty and feel ashamed of complaining before. Join Moran C and his wife, Diana, for a champagne toast, then to producer's box – bad for vision but right above orchestra pit. Simon Rattle sings every word throughout the evening; he's a lively and spirited conductor. Backcloth wiggles a bit in Act I (I see George Christie opposite vanish to correct it), but general pace and confidence miles better than dress rehearsal. Too many arias perhaps in Act I, which is $1\frac{1}{2}$ hours long. Dine with Christies. Lady Gage, a fellow guest, tells me she's thinking of building a small temple by the lake. 'Can't have too many temples', she says, quite rightly. Waitress has covered all the raspberries thickly with salt, which delays us all a

84

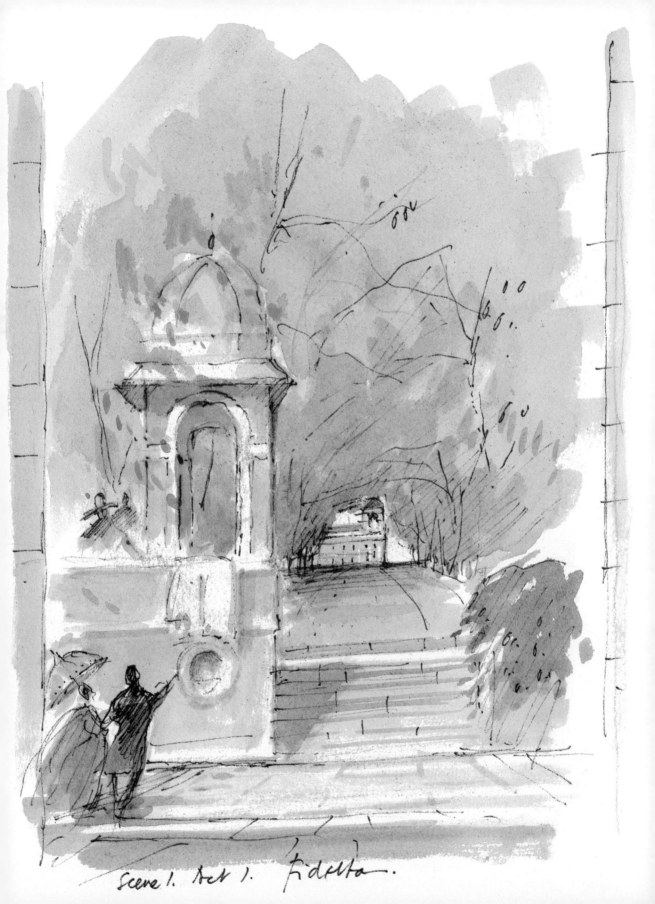

Scene 1. Act 1. Fidelio.

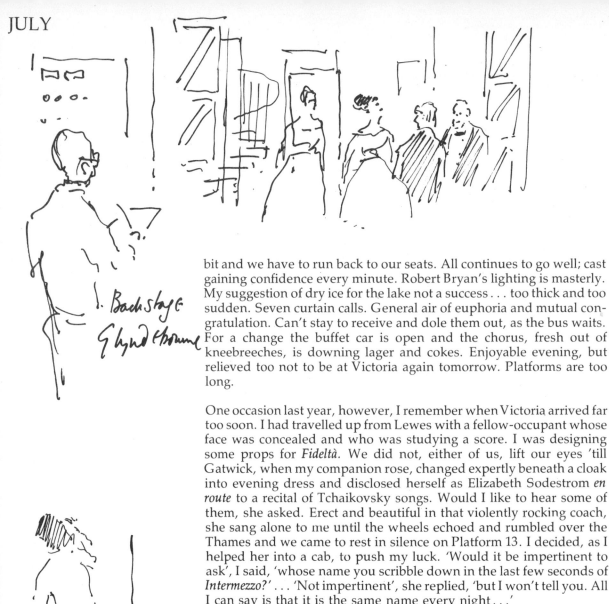

1. Backstage Glyndebourne

bit and we have to run back to our seats. All continues to go well; cast gaining confidence every minute. Robert Bryan's lighting is masterly. My suggestion of dry ice for the lake not a success . . . too thick and too sudden. Seven curtain calls. General air of euphoria and mutual congratulation. Can't stay to receive and dole them out, as the bus waits. For a change the buffet car is open and the chorus, fresh out of kneebreeches, is downing lager and cokes. Enjoyable evening, but relieved too not to be at Victoria again tomorrow. Platforms are too long.

One occasion last year, however, I remember when Victoria arrived far too soon. I had travelled up from Lewes with a fellow-occupant whose face was concealed and who was studying a score. I was designing some props for *Fideltà*. We did not, either of us, lift our eyes 'till Gatwick, when my companion rose, changed expertly beneath a cloak into evening dress and disclosed herself as Elizabeth Sodestrom *en route* to a recital of Tchaikovsky songs. Would I like to hear some of them, she asked. Erect and beautiful in that violently rocking coach, she sang alone to me until the wheels echoed and rumbled over the Thames and we came to rest in silence on Platform 13. I decided, as I helped her into a cab, to push my luck. 'Would it be impertinent to ask', I said, 'whose name you scribble down in the last few seconds of *Intermezzo?*' . . . 'Not impertinent', she replied, 'but I won't tell you. All I can say is that it is the same name every night . . .'

Sunday 20th: London
Children and grandchildren descend on us. Light fittings unscrewed, deep-freeze, 'fridge, gas stove disconnected, umbilical cords cut. Young voices help to dispel the misery. Bed exhausted.

Monday 21st
To RA in morning. Brief foray to Covent Garden to 'recce' drawing sites for Gala night. (I have been commissioned by Covent Garden to record this scene.) Choose my seat. Agree 'roughs' with John Tooley. Back to wreckage to change for Royal Tournament, the first we've ever seen. How have we missed it for 60 years? Black tie, pink lampshades, prawn cocktails. Fellow guests mostly charming and sophisticated ex-diplomats. Duke of Kent in Royal Box. Show totally splendid and

Children helping.

Royal Tournament

throat-catching – especially the muscial ride. M and I return, to camp at Victoria Road. Sleep badly and sadly.

Tuesday 22nd

Horrid start to day. M ill and no wonder. Have slept here for the last time. How horrible that word is . . . like the clang of a funeral bell. Crating, labelling, rumpling through one's life. The house stands impassive, dust-motes dancing. We picnic on cheese and biscuits (no gas or electricity), then drive over to the new house, full of loyal daughters painting, cleaning, humping, surrounded with dogs and grandchildren, to whom a totally empty deserted house is a place of magic. Children always lead double lives. Finish day at Rosie G's 70th birthday dinner at the Duncan-Sandys; 340 people of all ages, delicious dinner, room as full of affection as honey. Rosie, one of my first clients, is a passionate builder. Her husband Harry – a lovely, brilliant man whose threshold of patience (said Anthony Powell) could be reached in the middle of a sentence – was not. He could be thrown into a rage at the sight of a ladder. Bed 1 am in Campden Hill at Daphne S's, where we are staying during the move.

Wednesday 23rd

Brief visit to RA and join M for afternoon at Elgin Crescent. Amazed by indifferent quality of building (Victorian spec) after our 1890 solid, owner-designed masterpiece. Wobbly balustrade, bulging plaster, damp scrofula round skirtings, picture glass in windows, broken sash cords, none of it serious, all of it – one sees ahead – difficult to get done because too trivial. How one longs to be a handyman. Stand around moping. God bless emulsion paint – it dries immediately and the spots wipe off immediately. Hetty (blind old labrador) walks straight through paint-tray and down carpeted passage. We watch hypnotised. Calling her back will redouble the pattern, so leave her padding happily into the garden. (I am reminded of the Dali stair carpet in Edward James' house.) By eight we can do no more. Dinner with children and bed by two.

Thursday 24th

Lovely sunny morning. Peter Jones' removal men arrive on time, quiet, competent, uncritical of their burdens. (How many years since that

Hetty making tracks

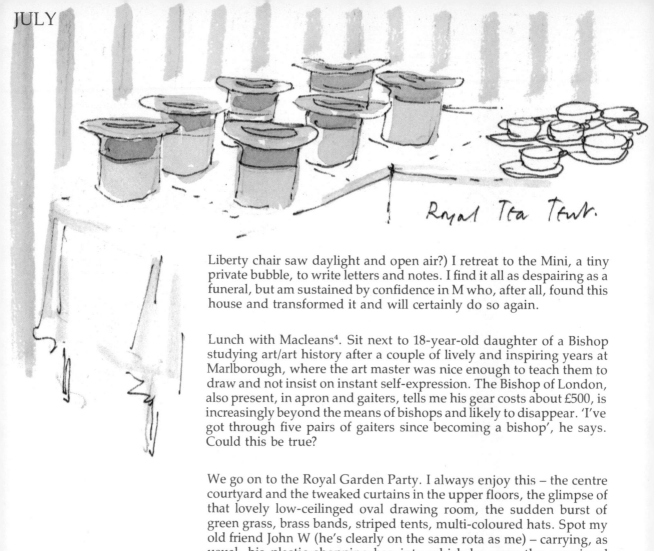

Royal Tea Tent.

Liberty chair saw daylight and open air?) I retreat to the Mini, a tiny private bubble, to write letters and notes. I find it all as despairing as a funeral, but am sustained by confidence in M who, after all, found this house and transformed it and will certainly do so again.

Lunch with Macleans[4]. Sit next to 18-year-old daughter of a Bishop studying art/art history after a couple of lively and inspiring years at Marlborough, where the art master was nice enough to teach them to draw and not insist on instant self-expression. The Bishop of London, also present, in apron and gaiters, tells me his gear costs about £500, is increasingly beyond the means of bishops and likely to disappear. 'I've got through five pairs of gaiters since becoming a bishop', he says. Could this be true?

We go on to the Royal Garden Party. I always enjoy this – the centre courtyard and the tweaked curtains in the upper floors, the glimpse of that lovely low-ceilinged oval drawing room, the sudden burst of green grass, brass bands, striped tents, multi-coloured hats. Spot my old friend John W (he's clearly on the same rota as me) – carrying, as usual, his plastic shopping bag into which he pops the occasional cup-cake to take back to his village children... 'straight from the Queen's tea table', he tells them. He circumnavigates the garden at high speed, returning to me at HQ with snippets of information. 'The – Ambassadress has lost her left heel'... 'the Bishop of — has ice-cream on his apron'... 'A flamingo seems to have fainted'. Tea in the Royal Tent, standing in its own circus ring guarded by Yeomen of the Guard. A red ticket, a permissive wave from a gloved hand, a table on which stand twenty toppers, upturned as if waiting to be filled up from a teapot, royal footmen, helpful ushers, introductions. Royalty in close proximity always charges the air and causes behaviour to go into a different gear. Preoccupations with falling crumbs, top heavy tea-spoons, the tendency of high heels to sink inexorably and anchor-like into the turf. Beyond the ropes, the guests sit on chairs or stand gazing with frank curiosity at the Queen and us downing éclairs. We behave under such scrutiny like extras in the background of a Drury Lane musical... feigned conversation interest... tiny forced laughs... exaggerated courtesies... wariness in the face of *mille-feuilles*.

Garden Party.

60 Elgin Crescent.

Join Libby for drinks and at Notting Hill Gate we run into David Hockney, flat-capped and friendly. He has painted six huge pictures in a few weeks, rehearsed *Magic Flute* and designed a set for the Ravel/Colette opera at the Met, which he regards as the greatest fun of his life – and the hardest (the furniture at one point has to come to life and sing) . . . 'but after that, no more theatre', he says. I wonder.

At Elgin Crescent the basement is carpeted and finished. The ground floor has books on the shelves. Sun streams in and M exhausted but encouraged. Quick supper and early bed.

Friday 25th: Salisbury, London
Early train with painter Mary Fedden to Salisbury. In two hours we sieve through about three hundred pictures in St Edmund's Art Centre, award a dozen prizes, lunch in the chancel, and train home to the house-moving drama. Removal men just leaving for ever.

Saturday 26th
All day humping stuff around . . . pictures . . . books . . . bedding. M has managed fresh flowers everywhere. The girls, our friends, and in-laws work non-stop. By evening it's all habitable and splendid.

Sunday 27th
Lunch on the terrace under the trellis. Clothes in cupboards. Curtains up. 'Fridge and tele working. Dine with Daphne S.

Monday 28th
Drop keys of Victoria Road at estate agent at 9 am and, like Lutyens leaving Delhi for the last time, kiss the wall of that lovely house in final farewell. All morning with partner David R on Hartlebury Industrial Estate. Museum of Year Award afternoon, sifting through next year's entries and allotting visits. Takes two hours and fellow judges are generous with offers of voyages; as always I am ashamed by my reluctance to leave the Home Counties.

At 5.0 to the Institute of Directors in Pall Mall. Reception on first floor. First prize winner Thorpe Park (which I've never seen). Among the runners-up, the Tate Extension (my favourite horror) and two fine

35 Victoria Row

The Great Hall
Sutton Place

Frank Matcham theatres – Buxton and Hammersmith. How surprised Matcham would have been. Present the plaques and vanish to find a parking ticket. A non-favourite afternoon.

First dinner at home, first night in new bed. The previous owner seems to have lived without light switches and with non-working telephones in every room. We move around with torches.

Tuesday 29th
Work at home 'till lunch – then to RA for General Purposes Committee and Council. Hardly a quorum – painters vanish to France as regularly as swallows in the last week of July and don't appear again 'till September. Both architects turn up and the faithful William Scott[5]. Visit from a first-year student at Chelsea Art School. Years ago in her teens she came to see me to enlist my aid in discouraging her school from insisting on putting O-Levels before art. Together we were successful. She is talented and happy and serious and strange . . . accompanying her delicate drawings with little poems and written observations on her recent visit to Florida. ('All American women carry their car-keys in their right hand while dragging their child in their left'.)

Wednesday 30th: Sutton Place, London
Morning at RA . . . correspondence, meetings. After lunch Mr Gregory (BP) arrives to give away a cheque for £1,200 to the picture voted the most popular in the Summer Exhibition. It is a Wyeth-ish watercolour of apples in a trug, meticulously painted with miniaturist views of Oxfordshire glimpsed through cracks. The painter, William Mundy, lives by his art, apparently. Clearly this one will be a popular print and bring him good luck and good money.

Pick up Anthony Powell (the overall designer for the job) and drive down to Sutton Place for lunch. Lamb and raspberries. The Local Authority arrives: Mr Pink (from Surrey County), breathless, with David Attenborough-ish charm and lock over forehead, and Miss Dangerfield from Woking, bespectacled and more reserved. We skate round the possibilities: a few bedroom improvements, replacing part of the garden, possible re-painting of some of the panelling, a new orangery, a replacement perhaps of the sash windows, which were

removed fifty years ago and replaced by Tudor casements by the Duke
of Sutherland. The local authority seems receptive and flexible, clearly
relieved that the house will be physically cherished, gutters cleaned,
stacks pointed, plumbing concealed, and that it will not become the
Sutton Place Holiday cum Garden and Visual Arts Centre.

Back in London, change, pick up Daphne S and drive to Zoo farewell
dinner for leaving senior staff. Black tie. Sixty or so members and
ex-members of Council. I remember a previous Zoo party in the small
mammal house. The usual party roar was given an extra *rondo* by the
squeaks and yelps of the permanent residents. I found myself, cham-
pagne in hand, by the vampire bats. The cage seemed empty except for
a tiny furry ping-pong ball hanging from the roof. 'We hope', said the
Expert, 'that she's pregnant... as her husband died this morning'.
Does she know, I wondered, or has she noticed? No sign. She had
learned, I gathered, to sip blood from a saucer (not a lesson I'd have
enjoyed giving) and her saliva was said to be good for haemophilia.
'So, too', said the Expert, 'is the urine of male Swedes. The Swedish
army tanks their urine, refines it and exports it'. Could this really be
true? Another mystery chalked up to that bewildering nation.

This evening is less astounding. I sit between a distinguished vetiner-
ary surgeon from Edinburgh and Terence Morrison Scott, ex-head of
Natural History Museum (it was he who caused a member of his staff
to faint with rage in his office when told of his dismissal). Friendly
evening but speeches a bit too long and we leave flogged. Hardly have
we left the kerb when there's a terrific crash and a Capri stoves us in
from behind. Nobody hurt much and luckily the Mini is still drivable.
The police arrive... After an hour we drive miserably and slowly
home.

Thursday 31st: Sudbury
Annual judging day for Arthur Koestler Award for creative work done
in prisons. Our hosts this year are at Sudbury. Up at 7. Insert my poor
scarred Mini into the last slot on the ramp at St Pancras and leave for
Derby with Trevelyans, Jo Pattrick[6], secretary Felicity, a Home Office
girl and a man from Bryant and May. Sunny day. By 3.30 it's done,
modest prizes awarded and totted up. Hot, crowded train home.

91

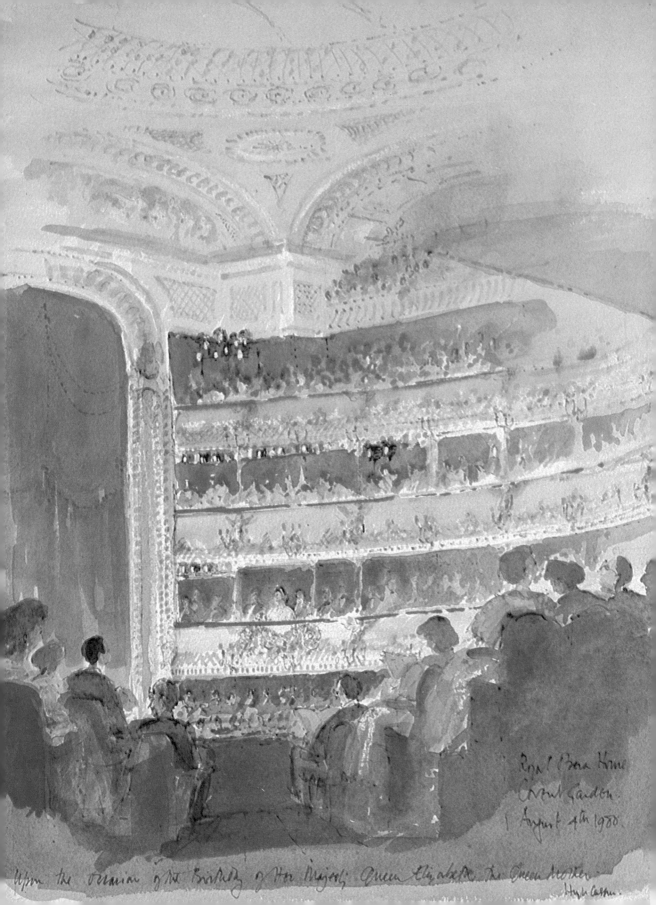

Royal Opera House
Covent Garden.
1 August 4th 1980.

Upon the occasion of the Birthday of Her Majesty Queen Elizabeth the Queen Mother.
Hugh Casson.

London – Windsor – Needs Ore – Yarmouth – Glyndebourne – Chatham – Cala al Volpe AUGUST

Covent garden Rehearsal.

Friday 1st: London

Partners' meeting. We decide from past unfortunate experience to pass up an invitation to compete for a building in the Gulf but to pursue (how could we resist it?) an enquiry from Arizona for the design of a holiday resort, which is to be called 'La Place'. 'It's from the French', says the letter, 'and is pronounced La Ploss'. (We never hear of this again.)

To Long Acre to watch hour-long film on Stanley Spencer by David Rowan: a minor masterpiece, stunning to look at, and, what's more, Spencer's own words beautifully used throughout ('I like Scotsmen, they're as easy to talk to as a hedge' . . . 'I'm never bored, such sadness is not me'). Self-obsessed, deeply religious (in the sense of finding everything from a button to a casualty station equally important) and a fantastic draughtsman, bursting with ideas and scriptural conversation. (When he and I, plus Freddie Ayer and Rex Warner, went on a cultural mission to Peking in 1954, he read nothing for three weeks but the Bible.) How we have under-used and misunderstood him.

Drop in at Covent Garden Opera House to check on detail of Queen Elizabeth's Birthday Gala. Find rehearsal in full swing . . . Freddie Ashton, Claus Moser, John Tooley surrounded by cohorts and courtiers. Sadly no time to stay and watch.

Saturday 2nd

Thrown into passionate irritation by letter from Hamish Hamilton saying the printers have lost one of my drawings for the Prince of Wales' children's book *The Old Man of Lochnagar* . . . and could I please do another . . . and also enclosing proofs of the book with a new inside cover over which I was not consulted and regard as unacceptable. Pen whining letters to HRH and printer and rouse Jamie Hamilton from his bed. He pleads exhaustion – he has just arrived from New York – but I mercilessly unload my rage. Still feel shaky with it when son-in-law Nick W takes us to Richmond for his lunch-time play at the Orange Tree. Small, appreciative audience – five characters, fifty minutes. Quite funny but he is unhappy that cuts have left some non-assembled ragged ends here and there. Back home to write in garden. Kitty ventures out. Shall we ever see her again?

Kitty

93

AUGUST

R.A.F. Sheds Harwellbury —

Sunday 3rd

Sort books all day; all now in shelves distributed over three floors. M seems to manage a 24-hour day getting it all straight. Kitty has returned.

Monday 4th: Windsor, London

Half the morning in garage trying to deal with aftermath of the crash. Coachbuilders, insurance, head-shaking, 'three weeks at least . . .' etc. Then drive down to Windsor to meet Bill Nash[1] and take another look at Suite 240. Sit there for an hour and draw and think. Back by five to change for gala at Covent Garden. Street crowds, parking nightmare, but stuff myself in Drury Lane and we reach our seats by the proper hour of 7.15. Apparently there are around 250 guests and friends and the rest is paying public. Black tie, party atmosphere. Our seats, chosen to give me a good drawing view, adjoin the royal box, and I find myself sitting next to Prince Philip, who starts immediate conversation across the partition on some technical stuff I've sent him about sail-aided marine transport.

Three ballets, the first old-fashioned and unalluring, the second, *A Month in the Country*, moving, beautiful with Julia Oman's evocative sets, the third Freddie Ashton's 'special'. Nice simple classical set, gold and white, Rachmaninov music. I try miserably to sketch in the dark, so as not to be noticed. National Anthem and Happy Birthday sung with fervour by all present . . . silver rain from the ceiling, balloons on the stage . . . cheers and claps for the Queen who, on Queen Elizabeth's evening, so to speak, has difficult problems of timing – when to stand, sit, indicate 'that's enough', not too soon, not too late. Her timing is unerring. She is in pink with a pearl embroidered belt, Queen Elizabeth and Princess Margaret in white. In front of us are relations or courtiers.

In first interval we go to John Tooley's box: St John Stevas, Armand Hammer, the Mosers. Second interval a variation in the Crush Bar: Mary Soames, Roy Shaw, the art establishment. Afterwards on-stage, where cake is cut, little dancers with necks as thin as celery sticks stand around with feet akimbo. Cheers again, general euphoria. We leave about 11 pm, lucky and happy.

94

Backstage Covent Garden.

Needs Ore Point

Tuesday 5th

All morning completing my drawing. I find Queen Elizabeth difficult
to draw at the size of my finger-nail but by lunchtime it's done. I give it
to Bob, the frame-maker at the RA, and with luck it will be delivered to
Clarence House by Friday. Buy a pair of shoes to celebrate a task done.
An hour at the office on various chores and home for domestic even-
ing. How different this house is from the one in Victoria Road: quiet,
un-urban, shabby, rambling, inconsequent. I'm beginning to love it,
becoming increasingly disloyal to No 35 and its strong, late-Victorian
rigour and solidarity.

Wednesday 6th

To Windsor at 8 am. Picked up from there by Libby and driven via
Oxford and Cheltenham to Hartlebury. Grey day... soft light...
Cotswolds looking bleached. An hour or so on the RAF storage site.
(How well I remember those sheds and those camouflage colours from
the 'forties, the Georgian-style gatehouses and officers' mess, the sash
bars, pantiles, flush-pointed vicarage brickwork.) Lunch with the
Bishop and family, who retire with Libby to discuss the exhibition. We
leave at 5 – Cheltenham again – back through familiar streets, passing
my old Air Ministry office, the terrace home where M and I and baby
Carola lived for a few weeks in 1940. (It was in Cheltenham that I made
my first public speech – in aid of Acland's Commonwealth Party – to a
group of seven people and a wheezy Aberdeen terrier sitting in a
blacked-out lock-up shop.)

Thursday 7th: Needs Ore

Leave midday for the country. Sunny, clear, empty roads... It is so
hot by tea-time I decide to bathe off the point with the grandchildren.
The air – but not the sea – is as mild as milk. Setting sun, long
shadows... the Solent, carrying its shoals of multi-coloured sails,
looks like a flat silver tray with a load of caterer's canapés. At 5
Britannia, immaculate and beautiful, steams slowly by with the Royals
aboard bound for Scotland, three huge flags as big as tablecloths
streaming from her three masts. As with many ships, *Britannia's* looks
seem to have improved with age, or is it that her lines seem now so
elegant in comparison with those boxy blocks of flats that steam daily
up to Southampton with their containers? It's thirty years since I

HMY Britannia.

95

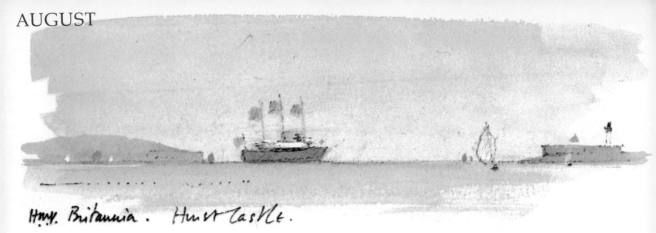

H.M.Y. Britannia. Hurst Castle.

worked on her, thirty years since that extraordinary voyage when, as a proud but quaking fellow-guest with Prime Minister Winston Churchill, I was picked up off the Needles and brought round to Tower Bridge and a vociferously welcoming London. The details of that extraordinary experience – down to the menus – are still diamond-sharp in my memory. The moment when Commander Preston, who had piped me aboard his naval escort vessel before a group of puzzled onlookers, began to sense my amateur – not to say phoney – status, took off his sword and accepted an iced cake . . . the Prime Minister in the admiral's barge, cigar stuck in smile, waving his little taxi-driver hat to the escorting yachts . . . *Britannia*, looking impossibly tall and heraldic, suddenly manifest, so to speak, out of the pewter-coloured horizon with her escort, then slowing down (but no stopping) to pick us up (the coxswain obviously facing the test of his career as we bobbed along her Nile-blue sides) . . . the fleet reviewed . . . the excited, sleepless night aboard . . . the end-of-term atmosphere as we entered the Thames estuary . . . the two men in trilby hats boiling shrimps in a small boat off Gravesend, too busy to give more than a perfunctory hand-flap . . . Tower Bridge and the fur-hatted Lord Mayor in an open boat with upraised oars . . . Britannia's captain Commander Dalgleish (with a broken ankle) hopping agonisedly from one side of the bridge to the other as we moor up, determinedly without tugs ('The Navy doesn't use tugs') . . . the lunch party and family re-union . . . the boatloads disappearing in order of grandeur (Royals . . . entourage . . . personal staff . . . luggage . . . finally, after a cup of tea, the Admiral, now bowler-hatted, and me).

Britannia disappears into the sunset beyond the Needles . . . the grandchildren are loaded up for baked beans, boasting and bed.

Friday 8th
Two warships pass each other at breakfast time, flashing and winking at each other like press photographers. Years since I've seen more than one warship at a time in these waters, though the chart on our sitting room wall of the 1900 Naval review shows hundreds.

Even in the 'twenties I remember battleships used to cruise around the south coast on a naval recruiting drive. There's nothing like a white

Escort vessel.

Yarmouth – Lymington Ferry –

ensign for nostalgia. I well recall the day when, at the age of 12, I was introduced in the boardroom of HMS *Barham* to my favourite author, 'Bartimeus' (Paymaster Ricci); that afternoon in Sibenik harbour when two white-ensigned destroyers foamed in behind the SY Nahlin (bearing Edward and Mrs Simpson) and we were mobbed in a local tobacconist, as my fellow-undergraduate was HRH's double; the 1937 Jubilee Review seen from my father's half-decked, clinker-built, twenty-foot *Nan*; and (earliest of all such memories) being lifted up by my nurse to the porthole of the second class dining saloon in a Bibby liner to see the Mediterranean fleet off Malta. The smell of Brasso, floor polish and lentil soup is with me still.

Saturday 9th: Yarmouth, Freshwater

We catch the 11 am Yarmouth Ferry, which slides like a giant chest of drawers down the Lymington river. Buses from everywhere meet the boat – it must be the most efficient service in the UK – and within 20 minutes we are across the island at Freshwater. It is not quite the place of my childhood (too many picture windows, carriage lamps and split level bungalows around), but traces remain: huge barge-boarded and gabled late-Victorian villas buried in shrubberies and tamarisk, moss-dappled unadopted roads drenched in forsythia. Behind these lurked the Tennyson group: Julia Cameron, smelling of chemicals, looking for sitters to pounce on; Mrs Barrington planning her life-long siege of G F Watts' heart; and the Royal Palace itself, Farringford, a long, low Georgian house in 'sweet and savory Gothic', now a hotel deep set in a park overlooking the downs inland to the east, where Tennyson made his home. (The attic study where he wrote *The Idylls of the King* is still preserved.)

There are traces still of the old village inland, but the church where Lady Tennyson is buried is less remarkable than its little thatched successor (dated 1908) near the beach, with its tiny rash of 'caffs' and a wishing-well. Lunch on a blazing pebbly beach, a brief exploration of the caves, then up on Tennyson Down – a favourite childhood walk – with not a house in sight except distant farms, nothing but gorse tugging in the wind and seagulls wheeling below. You can walk over the sea with Tennyson's wrinkled sea crawling hundreds of feet below you on each side, 'till the downs narrow to a point and disintegrate into

Tennyson Down

Cous- Cous
puts to sea.

the Needles... the Pepper... Wedge... Roe Hall... Frenchman's Cellar... the yellow funnelled pilot boat rolling in the swell and finally the striped lighthouse, as gaily painted as a croquet mark, to signal the end of the journey. Tennyson, no wonder, walked it nearly every day – once turning tail in terror in the face of a flock of sheep, which he mistook for autograph hunters.

The children are too young – and I'm too old – for the full walk, but we lie on the hot turf for an hour before bussing home past the guest houses and the pottery shops to Yarmouth.

Sunday 10th

Warm sun, light breeze, blue sea. Decide to rig *Cous-Cous*, our little black, blue-sailed scow and introduce five-year-old Matthew to his first sail (my own – at the age of 12 on a pouring wet day – was unalluring). We push off... through the swatchway and OUT TO SEA... then back into the river. M takes the tiller and seems to enjoy it, though for young things small-boat sailing can be tedious. There's not enough to do, nowhere to go, and occasional bouts of terror (rather like a quiet period of a war). Children spend a blazing afternoon under a self-constructed, pitch-dark tent of blankets.

Monday 11th: Glyndebourne

A Glyndebourne day – and another drizzler. An hour in the office writing irritable notes to the publishers of Prince Charles' book. They have already grovelled and I know that continuing to pick at the scab is unrewarding. The jangly word 'rankling' is just the word that describes my feelings.

I catch the afternoon train to Glyndebourne... grey scarves of mist hanging over the watermeadows south of Lewes... ladies upholstered like armchairs in flowered cretonne clamber into buses. There's a sense of *fin de saison* in the foyers – smaller queues for dinner reservations, pictures removed by purchasers, signs of unauthorised extra end-of-term 'business' on stage. Difficult to enjoy one's 'own' opera unreservedly. The eye is always alert for a chink of light in the painted masonry, a lightly waving gauze making trees tremble as in a heat haze, a 'stone' rostrum that echoes to feet like a drumskin, but it goes

Bear Dance – Fidelta –

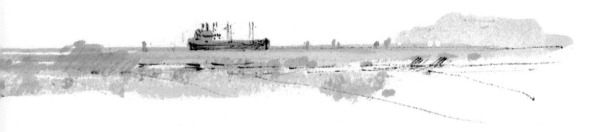

well and *Fideltà* is gone – for how long? Maybe for ever. Certainly the same cast will never re-assemble above the same orchestra. It's like losing a limb or watching a building one has designed burst into flames. I am low-spirited on the going home. My ideal? To design an opera every two years.

Wednesday 13th–Friday 15th: London
Working at home, Bedford College again. Finish pamphlet on St John's Smith Square at last. Journalism involves one in agreeable serendipity (a Victorian parish record of St John's claims that 'corpse beautifiers' employed at well-to-do 18th-century funerals were called 'plumpers'). I've always regarded St John's as a masterpiece of English Baroque – yet it is hardly known and certainly underestimated. Difficult to find, of course, and the English have always disapproved of the Baroque style. (As a nation we dislike rhetoric in any form.) St John's had a hard life – sinking into its swampy foundations, twice destroyed by fire. Its architect, on the other hand, had a soft one. Thomas Archer was well-to-do, handsome, agreeable and leisurely. He had a lucrative job at Court (like being head of Ladbrokes, the Jockey Club and the Tote Board) but just found time to do some splendid architecture, including Birmingham Cathedral and St John's and his own handsome house at Hale in Hampshire, where he died. Sad he wasn't poorer and thus busier, for he was a really original architect. Wealth can be a very efficient smotherer of talent.

Children return from holiday.

Saturday 16th/Sunday 17th: Groombridge
Drive in blazing sun to friends in E Sussex . . . a tortuous and ingenious route successfully negotiated. The house is 18th century, Victorian-ised, square and plum-coloured, packed with books and Victorian paintings and drawings, set in a romantic hilly garden with huge outcrops of sandy rock and a Poet's Temple built by Vita Sackville-West and carrying inscriptions (by poets) in praise of poets. (One who attracted disfavour later on has had her name removed by chisel.) Afternoon in a long chair working, a walk round the garden and a swim. Neighbours to dinner.

Leisurely, drizzly morning next day. Drink with neighbours, neigh-bours to lunch. Walk to Groombridge Park. The electric trains hoot

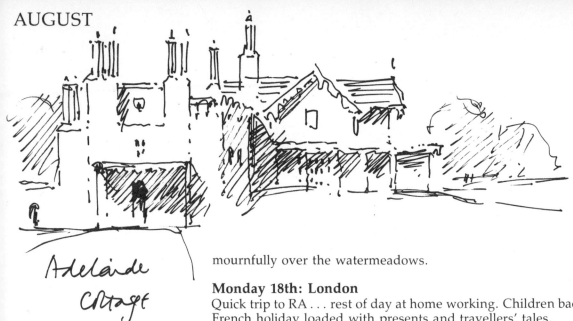

Adelaide Cottage

mournfully over the watermeadows.

Monday 18th: London
Quick trip to RA . . . rest of day at home working. Children back from French holiday loaded with presents and travellers' tales.

Tuesday 19th
At home working on Bedford College, Hartlebury, Sutton Place. Grandchildren, temporarily resident on top floor, descend with plasticine battleships for my mantelpiece, a new and pleasantly unfamiliar office hazard.

Wednesday 20th
Drawing commissioned watercolour portrait of the Building Centre, Store Street takes nearly all day. Hideous building, but lots of trees – even harder to draw – luckily obscure most of it.

Thursday 21st: Windsor
Windsor. To Suite 240 again to take more dimensions. I feel embarrassed by my crushed little Mini disappearing perkily through the gateway between the sentries. Lunch at Adelaide Cottage.

Friday 22nd: London, Chatham, London
RA for a change. Meeting with Mary Birkett, Director of Kendal Museum, and then leave for Chatham with M. Long, crowded, dead-slow drive. How do people endure living and commuting this way out of London? Lunch at Lloyds, Chatham in their new Arup building on the gun wharf overlooking the river. (Here fifty years ago we spent the night on a Thames Barge with its owner, Antony Coxe. The first day we unfurled the sail a wasps' nest fell out. At dawn the next day, on a sluicing tide, we cast off, carried away a mizzen mast on a neighbour's boat in the dark and sailed proudly off down river. I was dropped at Greenwich, the others sailed on, eventually to be run down by a small coaster somewhere off dockland. No one hurt except the poor barge.)

The Lloyds building is a triumph: beautifully designed, beautifully built and finished, packed with obviously happy staff. No recruitment troubles and higher productivity. Momentary lift of pride for architec-

Thames Barge.

Notting Hill Gate Carnival

ture. Drive back worse than that coming down. Two hours at office with Neville C on Aga Khan design issues. Design gets no easier.

Sunday 24th

Children to lunch. They demolish staircase partition and repaint exposed boarding. Enormous improvement, even if it means re-hanging half the pictures. How one enjoys pulling down really crummy bits of building - plasterboard, crooked nailed studding, etc. In the evening watch Notting Hill Gate Carnival for a while. Lots of 'whites' self-consciously weaving in the streets. Americans? Could be. Men with heads of grey fur instead of hair, white duck trousers and Martha's Vineyard brown faces, with headscarved girls – all from Updike country. Roads all blocked but eventually reach Festival Hall with M for evening concert. The Zuckermans, James Galway and the Brandenbergs. Hall packed to the brim, queues outside. Full moon.

Monday 25th (Bank Holiday)

To office in morning for brief encounter with Aga Khan. Run through summer wardrobe for packing. Draw, interrupted by Carnival events. Pack up and leave notes everywhere.

Tuesday 26th: Cala al Volpe

Up at 6. Disaster strikes (as so often) at Heathrow, but the fault this time is mine. Find only one booking and one ticket. Spend nearly an hour at desk. Feel exhausted, cross and giddy with self-reproach. Once again, one asks, why leave home ever? Buying a newspaper takes seven minutes. The luggage X-ray machine is halted for ten minutes while four toy revolvers are removed from a child's suitcase. Gate No 25 is at the far end of the corridor. Change of scene at Rome. Aga Khan organisation in charge, situation transformed: dark glasses and printed silk meets us at gangway, whisks us through passport/customs, drives us to domestic flight terminal, hands us boarding cards in a VIP lounge. Colleagues join us one by one. At 1.45 we are taken up to lunch. Prosciutto, fruit, coffee. The plane is held up for us as, giggling self-consciously, we climb aboard. Forty-five minutes to go. Sardinia is cloud-wreathed, Olbia hideous. Tiny airport, bougain-villea, no formalities. We climb into two buses and drive across the mountains. Once over the hills the Costa Smeralda begins: no hoard-

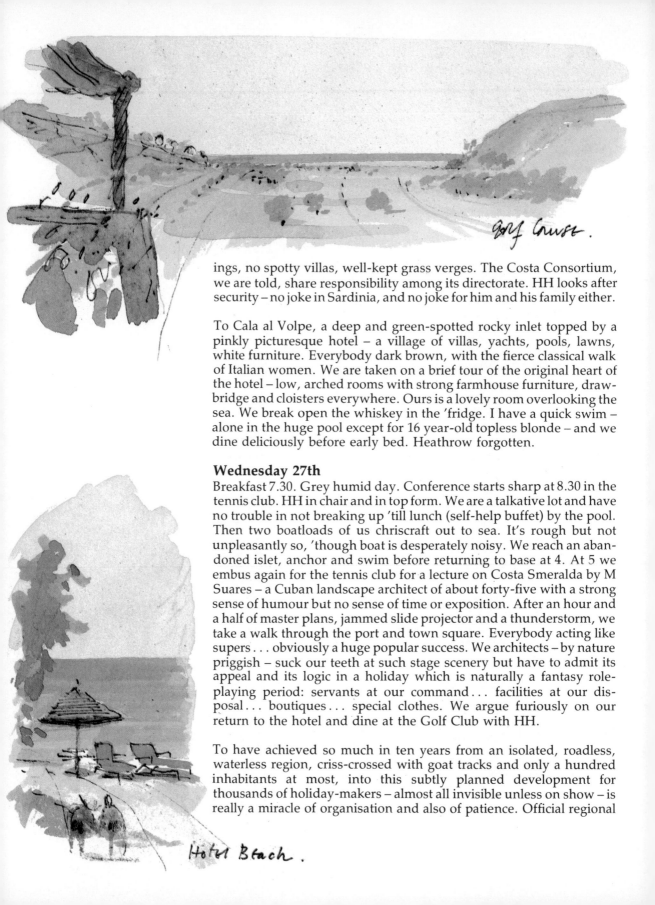

Golf Course.

ings, no spotty villas, well-kept grass verges. The Costa Consortium, we are told, share responsibility among its directorate. HH looks after security – no joke in Sardinia, and no joke for him and his family either.

To Cala al Volpe, a deep and green-spotted rocky inlet topped by a pinkly picturesque hotel – a village of villas, yachts, pools, lawns, white furniture. Everybody dark brown, with the fierce classical walk of Italian women. We are taken on a brief tour of the original heart of the hotel – low, arched rooms with strong farmhouse furniture, draw-bridge and cloisters everywhere. Ours is a lovely room overlooking the sea. We break open the whiskey in the 'fridge. I have a quick swim – alone in the huge pool except for 16 year-old topless blonde – and we dine deliciously before early bed. Heathrow forgotten.

Wednesday 27th
Breakfast 7.30. Grey humid day. Conference starts sharp at 8.30 in the tennis club. HH in chair and in top form. We are a talkative lot and have no trouble in not breaking up 'till lunch (self-help buffet) by the pool. Then two boatloads of us chriscraft out to sea. It's rough but not unpleasantly so, 'though boat is desperately noisy. We reach an aban-doned islet, anchor and swim before returning to base at 4. At 5 we embus again for the tennis club for a lecture on Costa Smeralda by M Suares – a Cuban landscape architect of about forty-five with a strong sense of humour but no sense of time or exposition. After an hour and a half of master plans, jammed slide projector and a thunderstorm, we take a walk through the port and town square. Everybody acting like supers . . . obviously a huge popular success. We architects – by nature priggish – suck our teeth at such stage scenery but have to admit its appeal and its logic in a holiday which is naturally a fantasy role-playing period: servants at our command . . . facilities at our dis-posal . . . boutiques . . . special clothes. We argue furiously on our return to the hotel and dine at the Golf Club with HH.

To have achieved so much in ten years from an isolated, roadless, waterless region, criss-crossed with goat tracks and only a hundred inhabitants at most, into this subtly planned development for thousands of holiday-makers – almost all invisible unless on show – is really a miracle of organisation and also of patience. Official regional

Hotel Beach.

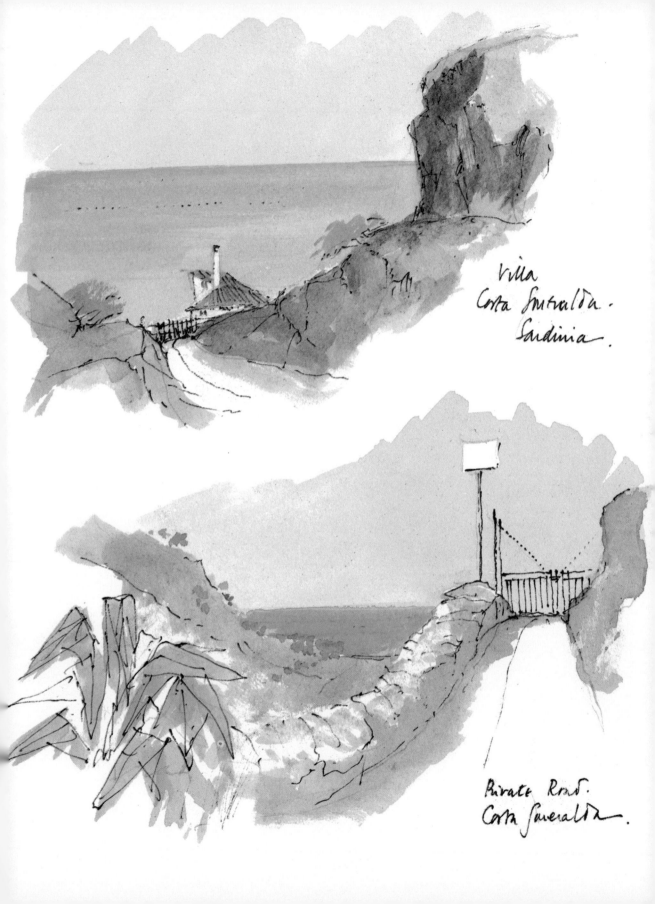

Villa
Costa Smeralda.
Sardinia.

Private Road.
Costa Smeralda.

Island swim.

masterplans were years late in preparation, the locals were (to start with) unfriendly, labour and skills were scarce. Controls are strict – everything, however small, goes to a design committee that meets every six weeks. The consortium handles domestic security, forest fires, refuse collection. The place is spotless, the gardens carefully looked after but not manicured. The children love it (boats, tennis, swimming, ping-pong), and there are hundreds of them, like little brown froglets, swimming, running, squeaking happily on the lawns.

Thursday 28th

Still grey. Conference continues 'till lunch (HH leaves at 12.45 for Deauville (*Deauville?*) ('I will be back for the 6 o'clock meeting', he says – and is) punctuated by squeals from children in pool below. After lunch we make a brief tour of the main features, including the marina, where crews are washing down in preparation for the Sardinia Cup Race. Fourteen countries, blond beards, nautical groupies, a van nostalgically from Lymington, Hants. Ted Heath is alleged to be here. Dinner with Michael Curtis in one of the oldest hotels – small, roofed with turf and stone, the pool overflowing into the sea below – all excellently done.

Friday 29th

Marathon day. HH has been up since 5 am, documented and ready with his questions. Agenda debris on our plates. Late lunch after a quick swim. The weather has changed overnight to blue skies and blazing sun. Unwillingly, we return to the conference room to discuss organisation of award ceremony. We are tired and tend to bouts of facetiousness. We break off at 8 from fatigue. Rush back to change and to huge evening party at Maire Hardouin's house above the harbour. I am introduced to Jacques Couelle, the architect of our hotel: ancient prophet face, white locks, leathery crevassed face, no English. We exchange professional gossip – how I cringe at my shamefully amateur French. After half-an-hour we move on like a flock of starlings to a hill-top eyrie with rocks as big as elephants protruding into the living room. The host is HH's brother-in-law and the guests 'our party'. I sit next to Begum, who is off tomorrow on one of the Australian yachts for an all-day race. 'The Captain shouts at you', she says, 'so I shall sit behind him'. We leave, flogged, at midnight and say farewell.

Cala al Volpe Hotel.

washing down
for the
Sardinia Cup
Race.

Saturday 30th: London

Awoken at 4.45 am. Breakfast beneath a ceiling of plaited straw and
reach the airport at 6.30. 'Plane leaves late and packed to the brim into a
clear, clear dawn. Our party is low-spirited. We have had three very
enjoyable years of work together, meeting two or three times a year,
and are about to disintegrate. HH wishes to strengthen the Moslem
element, to reduce the average age and the Bostonian preponderance.
All of us have resigned. A few perhaps will reappear next year. It's
been a fascinating experience – a grant-aiding institution dealing with
hospitals and airlines, schools, historical research, landscape designs
in a dozen countries, all of them in some sort of political ferment, often
mutually antagonistic. (No decisions can be taken without this element
as a prime constituent.) HH steers an experienced route through this
nightmare, too old a hand at generous patronage to expect anything
but abuse or misunderstanding at the butt end of it all. I should find it
discouraging, but he obviously enjoys the manipulation of events,
activities and people, is fascinated by detail – the choice of a floor tile or
the drafting of an agenda – and is a decisive chairman.

Difficult to avoid day-dreaming about how one would manage one-
self . . . the army of secretaries, accountants, lawyers and advisers, the
relentless march of meetings of a dozen idiosyncratic nationalities and
as many disciples, the unendable official ceremonies and public
appearances. How pathetically (and marvellously) uncomplicated in
comparison my own professional life is.

Our aircraft is late and the transit change desperately quick. We watch
a suitcase (ours?) drop off a truckload. It sits on the tarmac by itself and
is still there when we take off. We land at 2 pm; our cases and those of
six other passengers are lost. Whine, plead, howl to no effect. 'Have
you come from Rome? . . . Oh well . . .' Reach home and find ourselves
locked out by daily women. Find young and active neighbours to climb
up ladder and free windows. Home.

Sunday 31st

Unpacking, correspondence, laundry, chores.

Dropped suitcase
Rome Airport.

Acros the Cotswolds

London – Athens – Yalta – Odessa – Istanbul – Izmir

Monday 1st: London

To RA to judge another Disabled Children's Art Competition – difficult and lengthy. The drawings are pinned up out of order, one fellow-judge has strongly personal views, and there's a big launching party in full swing in the same room at the same time. In the afternoon record a brief interview with BBC on Stanley Spencer. Exhibition magnificent.

Tuesday 2nd

All day drawing. On the way to a quick office lunch pass a nun changing a wheel in Cromwell Road. Ashamed to say I don't stop to help.

Wednesday 3rd

Take part in a curious ESP experiment at Daily Telegraph office: complicated exercise of sealed envelopes, 'monitors', 'transmitters'. The plan is the the 'transmitter' should go to a place (secretly nominated) and 'transmit' to a 'receiver' elsewhere, who will try to draw what is 'transmitted'. I am chief observer and when results are in, will try to adjudicate. American experiments have had remarkable success. Will it repeat here? Everyone nervous. The party is a mixture of professional clairvoyants and their 'groupies' and odd enthusiasts like Michael Bentine – a lifeling ESP addict who tells me his father invented an aircraft so stable it couldn't turn round and had to be landed, turned, and taken off again. The company disperses to their secret destinations. (The experiment proves to be a disappointment, though a 'receiver' successfully achieves a creditable message about the Wellington Arch, and draws a recognisable picture of it.)

Penelope Gilliatt to dinner. She's been to BBC to discuss dramatising one or two short stories. She professed reluctance to do somebody else's story, but the script editor persuaded her to try one she thinks she'd like. It turned out to be one of her own, already dramatised and performed a couple of years ago.

Thursday 4th: Hartlebury

Hartlebury. Long three-hour drive with Tony T from the office. Meeting of local authority councillors to discuss our face-lift prosposals for the industrial estate. They are sympathetic, but their interest (rightly)

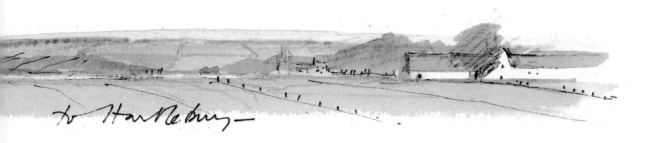

is more in jobs to be created than in colour schemes. Our neighbourly duty done, we return to London.

Friday 5th: London
Preside at AGM of RA Friends. Lively if confused meeting: tricky arguments on raising subscriptions, or reducing privileges, or both, crowds on private view days, minor abuse of privileges – all stimulated by complaints from sponsors that Friends mean long-term income to RA but loss of income to exhibitions. We pout and fluster a bit and decide to pass it all to the management committee, with a preference for joining the 'Leave-things-as-they-are-Society'.

Brief meeting to inspect the cotton duck wall lining for the Stanley Spencer exhibition. Some of it is discoloured but we accept it, no realistic alternative. A roller-skate round the Fine Art Fair (nearly completed), approve Spencer poster (2nd proof) and to Thurloe Place for two hours' architecture before supper.

Saturday 6th
Usual pre-hols chores. Cleaners, chemist's, bookseller's, cat food. Rest of day writing (belatedly) lectures to be delivered on boat in exchange for our passage. Grandchildren to lunch and supper.

Sunday 7th
More travel chores . . . suitcases . . . final letters. Write an article in the garden (feel like real author – deck chair, sun hat, manuscript, tea cup). Three young Australians in to drinks – one an ex-student, one a painter, one a lawyer. They are staying, improbably, at Boodles, and by strange coincidence are *en route* to Brantwood in search of Rus-kiniana. Pack 'till late and fail to sleep. How miserable are the hours before holiday travel, how alluring the look of one's room. The days of indecision – where to sit, where to go, what to wear, how much to tip – stretch menacingly ahead.

Monday 8th: Athens
Holiday imminent and inescapable (I recall the notice in a Charlotte Street restaurant window – 'Dreaded veal cutlet'). Pack . . . more let-ters . . . last-minute orders over cat food to lodger-daughter. Heathrow

writing lectures

Acropolis

for once comparatively quiet and empty. Leave on schedule.

Our Athens hotel, perched on the flanks of Lycabettus, is modern, humming and muttering to itself quietly like a 'fridge. We dine under the stars on the terrace. Our room looks through reinforcing bars into the bowl of a concrete mixer on a building site.

Tuesday 9th: Piraeus

Fine morning, self-help breakfast and a stroll around the neighbouring streets of Kolonaki: posh French-Bavarian architecture, lots of architects' offices in basements. At 11, Eugene Politi arrives – a beautiful ex-college student now working and practising in Athens. We gossip over terrace coffee 'till lunch time, when we are joined by Greek friends for lunch, which stretches 'till 4.

Taxi down to Piraeus (gradually the bay is being filled in, but the smell hasn't changed) to greet our ship, *Royal Viking Sky*, the largest in the port, moored next to an Egyptian destroyer and a Russian cruise ship called *The Odessa*. We are welcomed by the Yul Brynner cruise director (his staff encamped in a tent on the dockside), and go aboard. Polished wood, gleaming paint, soft carpets, softer muzak; she was designed and built in Finland and is spotless from funnel to keel. We find our stateroom starboard aft: two portholes, orange carpet and bed covers, teak fittings, nice lithographs. Make quick tour of main rooms, confirm our table (it's for eight), unpack and prepare for 'IT'. Our fellow passengers are much as expected, mostly slow-moving and grey, with a sprinkling of middle-aged. It doesn't feel full, but maybe with so many decks and so many rooms it's misleading.

At 5 pm we sail. At 6.15 M and I go to the theatre to meet the 'entertainment crew' – dancers, singers, travel guides, masseurs etc, even a rabbi, his 13th trip on this ship. (How strange are the occupations of others.) We down whiskies in our cabin and face the table: two married couples from Wisconsin (grey, heavy-boned, bespectacled, friendly) a professor and an engineer plus spouses, two empty seats and us. M is blissful – a flower box on her left, me on her right and nobody opposite. Our steward, 'Raymon', is delighted we are English. He is the only English crew member and comes from Windsor.

Dockside

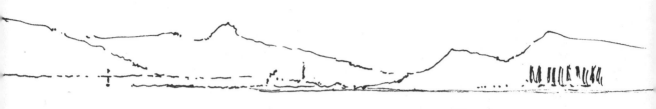

Entrance of Bosphorus

Excellent dinner, then we assemble in the lounge for 'get-to-know-get-together'. The spiel is spine-chilling to Anglo-Saxons, like a TV quiz show: 'Where are you from?' 'Ohio'. 'Why, that's *wonderful*'. 'Any honeymooners?' (a young embarrassed pair and another in their sixties are coaxed from their seats and given a bottle of champagne each). Oldest married couples are publicly assailed, specific ·people named and asked to buy each other drinks. Good humour reigns. The cruise director's bald pate is dark with sweat, his eyes are anxious above his smile – but after half an hour he has had some success. He finishes by asking us not to go to the cinema but to dance and switch partners. M and I – I hope inconspicuously – switch off for a quick deck circuit. The sea is black calm, the stars slung like lamps in the sky. The ship trembles slightly . . . occasionally wagging her tail as if glad to be at sea.

Wednesday 10th: Bosphorus, Black Sea

7.30 . . . pearly dawn . . . silky sea . . . distant Turkish cliffs. Breakfast arrives at 8 with pretty stewardess. At 8.30 we watch the pilot and health boats come alongside. The first joggers appear. The sea sparkles; lion-coloured hills appear and then disappear into the mist. I dread my talk: will anyone be there and if so have I hit the right note? No trace of scholarly Serenissima/Swan types yet. Have we made a terrible mistake? With sun, sea and comfort and an uncrowded ship, surely not.

Read 'till 10, when we have our first briefing from the ship's tour guide, a very bright German girl. It is excellent: factual, honest, useful. A quick swim, then to lecture. About 50 people maybe, more – I notice smugly – than for the one on golf. Amazed so many people come out of the sun to listen. I speak too fast but think it goes down well. My subject – a bit risky? – it's the Philosophy of Keeping . . . Why do we do it? What's missing in our lives that makes us go on trips like this, inspecting ruins and museums, relics of the past? And how odd it is that we are shown – and accept without question – what is chosen for us, usually by the tourist industry or by pedants in museums, and not necessarily what we would have chosen for ourselves. M is loyally reassuring.

Doze and read and swim 'till 4, then sit and gaze for two hours through

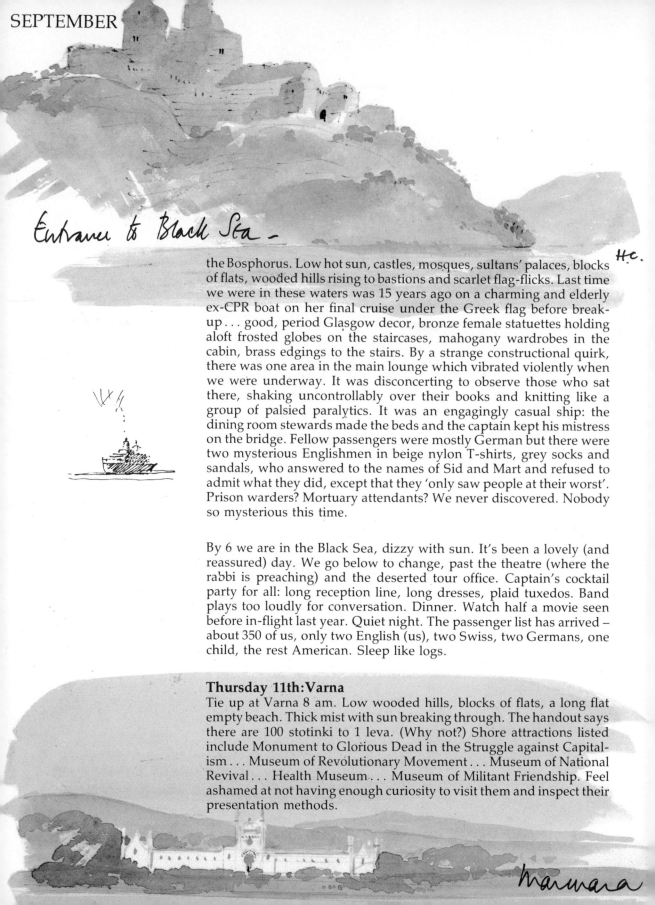

Entrance to Black Sea —

H.C.

the Bosphorus. Low hot sun, castles, mosques, sultans' palaces, blocks of flats, wooded hills rising to bastions and scarlet flag-flicks. Last time we were in these waters was 15 years ago on a charming and elderly ex-CPR boat on her final cruise under the Greek flag before break-up... good, period Glasgow decor, bronze female statuettes holding aloft frosted globes on the staircases, mahogany wardrobes in the cabin, brass edgings to the stairs. By a strange constructional quirk, there was one area in the main lounge which vibrated violently when we were underway. It was disconcerting to observe those who sat there, shaking uncontrollably over their books and knitting like a group of palsied paralytics. It was an engagingly casual ship: the dining room stewards made the beds and the captain kept his mistress on the bridge. Fellow passengers were mostly German but there were two mysterious Englishmen in beige nylon T-shirts, grey socks and sandals, who answered to the names of Sid and Mart and refused to admit what they did, except that they 'only saw people at their worst'. Prison warders? Mortuary attendants? We never discovered. Nobody so mysterious this time.

By 6 we are in the Black Sea, dizzy with sun. It's been a lovely (and reassured) day. We go below to change, past the theatre (where the rabbi is preaching) and the deserted tour office. Captain's cocktail party for all: long reception line, long dresses, plaid tuxedos. Band plays too loudly for conversation. Dinner. Watch half a movie seen before in-flight last year. Quiet night. The passenger list has arrived – about 350 of us, only two English (us), two Swiss, two Germans, one child, the rest American. Sleep like logs.

Thursday 11th: Varna
Tie up at Varna 8 am. Low wooded hills, blocks of flats, a long flat empty beach. Thick mist with sun breaking through. The handout says there are 100 stotinki to 1 leva. (Why not?) Shore attractions listed include Monument to Glorious Dead in the Struggle against Capitalism... Museum of Revolutionary Movement... Museum of National Revival... Health Museum... Museum of Militant Friendship. Feel ashamed at not having enough curiosity to visit them and inspect their presentation methods.

Marmara

Go ashore around 9.30. We skip the excursion and, greatly daring, catch a bus. Hand over a leva and get back (presumably) some stotinki. Nervous of being carried too far, we get off a bit too soon and walk through the town, with its heavily shaded streets, crumbling stucco, cast-iron doors, washing in tiny gardens. We find a splendid church full of icons just before it closes and some unexpectedly spectacular Roman ruins. Old moustachioed men sit, chins on sticks, under the chestnuts. In the town centre, behind the opera house, the streets are cleared and lined with crowds and flag-waving children. We discover it is the visit of a foreign dignitary, but decide not to wait for him and walk back along the quay to the ship. The hot mist has gone, leaving behind a chilly breeze and clouds. Departure is always a form of judgement on what is left behind – here, a taste remains of poverty and vigour.

Sanitorium – Yalta.

At lunch an empty dining room. We sail at 3 – delayed by an errant bus-load. The harbour is packed and busy: a Bulgarian warship, hydrofoils, a Chinese freighter, a Russian cruise ship as big as ours. Bathe and read all afternoon, pass up 'meet-the-other-singles' party in the Buccaneer Bar, but not the election of Miss Viking after dinner, which is done by drawing lots (how else?). A tall, grey-haired lady from Toronto accepts the crown and sceptre and good-humouredly spends an hour sitting on a 'throne' presiding over the dancing. Long, pitch-dark walk round the deserted deck, my only companion a tiny finch-sized bird with a white breast. Is it Bulgarian? Does it know and will it mind that we are going to the Soviet Union?

Friday 12th: Yalta
Grey, overcast. Little silver plates of sunshine set out on the pewter-coloured sea, the fantastic mountains of Crimea to port. Pilot – dark glasses and khaki trousers – climbs aboard at 9.30 off Yalta. The ship is coaxed into its harbour berth – like putting a book back on the shelf – and we fit so perfectly it's hard not to applaud. In front of us a crowded, palm-treed promenade, elaborate silver painted lamp-posts, balconied hotels in dark shrubberies climbing up the flanks of the mountains, the occasional brilliantly painted cruet of an Orthodox church. Skies are grey, and by lunchtime (after a morning sketching

Roman Baths – Varna

111

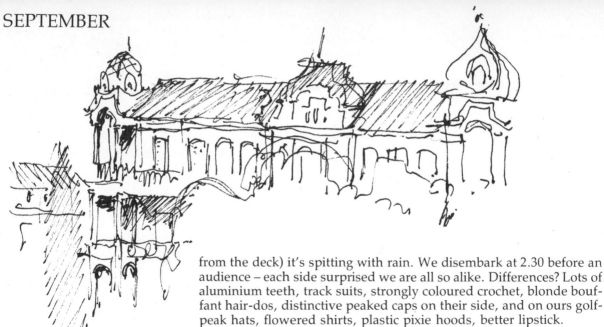

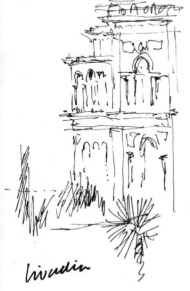

Villa. Yalta

from the deck) it's spitting with rain. We disembark at 2.30 before an audience – each side surprised we are all so alike. Differences? Lots of aluminium teeth, track suits, strongly coloured crochet, blonde bouffant hair-dos, distinctive peaked caps on their side, and on ours golf-peak hats, flowered shirts, plastic pixie hoods, better lipstick.

The coast drive through grey skies is as ravishing as we remember from our last visit. Tropical vegetation drowns the dotty, zinc-roofed villas hung with the laundry of the infirm. ('There are few hotels', says the guide, 'we believe the sick should come first'.) We sit on, guiltily aware of our floating luxury. 'Just imagine', says the guide as we pass a pretentious Maidenheadish-looking villa, 'in the old days (before the revolution) there was only one bed in each of the bedrooms. Now there are thirty'. We imagine in silence.

We reach the Palace of Livadia, designed by Krasnov for the Tsar around 1900 in Thames Valley Italianate style with a touch of Osborne: cream limestone, granite, marble, well-tended gardens. Our guide – tiny black eyes, elegantly shirted, amiable – shows us where Roosevelt sat and the door through which Churchill came. 'First the puff of smoke . . . then the cigar . . . then the stomach . . . then the man'. We don overshoes and are conducted, slip-shod, over the parquet through the house. Unremarkable, with no pictures or furniture to speak of. Where has all the royal stuff gone, I wonder?

Embus again and drive past steeply curving cliffs to Alupka, designed for Prince Worontsow – an ex-Ambassador to London, wealthy and enterprising – by the English architect Edward Blore, who was working at Windsor Castle for Queen Victoria at the time. Outside are crenellated walls, arrow slits, Hampton Court twisted chimneys, balconies held up on delicate cast-iron palm tree colonettes. Inside is heavy Windsor Gothic – dark oak, flat mouldings, fireplaces as big as sarcophogi. A delicious conservatory, trellised and palm-treed, is guarded by marble busts. Outside, a lion sleeps in a marble heap (Churchill, says the guide, tried to buy it). Sad the anecdotes are all about Yalta 1945 and not about the preceding 50 years. How annoying too to be within a few miles of Balaclava and hear and see nothing of it.

Livadia

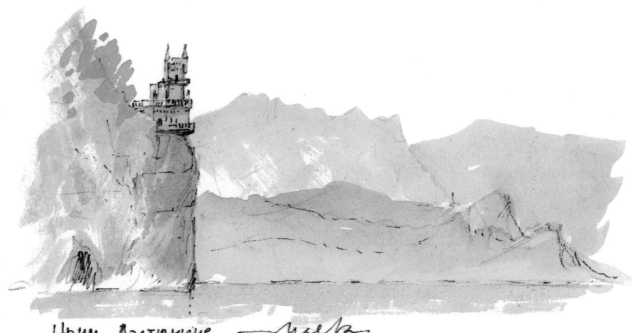

Нрим. Ластівуине ——— Ялта

Yalta.

We trail back along snaking gravel paths to the bus and eventually the ship. The entertainers are practising in the lounge, so we go below for a hot bath and a whiskey. It's been miserable weather but a fascinating trip. (How nice the guide knew that Blore had put the front on Nash's Buckingham Palace . . . I am ashamed that I hadn't expected her to). We sail at sunset, having, for the second time, not seen Tchekov's villa.

Saturday 13th:Odessa
Fine blue morning. At 7.30 captain announces that, owing to the military coup in Turkey, there will no Istanbul or Izmir. Sad, but luckily we have seen both before, several times. Instead to Thessalonica and Samos, which will be nice – the first I haven't seen for 50 years, the second never. Odessa arrives at 8.30. More low wooded hills covered with boxy flats, the occasional dome and, spread out below, a huge port . . . ships, dry docks, warehouses, cranes with dejected broken necks grieving over freighters. The famous Potemkin steps can just be seen to starboard. Maddening that we have no visa so can't go and wander by ourselves.

At lunch the captain reverses engines: Turkey has re-opened frontiers and airports and tomorrow we will be in Istanbul. Loud applause. Afternoon sunning and reading Gittings' life of Hardy 'till 5 pm when we assemble for early (pre-Opera House night) tea. Embus for Opera House, a Viennese masterpiece by Fellner and Fellner – huge, ornate, splendid staircase, beautifully restored auditorium. Usual peroxided termagants at door. Performance by Ukrainian mixed choir, expert but not to my taste. The architecture more than compensates for the music. Two brides in full bourgeois white plus attendants debark from a taxi. One is in tears. Oh dear. Home for buffet supper and dancing in what our table mate calls the Coronary Club.

Sunday 14th: At sea
All day at blue sea. At midday we pass a small freighter which disgorges a rubber dinghy with an outboard motor. It circles us twice at high speed, carrying three girls in bikinis and a sailor. Who are they? Swim. Discuss the typescript of a book on American architect Stanford White with the author, a fellow passenger. Lunch on deck. Sleep, swim, bask. The ship is moving at under ten knots – saving fuel or

Opera House
Odessa

Odessa.
Potemkin Steps.

I stanbul

ahead of schedule? Lecture 2 (more people than last time but talk less good). Dinner, movie, bed.

Monday 15th: Istanbul

Up at 7. Cloudy day, cool. Move alongside at 8 am, in buses by 8.30. A sophisticated guide: 'The coup? A few big wheels turned round in Ankara. No problem'. 'Please do not encourage the dancing bears. We regard it as cruel . . . do not laugh or point at them'. Blue Mosque first, packed to bursting. Then to Kariye, to a sweet little mosaic mosque we last saw under repair ten years ago. (The mosaics were first restored to delight the Kaiser on his visit nearly a century ago.) It is cool and empty. Then across the new suspension bridge to a charming tea garden by the water's edge, and back to ship for lunch. Cats and kittens everywhere, but unfrightened and therefore, though thin, probably not persecuted. It's strange, after Russia, to see so much traffic, so much in the shops, such willingness to accept minimum of passport controls, even to take personal cheques. We try to pick out Barry's British Embassy (replica of the Reform Club) where we once stayed, but fail to spot it.

Afternoon trip to Topkapi – magical as ever with its weeds and diamonds, porcelain and cracked paving. Pigeons . . . cats . . . a cool breeze off the sea. Then an hour in the bazaar, tiring, noisy but enjoyable. Sit on deck happily watching the harbour – tugs, tiny boats, tankers, hydrofoils, more ferry boats, all as busy as taxi-cabs. There is a curfew at 10 and the city suddenly goes quiet, as if snuffed out by a great felt hat. The streets are empty, the quays deserted.

Brood on the day's events. Why do comparatively poor countries with an inflation rate of around 60% bother so much about shoe-shining? Is *Schmuck* really the best German word for *bijoux*? Does the wirescape of Istanbul, as tangled as a gypsy's hair, really work? Why is the European terminus of the Orient Express so tame and the Asian version so flamboyant?

Tuesday 16th

Up at 7.15 for 8.30 departure. The kittens are busy on the quay, the buses already hot to touch. The coup here seems quiet enough – the

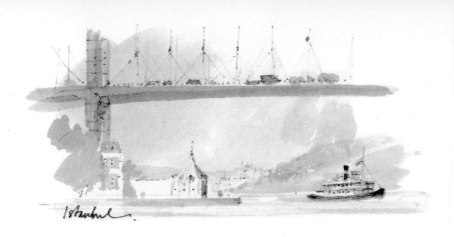

Istanbul

odd machine-gun post or armoured carrier, armed sentries at all public buildings. The guides, as conservative as taxi-drivers, say it's a popular coup – given the choice between liberty and stability, would most of us choose the second, particularly if we've only had limited experience of the first?

Our first stop, the Suleiman Mosque, huge and spacious, filled with pale liquid light – a masterpiece. Next, Santa Sophia, with its mosaic narthex and dark grey-green subfusc colours. Hit the floor with your fist and it echoes as a drum, just like the floor of the Temple of Heaven in Peking. Over the *mihrab* a marble dunce's hat. A German student measures a paving stone; a legless parking attendant moves like lightning across the gravelled approach. The guide reminds us – 'as a Barbarian Ottoman' – of the devastation of the Christian Crusades in the 13th century, stripping and looting every church in sight. 'Civilisation, to me', he said, 'is to respect the religions of others'. (How tactful Mohammed Ali was in his choice of names.)

Suleiman Mosque

We thread our way back to the Dolmabahce Palace, built about 1850 by Baliyan and looking like a huge, ancient White Star liner moored along the Bosphorus. Inside, unabashed exuberance: oxidised silver elephants as high as your hat, old oil paintings of Greco-Turkish wars, a 5-ton chandelier (given by Queen Victoria) dominating the ballroom the size of the Suleiman Mosque. Fireplaces of blood-red Bohemian glass, taps of silver in the marble bathroom, balustrades of cut glass (but the treads and risers ill-proportioned). Surfaces rise and retire, *trompe l'oeil* takes over from the 3-dimensional. It is confident Victorianism with a strong smell of Bavaria and an Oriental flavouring. Irresistible.

Back to the ship for lunch. Go ashore – through fish market, over German-built pontoon bridge and back – then long hour's walk, past a shop called *Eczema* selling switch gear, to top of Galata hill and taxi home. Ship sails at 7 and we watch the lights of Istanbul sparkle across the black water 'till they sink from sight.

After dinner finish up in the cabaret with 'Rosabelle at Midnight': usual songs belted out with usual nudges, occasional audience participation.

116

It is a traditional style as old as Punch and Judy by now, but she bangs it over confidently enough. What did cabaret singers do with their hands before the arrival of microphones?

Wednesday 17th: At sea

Delicious misty morning at 7 am. Poplars and hills on each side, Russian tankers steaming imperturbably in all directions, the Gallipoli memorial whitely vivid on the hill tops. Blissful morning reading on deck. Dark blue, white-flecked sea, a following breeze. The elegant linear geometry of ship-board decks and spaces and shadows.

The ship's library is not the usual collection of publishers' remainders. Turn up two surprises – Lady Malet's reminiscences of court life in 1901, from which I learn not just of the rigours of Balmoral, where teeth could be heard chattering in the drawing room, and a two-hour drive with the Queen in driving sleet was commonplace, but also of Queen Victoria's fascination for the trappings of death (even the demise of a housemaid would involve a royal visit to the coffin, lid unscrewed, by the whole entourage), and also of royal disapproval of taking communion too often. (Two or three times a year in her view was *more* than adequate.) This morning's treat was a life of Lady Ottoline Morrell – seen often in the 'thirties by M in a Gower Street dairy attired as if for a garden party at a sultan's court. Once again, she, to my mind, comes out top of her particular court . . . courageous (to entertain homosexuals openly before 1914 was a brave thing to do and her defence of pacifism no less so), genuinely warm-hearted and generous and almost universally mocked and giggled at by all those she befriended. No doubt she was – in Leonard's Woolf's words – 'silly', but then who at this time could be sillier than many of the intellectually superior (and many of the lazy and incompetent) conscientious objectors she housed and fed on the estate; friends who lacked her loyalty and her wish to help? By lunch-time – served on deck, off Troy – I am hers, a happy voyager in her company, 'hung with silken sails and golden coils'.

At 3, I check the slide projector, as always not what was promised – one carousel takes only cardboard, the other only glass slides. I have both. How endlessly this happens. Excellent brief from Ursula, our German courier, this morning: 'Do not be excited by windmills at Mykonos.

SEPTEMBER

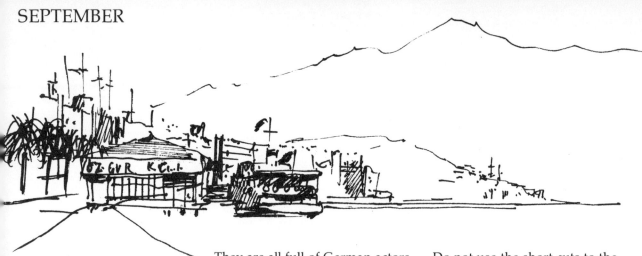

Ferry Station Ismir

They are all full of German actors . . . Do not use the short cuts to the monasteries at Patmos. They are longer than the proper road . . . Do not use the donkeys. They are too slow and badly treated . . . Do not buy expensive icons. They are all fakes'.

Lecture is a muddle: 30 minutes on Greek modern history. My message is that Greek history as taught at school (and on Greek cruises) begins and ends between 800 BC and 100 BC; and that contacts with England are confined to Lord Byron, Mr Gladstone and Sir Winston Churchill, whereas in fact trade existed between Greece and England (known as the Tin Isle) as long ago as 1500 BC; that Anglo-Saxon art was deeply influenced by Byzantine designs; that Richard Coeur de Lion crowned his Queen Berengaria on Cyprus (before putting the island on the market); that in 1841 somebody unearthed in the Bodleian the log of a Greek Captain Nicander's voyage to England around 1545. (He was surprised to find women engaged in barter and commerce, but our government was tolerant, our climate misty, the Irish ate too much butter, and made love in public . . .). To say nothing of Master John Dallam, organ builder, who in 1600 built and took to the Sultan at Constantinople an automatic organ as a diplomatic gift from Queen Elizabeth and came back overland, encountering *en route* through Thrace a dragoman who turned out to be a Mr Finch from Chorley in Lancashire (how did he get there?); and concluding with the British Protectorate of the Ionian islands, the War of Independence, the Balkan Wars, Gallipoli and the disaster of 1940. I follow this scamper through the centuries with a plug for the National Trust. The audience is nicely appreciative but clearly puzzled.

By midnight we are anchored in a necklace of lights . . . Izmir.

Thursday 18th: Izmir, Sardis

Pink haze over milky green water at 7 am. A Swedish coaster unloads huge, dirty-white containers – smaller versions of the city itself, which is boxy and boring below the backcloth of mauve/brown mountains. Ashore at 8.30. It must be 20 years since we first saw Izmir. M and I had bucketed down from Istanbul by local airline (+ 2 queasy children) to advise the British Embassy upon a site for the British Pavilion at the Trade Fair. The site offered was farcical, but luckily the best pavilion in

Villa Ismir

118

the whole place remained unallotted, an airy, glazed hangar with mezzanine floors and generous approaches. We snatched it quickly with the help of the British Consul, Mr Wilkinson, a grey, grave man who had lived all his life in Izmir (indeed had never been to England) and was a member of one of the great English families who had dominated the trade of the Levant for a hundred years or more. He gave us lunch in his high, shuttered dining room and waved us a courteous good-bye at the airport.

We decide on an excursion, winding our way out past raisin depots, cement factories and unweeded boulevards into the country, where half-built blocks of flats – abandoned by whirling costs – dot the suburbs. In the distance, looking as old as time, are the shanty towns, clambering up the skirts of the mountain, with every house (says our guide) built overnight to establish right of possession. She is a sturdy, cheerful girl with a voice (or microphone?) so ear-splitting that M has to construct ear-plugs. We plough on for an hour and a half through vineyards, poppy fields ('medicinal', she says . . .), olive groves, cotton fields. 'Country women – you will note – bend from the waist, not from the knee' . . . 'Marriages are still arranged for reasons of real estate and families still live together in groups of up to 25, with the eldest in charge' . . . 'Average family size in the country, five, in cities, two' . . . 'Schooling is free and compulsory 'till 12 years and there is a desperate shortage of university places' . . . 'Everyone is happy about the coup'. There is a brief rug-plug . . . (those woven by the girls are, she says, 'diaries' of their lives, which can be 'read' by their future husbands . . . ('Yes, dear, that was a dropped stitch'.) The landscape is dramatic: a frame of fierce mountains, a fragment of folded little wooded hills and then wide, far-stretching plains pricked with poplar groves and scarred with dry river beds . . . beige, lilac, coffee.

Sardis when reached is stunning, as lovely as Olympia and Delphi once were, silent except for the sound of breeze in the dry grass and a few children squeaking in a nearby village. There is nobody about among the huge stones and full-height columns but the goats. Nearby is an over-restored Hellenistic synagogue, some mosaic pavements and an impressive 60-foot-high reconstruction of a gymnasium. The bus drive back is hot (I am reminded of Ruskin's 'tourists carted round

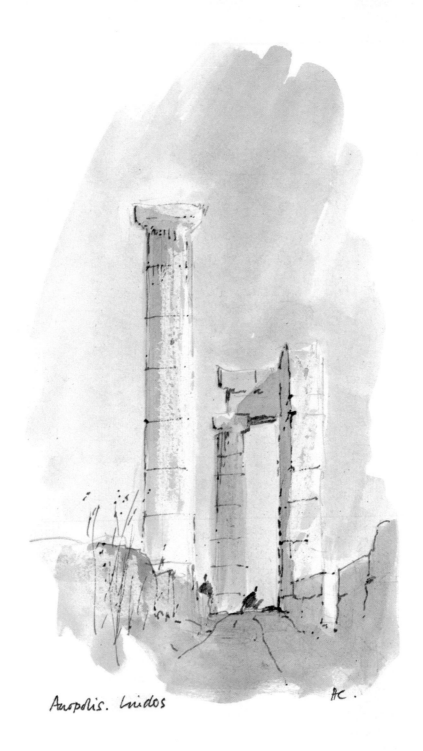

Acropolis. Cnidos
AC.

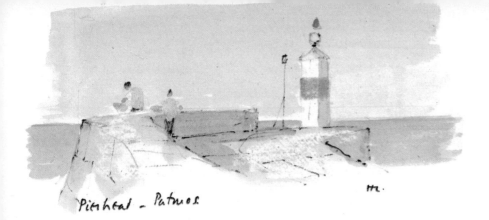

Pierhead - Patmos

Europe like felled timber'.) 'Air conditioning is not permitted by the government', says the guide, 'it makes the buses too heavy for the roads' – we hurtle past two ten-ton trucks as she speaks – 'now the buses are sealed for air conditioning but do not have it'. 'Ah', she adds, 'it is often insupportable'.

We drive back through the town, past the exhibition ground, along the promenade lined with palm trees and fishermen, past the NATO office block and Mr Wilkinson's house – shuttered still against the sun. The port is busy as ever, the breeze strong, but there's nobody sailing (yachts are a sign of prosperity). A Turkish cruise ship has arrived, a Swedish coaster is loading cotton to the encouraging whistles of a little steam locomotive, a Turkish freighter, called (could it be?) *Vagina*, is discharging concrete blocks. *Royal Viking Sky* roars quietly to herself by the quayside.

Fishing Hut. Patmos.

A swim, lunch and a swim again. How lovely is an empty luxury liner. (Nearly everybody has gone on a day trip to Ephesus.) The decks are deserted, nobody's in the pool, in the lounges the curtains stir quietly in the breeze. Somebody's jig-saw lies abandoned . . . a deckhand slowly paints a handrail . . . the little locomotive pants off-stage like a spaniel. It's Edwin Muir again. Notice on top deck reads 'Make sure nobody in this room is on fire'. (At Sandhurst where M and I once worked, the fire instructions were equally succinct: 'In case of fire the following action should be taken . . . Put it out'.)

At 5 pm we go for a short walk along the promenade. There's a stormy Aegean wind – waves slap at the wall and the palm trees rattle their brown petticoats. Mr Wilkinson's house, almost the last survivor, is shuttered tight against the horizontal sun. We sail at 7. Drinks with a Hungarian couple. She is a spectacular blonde in white and gold lamé dress, a singer and 'radio artiste', who spent the war in Shanghai. He is a merchant banker, liver-spotted, lizard-skinned.

Friday 19th: Patmos, Mykonos

7 am: Dawn and Patmos. We anchor outside the encircled harbour below the monastery; boats are lowered. The wind has dropped, the light is clear. The lonely, stony island is as bare as a biscuit, with

Patmos

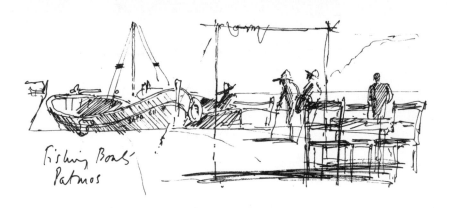

Fishing Boats
Patmos

virtually no classical traces and a reputation for piracy. It is crowned by the famous monastery and its celebrated library, both well worth the climb. However, having 'done' it last time, we lazily decide to saunter instead through the port, drawing and coffeeing. Despite a few *Wandervögel* and bed-bags on the beach, it's still modestly unspoiled. The shops sell fish-hooks and kettles and nappies as well as handmade jewellery; we enjoy our two hours ashore. There is a Swan Tour cruise ship in the harbour and we amuse ourselves by spotting its members in the alleyways. *Murray's Guide*, a crushed panama, and a bunch of wild flowers are the usual signals.

At 12, back to the ship, a swim, lunch on deck. The wind has risen to its usual Aegean agitation and we are almost blown off the top deck. Somebody asks me the name of a passing island. I give a guess, remembering Harold Nicolson's encounter in these waters with Miriam Codd.

At four we reach Mykonos – much enlarged since last seen, and what seen sadly degenerated. But you mustn't miss it, any more than you can miss Venice or Oxford: 'it's like being inside a seashell', said Lawrence Durrell, ageless and styleless, without history. True, the whole place has become a shop – every street, festooned with weaving and jewellery, is loud with strange German exiles, who live by selling bad poems, worse woodcuts and bent pin brooches. But at dusk the magic returns, and how pleasant to drink an ouzo in a bar where the chair legs are almost in the sea.

Saturday 20th: Rhodes, Lindos
During our early morning walk we notice that our official life-boat, as well as being roofed, has a built-in WC. We may be aft of midships but it has its perks, evidently. By 8.30 we are in Rhodes. The coast around looks like Torremolinos . . . only the Mussolini-period grand old Hotel des Roses – arched windows, ochre stone – looks appropriate. We embus for Lindos, our guide quickly establishing himself as a wag. 'Forgive the delay', he says, 'the driver is chairman of the Drivers' Union and his office is in the bus. He is dealing with today's mail' . . . 'It takes 6 men to lift one of those cannon balls; and when they have lifted it, all they can do is put it down again' . . . 'This square we are coming to

Patmos

has seven palm trees set in stone bases and planted with bougain-villea . . . naturally that is also the name of the square, so I tell you now before we get there because if I left it 'till we got there, we'd be past it before I'd finished the name' . . . We smile encouragingly.

Mykonos.

The countryside is rugged, empty and more unkempt than the village streets, which are spotless. We pass a golf club, an abandoned wartime aerodrome – always so poignant those vestigial, weed-growing run-ways – a monastery on a hill, a broken-down bridge, a half-built hotel. 'This was started first after the war and it will be soon finished; note the feverish activity' . . . (the place is deserted, grass grows on the main staircase). Although well reforested by the Italians, rural Rhodes is desperately underpopulated, it seems (only 60,000 people), and nobody bothers to harvest the olives any more . . . 'They are all making and selling things you do not want to give to people who do not want them either'. The landscape is restless, heavily treed with olives and figs, criss-crossed with dried-up river beds. Everywhere the aban-doned reinforced concrete frames of buildings yet to be . . . Money run out? Awaiting sub-contractors? Or are all builders hotel waiters in the summer?

At Lindos – beautiful within its mediaeval walls – we are divided into three parties: the mountaineers, the donkeys and those who stay to cheer. Most of us gallantly try climbing . . . about half an hour up a slippery stone paved track. Matchless view (beautifully restored by the Fascists), a cruise liner moored like a toy in the bay, with a string tied fore and aft to the rocks. The crowds are too thick for comfort and the streets of Lindos like the aisles of Harrods, but as most of it is white or ivory the effect is magically beautiful.

Lunch on board after a quick swim. The harbour is frantically busy, like Southampton or Liverpool in the old days: three cruise ships in and out, two ferries, a mail boat, a handful of coasters unloading concrete pipes, beer and Japanese half trucks. It's a joy to see again a working harbour. We decide to go ashore to walk round the town – usually derided by sophisticates as an over-scrubbed, over-restored 1920s Fascist fake. (The island was in Italian hands for nearly 40 years.) But in fact it's all been excellently and sensitively done: pebbled patterned

123

Street Photographer

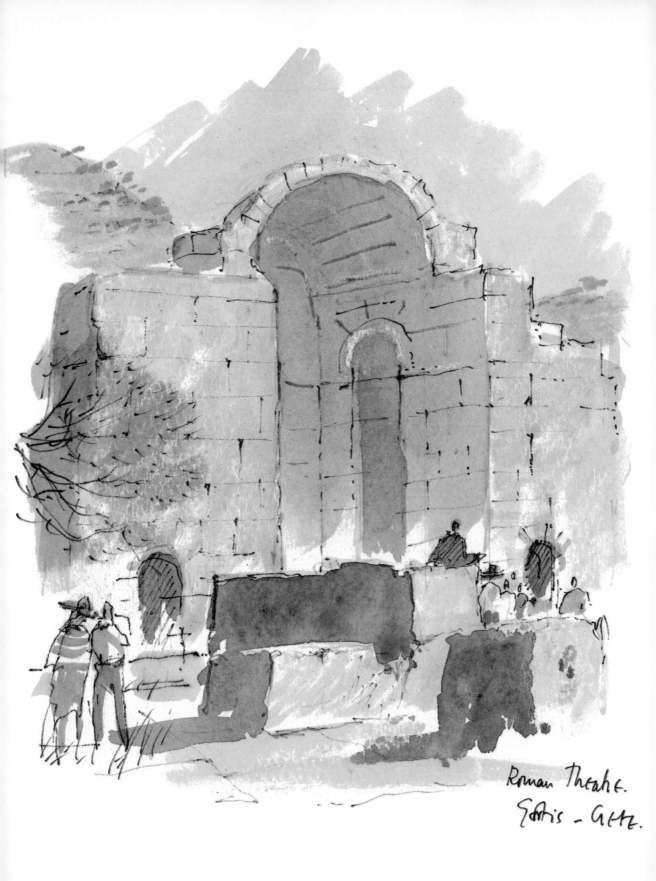

Roman Theatre.
Eatris - GETZ.

Zephos. Crete.

floors, rope-moulded architraves, stonework as warm and blistered to the touch as the hull of a beached fishing boat, arched and buttressed alleyways, planted courtyards and shaded cafés. We stroll happily around for two hours or more. I find M's birthday present, for which I have been looking the whole trip. What a success . . . and on almost the last day. It is a tiny Victorian postal envelope – hardly a half inch long – strung on a chain. Beneath its miniature hinged flap (marked Exprès) are two little scarlet hearts. I am as delighted as the shopkeeper who, a plate of tomato salad in his hand, comes out of his garden to sell it to me. Back to the ship for another swim and the captain's farewell dinner. The sea has got up and the ship rolls steadily, making corridor passage a weaving process.

Sunday 21st: Herakleion, Phaestos

With the help of tug *Evangelista II* (tiny yellow funnel and a captain with a wrist watch flashing for 100 yeards across the water) we dock at Herakleion at 7 am. Taxis, grey and smart, gather like starlings on the dockside. It's Sunday. 'Love lives on propinquity', wrote Thomas Hardy, 'dies on contact'. Ditto Herakleion – from the sea, all you notice is the slap and tickle of water and rigging in the fishing harbour, and beyond that an agreeably composed pile up of dust-coloured boxes (sadly no domes, castellos or minarets), scribbled over with wirescape and tele aerials. But once inside the splendidly restored Venetian walls it's a nondescript and ill-kempt place, composed of travel agencies, toy shops, old tyre dumps and half-built buildings, with only the little church of S Titus (carved, it seems, out of solid crusty Camembert) and the Venetian fortifications worth a glance. After a hour's wander, we return to the ship to bathe and toast 'till the Knossos party return.

After lunch we embus for Phaestos . . . through the river suburbs, paper-strewn and dusty, past the Sunday-shuttered British Leyland Agency (in the forecourt of which stands a brand new Toyota truck). We hustle through a village and I catch a glimpse of a girl – 18 perhaps? – brooding, chin on hand, at an upper window behind some flower pots, wishing, no doubt, to be another person in another place. We pass a man telephoning excitedly from an ice-cream tricycle (*there's* prestige for you), then swing out into the countryside and the green valleys, brown mountains, white villages. From the top of the pass the

Tourists – Phaestos.

valley below is spectacularly flat and wide, and as green as summer. At Phaestos it's baking-hot and the bus-load – after two weeks – is less docile in the presence of ruins. But the guide is clear and firm, the site impressive. Though Italian-excavated, the archaeologists (nervous of previous criticism perhaps) have sadly attempted no Rhodes-like reconstruction – always such a pity since you get no idea of vertical scale. We wind down again to Roman Gotis, a sort of ancient Glyndebourne, a small private theatre in a grove of trees, quiet and bee-haunted.

Back on board we pack, pay bill, return library books and have a quiet whiskey with J-J – the blonde 45-year-old Australian who is a maid of all work on the cruise, teaching Greek dancing or trap-shooting, dancing with lonely ladies, making himself agreeable. He has done this now, on various ships, for 20 years, is rich enough to retire and is only here in response to a cry of help from the line. He has been everywhere, done most things, lives (when at home) in the shanty-town of Acapulco, owns a fleet of fishing boats and could, if he wished, never work again. After dinner the entertainers give a brief enthusiastic show in which Raymon, our table steward, takes part. We say goodbye in all directions.

Monday 22nd: Piraeus, Athens

At six we are off Piraeus; at 7 docked. At 8 all luggage ashore. The 'entertainers', headed by J-J, form a farewell guard of honour, tanned faces, gleaming smiles, white shirts and slacks. In eight hours' time they will be there while a new stream goes the other way. We taxi to Grande Bretagne Hotel, and sit in the cool square writing letters 'till lunch time. Behind us the old dolls' house palace by Van Gastner and its cargo of Empire furniture is empty ('It's only since God and Royalty ceased to exist', Robert Byron once said to me, 'that they have been genuinely revered'.) This 'city of dust and politicians' – clamorous, shrouded in smog, derided by the cultured – is still a place of individuals and spirit. Where else in the 'thirties (Robert Byron again) could a leader exiled by the Italians from the Dodecanese dive into the sea and claim – and be believed – that the bottom of the sea was covered with broken glass placed there by the Italian Legation?

I lived in Athens for a time as a student on a travel scholarship at the British School, studying Byzantine brickwork. I quickly learned that the best approach to the Acropolis is from the old streets of the Plaka; that the Agora was (and remains) visually a disaster; that Lycabettus, which we used to climb nearly every evening, was every evening equally worth the climb (no funicular then); that, whatever schoolmasters say, the architectural glories of Greece consist of more than broken colonnades and fallen sculptures (though you'll still be hard put to persuade the guide books and tourist industry of this); and that, as well as the beautiful little Kapnikaria and the miniature cathedral, S Nicodemus, even the stuccoed villas of Patissia (in what Osbert Lancaster likes to call the Othonian style) were worth drawing. How unsympathetic I was with my fellow students as they patiently sorted shards in dusty cardboard boxes . . . How could they seriously enthuse over these absurd fragments with the whole of Greece outside the library door?

Dick and Joyce S arrive from Aegina and we meet in the foyer of the GB Hotel – today in some ferment as Mrs Thatcher is expected. The usual red rose for Joyce from the head waiter is only just available in the mild panic. We reach the airport at 3, sadly this time not in the charge of Christos, our old taxi driver friend with his passion for East Anglia . . . 'Ah, King's Lynn', he sighs as he roars down the Piraeus road. He is married and in America. We take off on time and brood over the last two very enjoyable weeks. Cruises have their critics but I am not amongst them. I know that Dr Johnson – thinking perhaps of the confined space, the restricted company, the daily routine and the uniformed staff – said that to be at sea was to be in prison . . . Yet how lovely to see so many places and always return at night to the same bed, to be surrounded always only by the sea and the white-painted architecture of a ship.

Tuesday 23rd: London
All day at RA catching up with correspondence. Membership sub-committee breaks up, once again, in disarray, blocked minds on both sides. It's like the Korean Armistice Committee, locked in misunderstandings. At 6 pm launch son-in-law Ian's *Book of London* at the Design Centre and at 7 am attend an *Observer* party at BH. An exhausting two

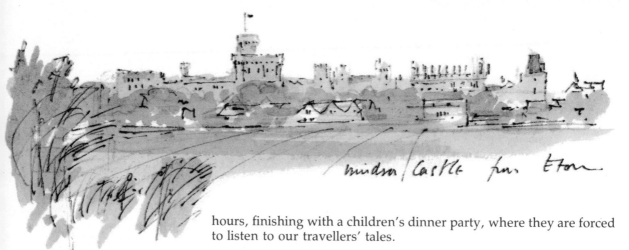

Windsor Castle from Eton.

hours, finishing with a children's dinner party, where they are forced to listen to our travellers' tales.

Wednesday 24th
To doctor for cholera and TAB jabs for my trip to India in October. By lunch it's hurting, by 3 pm I have a temperature and my meeting on the *Royal Performance* exhibition with Libby collapses (as I do).

Thursday 25th
10.30 BR meeting on the new Victoria Station project: the proposed Channel Tunnel terminal, cross-London rail-link and Gatwick problems (estimated traffic is to be double). An ingenious plan and design well-explained, though architecture a bit banal. On to the Zoo to discuss new Whipsnade logo and to meeting at RA with Sam Wanamaker, exuberant as ever on his Globe Theatre project.

Friday 26th
M's birthday. All morning at RA. Lunch with Treasurer, Roger de Grey. Afternoon at Thurloe Place on Sutton Place. Family supper party with no committees. A really nice day.

Saturday 27th
Morning chores. Down to Barnes to look at St Mary's Church and am intercepted by protesters who hold me captive for an hour. A difficult case: keen churchgoing parishioners in favour of a re-building solution by a good architect, but more numerous non-churchgoing parishioners bitterly opposed. Rector resigning on the grounds of ill-health. I prevaricate. Teatime barbecue with grandchildren, Punch and Judy and a new dressing-up game invented by daughter Nicola. Domestic evening.

Sunday 28th: Windsor
To Windsor to go through *Royal Performance* stuff with Libby. Then to Nigel J's house at Eton for an hour to write up diary. Meet M and Dinah and Laurence West, Director of Windsor Festival and go over to the Chapel for concert by choir of King's College, Cambridge. Byrd, Stanford, Britten. Extraordinarily successful lighting. Philip Ledger and his tots climb into bus for their voyage back to Cambridge.

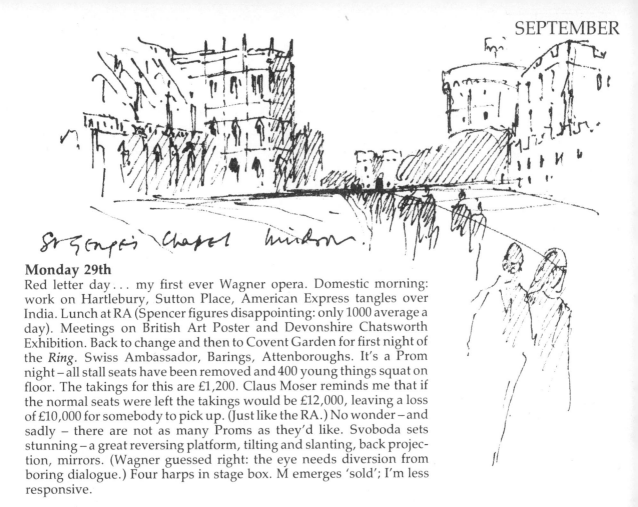

St George's Chapel Windsor.

Monday 29th

Red letter day... my first ever Wagner opera. Domestic morning: work on Hartlebury, Sutton Place, American Express tangles over India. Lunch at RA (Spencer figures disappointing: only 1000 average a day). Meetings on British Art Poster and Devonshire Chatsworth Exhibition. Back to change and then to Covent Garden for first night of the *Ring*. Swiss Ambassador, Barings, Attenboroughs. It's a Prom night – all stall seats have been removed and 400 young things squat on floor. The takings for this are £1,200. Claus Moser reminds me that if the normal seats were left the takings would be £12,000, leaving a loss of £10,000 for somebody to pick up. (Just like the RA.) No wonder – and sadly – there are not as many Proms as they'd like. Svoboda sets stunning – a great reversing platform, tilting and slanting, back projection, mirrors. (Wagner guessed right: the eye needs diversion from boring dialogue.) Four harps in stage box. M emerges 'sold'; I'm less responsive.

Tuesday 30th: Windsor

Delicious fresh autumn morning. All day at Windsor at St George's Chapel Advisory Committee. Meeting with three engineers, two architects, three canons (plus me) on condition of vaulting. This has been something of a worry for fifty years; as the DoE engineer observes, 'corrections' and 'strengthenings' devised from time to time often seem to produce new strains and tensions, which are still harder to deal with. We are shown graphs to enlarged scale of cracks of apparently alarming dimensions, but in fact they are less than a hair's breadth in size. The DoE expert, who deals with much nastier things – eg Big Ben out of plumb – advises us to keep an eye on movement, but to do nothing to disturb anything. We happily agree. Continue meeting on lighting, altar size, treatment of Oliver King Chantry. Back to change for Mansion House dinner party. Enjoyable and unpompous. (Teenage daughters, jean'd and bed-roll'd, arrive with coffee from Greek island holiday and are, quite rightly but unexpectedly, brought into the party.)

St George's Chapel West Front

Natural History Museum

Wednesday 1st: London

Building committee at Natural History Museum, followed by lunch at Serpentine Gallery in honour of Henry Moore's presentation of *The Arch* to Hyde Park. He is in cracking form – due, I suggest, to the fact that he's stayed at home all summer. 'Quite right', he says, 'never want to go abroad again'. Art establishment in full force. Mrs Kenneth Robinson suggests a ballet on Stanley Spencer. What a good idea (I write later to K Macmillan about it).

Go on to Arts Council for Lutyens Exhbition Meeting. This drags on for three hours – chairman too soft-hearted, some members too volubly enthusiastic, too much to put in but nobody can face throwing anything out. Architect Piers Gough produces an excellent plan but there's no room for the great Liverpool Cathedral model. Consternation. Possible compromise to place it in National Theatre foyer (which Lutyens would have hated).

Home to change for Covent Garden. A gala night, so all normal parking places policed off and only just reach seat in time. 'Cabaret' programme – the performances variable in quality, the setting (red velvet, palm trees, property chandeliers, black floor) quite dreadful. Auction starts after interval. I don't mind giving to charity auctions but I hate attending them: the moral blackmail of the buyers, the temptation to exhibitionism, the joky TV compering. The first half is selling claret – so boring we decide to slip out. Princess Margaret and Prince Charles politely stay.

Thursday 2nd: Southampton, Hartlebury

To Southampton. Lovely warm day; Hampshire looks ravishing. Lunch at university with fellow committee members. Slight spurt of argument with young ex-ICA gallery director. 'As you are running the equivalent of a repertory theatre', I ask, 'will you risk occasionally *Rookery Nook* in between the visual equivalents of *Antigone*, *The Doll's House* and Brecht?' He stalls a bit, anxious, quite naturally, to build up a gallery noted for advanced patronage, and nervous perhaps of Arts Council raised eyebrows if he puts on, say, an exhibition of Valentines or a 19th-century naval architect's working drawings from the local shipyards. I leave the thought to simmer – not to say fester.

130

The Arch' Kensington Gdns –

Broadway Hill.

Catch the 6 pm train to Birmingham – in theory an agreeable railway saunter across the lower Midlands, but, like all cross-country trains, tending to expire at each station. At Banbury we are half an hour late, and since previous passengers have removed all the light bulbs in my compartment, it's too dark to read. Dusk in a train – or on a ship – is always melancholy. Lavatories are spotless, water hot, over the WC a notice 'Please do not use while standing at a station', to which some-one has added the words 'except at Woking'. Libby, patiently waiting at New Street, drives me to Hartlebury. After supper we make a quick tour of *Royal Performance.* It's finished and looks splendid.

Friday 3rd
Press arrives 10 am. Do three tele interviews, pose for endless photo-graphs and answer questions 'till lunchtime. Libby, who has put it all together, self-effacing. After lunch, Woods, children, grandchildren, three dogs and cat disperse; we drive over to RAF site and then to little, lovely church, prettily decked out for a wedding. At 6 pm reception. Speeches, presentations 'till 9. I meet the legendary Nysfer Jones from Portmadoc. (A family tradition was that they were keen otter-hunters and when they broke their legs they laid up in the hills 'till the bones mended. They admit to the partial truth of some of this.) Meet also one or two greying architects to whom, as students, I once handed dip-lomas. 'Excuse me', asks one, 'weren't you Hugh Casson?'

Saturday 4th: Broadway, London
Another lovely day. Exhibition opens to gratifying local publicity. Let's hope for a success. We drive off at 12, picnic above Broadway and I'm dropped off at Slough for train home.

Sunday 5th
Office all afternoon on orangery drawing for Sutton Place. Still can't get it quite right.

Monday 6th: Coniston
Office at Thurloe Place broken into this morning. Doors kicked in and £70 stolen, putting one in no mood for liberal thoughts about thieves. To BP House for opening of Arthur Koestler Award Exhibition. Lord Mayor of Westminster, amiable and interested, Lord Belstead (Home

Dorset - Hartlebury –

On location. Coniston.

Office), tall, gangling, sensitive; massive 'Tiny' Milne (our BP host); and Huw Wheldon the opener. Three quick, light-hearted speeches, a couple of good jokes and it's all over except for lunch. Arthur K himself creeps about modestly like a tortoise among the frigates made of matchsticks, the strange staring portraits, the flat wooded landscapes.

Meeting with Surveyor on BH Council Room floor (discovered to be fragile) and with Secretary on trustee membership. Then to Euston for the 4.45 train to Lancaster. Cold grey evening. Low spirits. Henry Moore was right, stay at home more. At Lancaster I am met by Austin Princess, plus careful grey-haired driver. Lashing rain, flood notices, oil-skinned road workers cleaning drains in the headlights. We reach the hotel, a strange gabled and turreted Victorian villa built of blue-black slate with an Arabic inscription over the door. (Why?) In the sluicing rain it looks indescribably sinister, but inside it's warmly panelled, like an interior from Vera Brittain's film *Testament of Youth*. The BBC crew are finishing supper. I join them and then flop into bed.

Tuesday 7th

Wakened by buzz of teamaker. Such a complicated mechanism I switch it off hopelessly. Fine day: cloud shadows, racing clouds, bursts of hail. Drive to Ruskin Museum with Anne J for all-day filming and recording. Goes reasonably well and the museum is so fascinating I don't mind hanging about. Too rough for the lake, maybe tomorrow. We lunch in a caff (ratatouille and French bread – how village catering has changed). I sit on over a coffee to make notes and am recognised and drawn by the local doctor, who introduces himself as a fanatical RA Friend. A warming experience. Return to the museum for more filming. I try to insert odd information: that Ruskin liked little girls, dogs, babies, chopping wood, mountains, water and boats, and disliked smoking, railways, capitalism, the colour black, all games, Rome, Florence, Houses of Parliament ('foolscap in freestone', he called it); that he was selfish and difficult but full of insight and sensitivity.

At 5 pm the camera/light crew pack up, leaving us alone for some quiet recording. Alas, the wind is howling in the ventilators and after three attempts we give up and go home. Supper and more reading about Ruskin. There are more than 40 biographies available and I've got six

Boathouse

The Pier
Coniston.

with me. After dinner we pass through the empty lounge, where the television squeaks and mutters to itself like an idiot child. It's on the ITV channel and as we pass it Anne J switches it over to BBC 2 – 'I always do this in hotels', she says.

Wednesday 8th

Unpromising day. Waving scarves of low cloud and rain, distant flashes of light. Anne J and crew leave at 9 am and fetch me later. Weather gets worse: driving rain, NE wind. We spend morning in the museum, interrupted by impatient tourists and moaning ventilators. Our boat trip on the lake is cancelled. All afternoon in Brantwood, Ruskin's rambling old house above the lake. First the bedrooms over the study. In Ruskin's day, the bedroom was hung with Turner water-colours – each with its own little protective curtain, so that the room looked as if it possessed a score of tiny windows. The clouds lift a little at 5 as we finish and pale blue sky is perceptible before the clouds descend in Ruskinian mist. The mountains are streaked with white cascades. White caps on the lake (Ruskin would like that... he enjoyed rowing against the wind for a bit and then, when he'd had enough, beaching his self-designed boat, *Jumping Jenny*, and leaving it to the servants to bring back. He was always honest enough to admit he liked doing good only within the limits of his own convenience. 'When you find it's too much to do', he would say, 'don't do it'.)

Thursday 9th

Better sky... clouds racing, sun-shadows on mountains. When filming you get obsessed with the weather – at least amateurs like myself do; the pros take it easier. We nip off early for quick take in study, then on to the pier for boat ride on *Gondola*, 120-year-old, steam-driven pleasure boat, built in three pieces in Liverpool and reassembled here. After many years of service on the lake and then as a houseboat, she was wrecked ashore in 1963. The National Trust have restored her beautifully – red velvet benches, gilded colonettes, quilted ceiling.

Weather: hail and sun, long shadows, white caps. *Gondola* is quiet as a whisper. Pub lunch, then another long session at Brantwood, down on the shore at sunset, freezing. Bed at 10 pm. The cameraman – it's his first film on his own – has a very efficient assistant, who spends her

133

'Gondola'

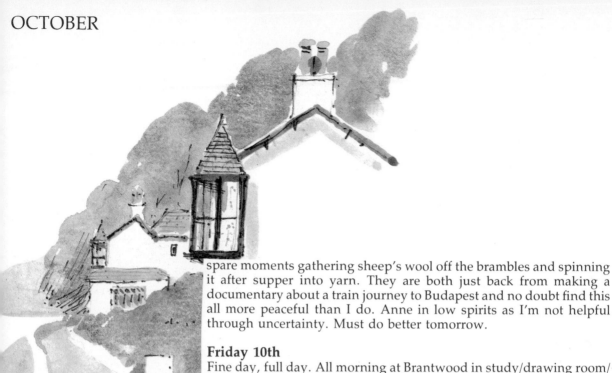

Brantwood - Coniston

spare moments gathering sheep's wool off the brambles and spinning it after supper into yarn. They are both just back from making a documentary about a train journey to Budapest and no doubt find this all more peaceful than I do. Anne in low spirits as I'm not helpful through uncertainty. Must do better tomorrow.

Friday 10th

Fine day, full day. All morning at Brantwood in study/drawing room/ dining room. Pictures, readings, learned observations. Sun and cloud on lake outside. After lunch we have a go at Ruskin's coach (with its special upholstery, its travelling bath, in which he used to pack his books, its Ruskinian details – dust-tight drawers and flaps for papers and watercolours) and at *Jumping Jenny.* We carry on late, as the electricians must leave tonight. We go up in the woods to his 'seat' – an ice-cold, mossy throne of slate – 'till the light fades and the lake goes lead-coloured and glassy. Not much left to do now, though how Anne J will get it into a coherent movie goodness knows. In bath when M arrives for dinner.

I've enjoyed this despite dismal weather and very uncoordinated thoughts. By ordinary standards Ruskin's life was a failure. A hideous, lonely and oppressed childhood . . . a marriage as disastrous as his love affairs . . . a body of art criticism which, however influential at the time, was by his death irrelevant . . . a programme of social reforms which was almost totally ignored or derided. Yet you could regard it also as a triumph. He was the first person to make art criticism an art form, to create, when writing of one masterpiece, another. He acquired a skill and sensitivity in drawing (once he had discarded imitations) as outstanding as his magnificent prose style, which was the envy of such masters as Proust; and his social reforms – smokeless zones, green belts, town planning, free education – have long been absorbed into the welfare state. Most important of all, this lesson, that to *see* is to *understand*, and that if art is not part of life, it is nothing. How sad his name was never mentioned at school and we were actually discouraged from reading him at university.

Saturday 11th

All morning pottering around Brantwood and down by the lake tying

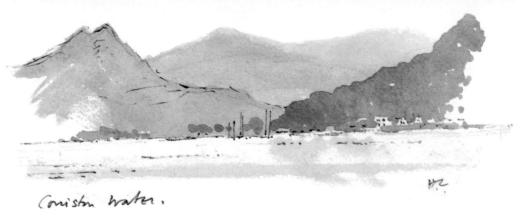

Coniston water.

up ends. Freezing north wind. Rattling oak leaves make me inaudible, so we are driven indoors for a couple of interior takes. Lunch at hotel with Paul and Elizabeth C from Gloucestershire. Rush them all off for trip in *Gondola* and return to museum and village for rest of afternoon. M and the others don't get back 'till 7 after a long drive over the mountains.

Sunday 12th: To London

Cloudless blue sky, mist in valley. We are released, though crew is to stay on a few more days. Decide to do a morning sight-seeing over Wrynose Pass. Near the top meet the doctor from Coniston and his wife, both over 70. She's really had it, she says, but loyally refuses a lift and takes a glucose sweet instead. We drive on guiltily, bound for Lancaster and Euston. Weather and scenery matchless: farms, sheep, cloud-shadows, stone walls, cascades.

Monday 13th

Fiddle about all day. Stanley Spencer attendence figures up 50%, which is encouraging. Thurloe Place broken into again, which is not. Mansion House Banquet to celebrate 50th birthday of the Society of Industrial Artists and Designers. Sit between Duke of Gloucester and Lady Mayoress, both lively and cheerful. Speak first; Lord Mayor next; Milner Gray[1] last. None of us apparently very audible. My theme – pinched from Jonathan Miller – is that institutions, codes of practice, grammars and rituals nourish clarity rather than obscure it, and that incoherence doesn't necessarily imply sincerity. (Perhaps that particular student faith – so strong in the 'sixties – is at last on the decline?) Many familiar faces, ex-students, old colleagues fingering their design campaign medals. Escape by 11 pm.

Tuesday 14th

Bedford College to meet (I had thought) the Building Committee. Find instead democracy at work: a lecture theatre, blackboard, open invitation to staff and students (about 50 people). Plunge straight in – all the better perhaps for being unrehearsed. Good questions, nice audience.

Lunch at RA in honour of Stanley Spencer's friends and relatives. Sit between two charming, slightly fey daughters – one a musician and

Coniston.

OCTOBER

Bedford College

Isambard Brunel.

ex-missionary, the other an artist with a 17-year-old son training with Peter Jones. 'Sometimes', she says, 'I think I'd like to be married'. RA Trust meeting, then Museum of Year meeting, both brief and constructive. Dinner with Jo P, full of traveller's tales from her holiday in Corfu.

Wednesday 15th

Chantrey Trustee meeting – Lord Pearce, Lord Ashburton, Antony Hornby – followed by lunch, at which we are joined by Alan Bowness[2]. A delightful and optimistic meeting. With luck the old RA/Tate quarrel is dead and buried. High time too. Both sides have behaved like babies.

BR dinner in Brunel Room at Paddington. Host Peter Parker. Guests Margaret Weston[3], Brian Organ[4], Diana Reader Harris[5], Bill Barlow[6], James Cousins[7] and David McKenna. Subject: 'Design Management'. Talk too much and sleep badly afterwards as a result.

Thursday 16th

Press Conference on our January Modern Art exhibition, subtitled – grudgingly as far as I'm concerned – A New Spirit in Painting (sounds to me more like a thesis than an exhibition). Encouragingly large press turnout. After lunch, Norman St John Stevas' opening of the Guggenheim's show, British Art Now (another rotten title). He does this with his usual wit and grace. I am facetious and very nearly impertinent but all goes well – and anyway it's up and off and away.

Friday 17th: To Fort Aguada, Goa

Today we leave for India and Pakistan and the Aga Khan prize ceremony and seminars, topping and tailing these with a few days' holiday.

Saddened by the early morning news of the death of Colin Anderson who – with Gordon Russell, who had died a few weeks earlier – did more than anyone in pre-war days to nourish and promote good design, in particular through his sparklingly adventurous patronage as chairman of the Orient Line. His ships, the *Orion* and the *Orcades*, were pioneers in an otherwise design disaster area. Even the big Queens stuck pretty firmly to the old floating hotel concept. (My friend Michael P, working on the ship's chapel for the *Queen Elizabeth*, alleged that he

136

managed to insert a 'leper's squint'.) Through Colin's persistence and enterprise virtually every designer of any note was employed (under the direction of architect Brian O'Rorke) in the design of carpets and textiles and crockery and light fittings and furniture and menu cards. The ships were not perhaps so elegant outside ('they aren't ugly', Colin used to say, 'they just *look* ugly'), but inside they were cool, stylish, comfortable and delightful to ride in. I remember the press 'voyage' from Tilbury to Southampton of the *Orion*, where I represented the weekly magazine *Night and Day*. (This was edited by Graham Greene, included on its staff, Peter Fleming, Anthony Powell and Elizabeth Bowen and was eventually killed by a libel action brought by Shirley Temple.) 'Did they like my carpets', asked Humphrey Spender on my return. 'They were walking about on them, if that's what you mean', replied Edward Bawden. The design of ship interiors has fascinated me ever since, and working on the royal apartments of HMY *Britannia* and the public rooms of the P&O flagship *Canberra* – both still in active service – was among the most interesting experiences of my professional life.

Heathrow

Sitting after lunch in the departure lounge at Heathrow the dreadful message crackles over the loud-speaker 'Fuel pipe fault . . . we hope to move you to more comfortable surroundings while you wait . . .'. Could he possibly mean *home*? Flat, resigned faces stare ahead, but in ten minutes all is well. We take off (having missed our slot) an hour late into sopping clouds. Doze and mutter 'till dawn. We are making our approach to Bombay when fog suddenly descends and we rise again, *en route*, says the Captain, to Madras. Here – an hour later and quite unexpectedly – we are greeted on the apron by a solitary grey pi-dog, who sits undisturbed by our arrival. Curious bystanders stroll up, an official fusspot in sandals and dark glasses struts about with a clipboard. We sit on as if hi-jacked. The cabin is boiling hot (an air-pressure pump has failed) and the dog has long ago collapsed in sleep. After two hours we take off to a resounding bang. (A bird has flown into an engine intake.) 'This', says the Captain, 'is one of those flights . . . but we *hope* to reach Bombay'. And we do: temperature 83 degrees, humidity like a wet dishcloth flung in our faces. The airport, recently damaged by fire, is a nightmare of bursting suitcases and gesticulating officials. But we successfully meet our colleagues – Dean

Pi-dog. Madras

137

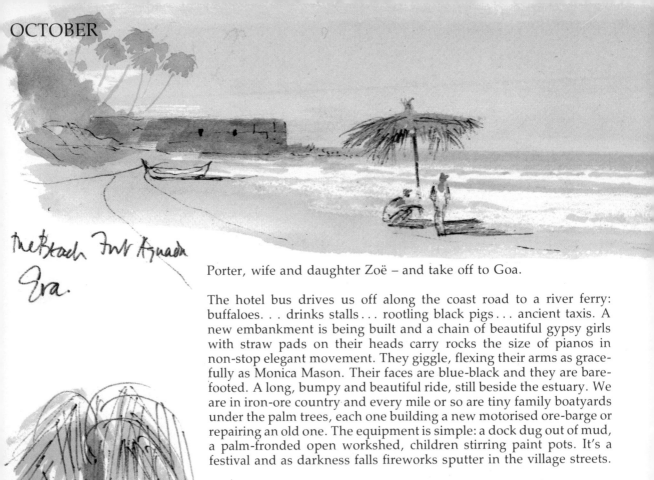

The Beach Fort Aguada
Eva.

Porter, wife and daughter Zoë – and take off to Goa.

The hotel bus drives us off along the coast road to a river ferry: buffaloes. . . drinks stalls . . . rootling black pigs . . . ancient taxis. A new embankment is being built and a chain of beautiful gypsy girls with straw pads on their heads carry rocks the size of pianos in non-stop elegant movement. They giggle, flexing their arms as grace-fully as Monica Mason. Their faces are blue-black and they are bare-footed. A long, bumpy and beautiful ride, still beside the estuary. We are in iron-ore country and every mile or so are tiny family boatyards under the palm trees, each one building a new motorised ore-barge or repairing an old one. The equipment is simple: a dock dug out of mud, a palm-fronded open workshed, children stirring paint pots. It's a festival and as darkness falls fireworks sputter in the village streets.

Three hours later we are in Fort Aguada, and after our journey it almost seems like heaven . . . a mile-long silver beach fringed with palm trees, a full moon on an inky sea, a luxury hotel built in an old Portuguese stone fort, deferential staff, scented gardens, a bedroom with the Indian Ocean surf thundering almost beneath the window. We go to sleep to its regular music.

Saturday 18th

We try an early morning swim but the surf is too powerful for ancient bones and we retire cravenly to the hotel pool before leaving with the Porters for a day's sightseeing. At first we stop the car every mile . . . a ruined baroque church in a forest clearing with valerian sprouting from its cornices . . . a tiny boatyard where two men are caulking a deep-draught fishing boat with tow . . . a village market alive with flies and pink and green umbrellas . . . the old Portuguese port (and capital) Panjim, beloved of Captain Marryat. Vasco da Gama arrived in 1524 and descendants of those who followed after him still live here. The port is quiet now: the great Japanese ore-carriers anchor are out at sea and loaded by lighters, and the yellow stuccoed offices and ware-houses, corniced and pillared, doze behind sun-blistered shutters along the quayside.

Three miles or so inland across a causeway is Old Goa, the first

138

Boatyard.

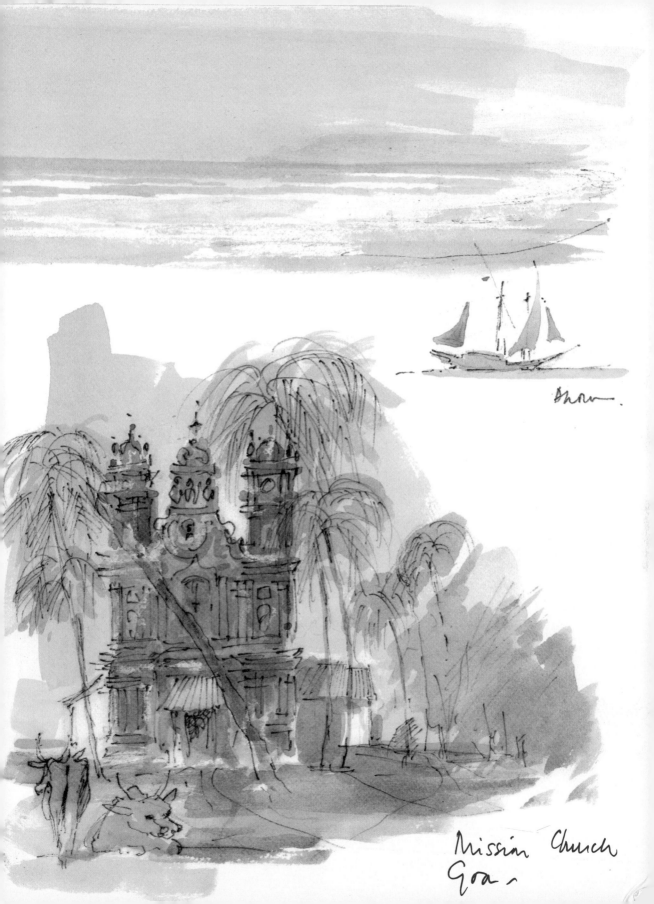

Mission Church
Goa.

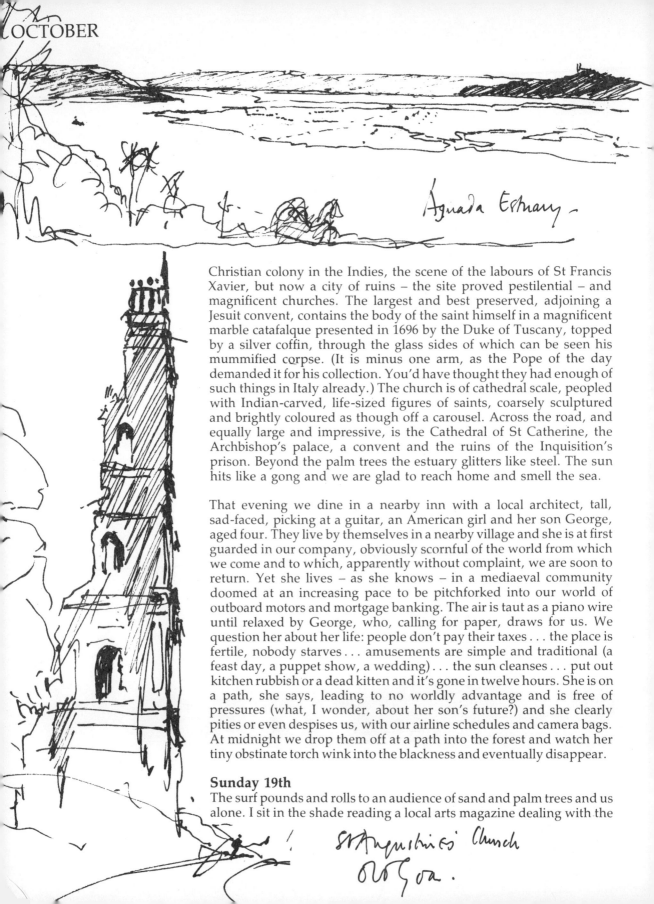

Aguada Estuary.

Christian colony in the Indies, the scene of the labours of St Francis Xavier, but now a city of ruins – the site proved pestilential – and magnificent churches. The largest and best preserved, adjoining a Jesuit convent, contains the body of the saint himself in a magnificent marble catafalque presented in 1696 by the Duke of Tuscany, topped by a silver coffin, through the glass sides of which can be seen his mummified corpse. (It is minus one arm, as the Pope of the day demanded it for his collection. You'd have thought they had enough of such things in Italy already.) The church is of cathedral scale, peopled with Indian-carved, life-sized figures of saints, coarsely sculptured and brightly coloured as though off a carousel. Across the road, and equally large and impressive, is the Cathedral of St Catherine, the Archbishop's palace, a convent and the ruins of the Inquisition's prison. Beyond the palm trees the estuary glitters like steel. The sun hits like a gong and we are glad to reach home and smell the sea.

That evening we dine in a nearby inn with a local architect, tall, sad-faced, picking at a guitar, an American girl and her son George, aged four. They live by themselves in a nearby village and she is at first guarded in our company, obviously scornful of the world from which we come and to which, apparently without complaint, we are soon to return. Yet she lives – as she knows – in a mediaeval community doomed at an increasing pace to be pitchforked into our world of outboard motors and mortgage banking. The air is taut as a piano wire until relaxed by George, who, calling for paper, draws for us. We question her about her life: people don't pay their taxes . . . the place is fertile, nobody starves . . . amusements are simple and traditional (a feast day, a puppet show, a wedding) . . . the sun cleanses . . . put out kitchen rubbish or a dead kitten and it's gone in twelve hours. She is on a path, she says, leading to no worldly advantage and is free of pressures (what, I wonder, about her son's future?) and she clearly pities or even despises us, with our airline schedules and camera bags. At midnight we drop them off at a path into the forest and watch her tiny obstinate torch wink into the blackness and eventually disappear.

Sunday 19th
The surf pounds and rolls to an audience of sand and palm trees and us alone. I sit in the shade reading a local arts magazine dealing with the

St Augustine's Church Old Goa.

Ferry Boats

cultural influences upon India of foreign colonisers . . . Persians, Portuguese, French, finally the British ('the worst cultural disaster', says the author, 'in India's history . . . philistine, dour, methodical and contemptuous of the delights of indolence . . . How much more splendid if New Delhi had been built by French architects . . .'). Comparing Lutyens' masterpiece with its French contemporary, the League of Nations Building in Geneva, I know which I'd choose. As the son of a dedicated and hardworking Indian Civil Servant I work myself into an even more defensive mood. How gracefully and modestly at home, surely, are the stucco'd barracks, churches and bungalows of 19th-century army engineers; how discreetly Colonel Jacob paved and gas-lit the wide streets of Jaipur, and even the fretted extravagances of Bombay Railway Station and Simla have a dotty fascination. Nevertheless the author is right to praise the Portuguese, for their architectural legacy is remarkable – elegant, formal and sympathetic.

Portuguese Fort Aguada.

Brooding on these issues under the rattling palm fronds, I am approached by a smart, young, white-clad figure, who trudges from a distance across the sands like a survivor from some disastrous desert expedition. He is carrying two bottles. He suggests I need a massage. 'Ah', he says, 'you very, very old man . . . very tired . . . very much work' . . . he pinches my leg and my upper arm . . . 'very, very old', he says, shaking his head. I am nettled by this and, refusing his attentions, walk off into the surf squaring my shoulders. But he has the last laugh as a comber knocks me off my feet. I remember a previous encounter with an itinerant masseur at Agra. When I refused his ministrations, he offered, in sequence, his daughter or a copy of *The Reader's Digest*.

The Porters leave at 12.30. Zoë is cross at leaving beaches for cities and eats chocolate rather grumpily. We picnic-lunch by the pool, decide against expeditions, snooze, wash hair, pick up shells and enjoy ourselves – including a long and hot cliff walk to the south above the old battlements. Nobody about but an occasional fisherman on the rocks . . . booming surf . . . wild orchids . . . soaring kites.

Monday 20th: Delhi, Lahore
Calm, cool morning. Difficult to leave this lovely place. We have a last

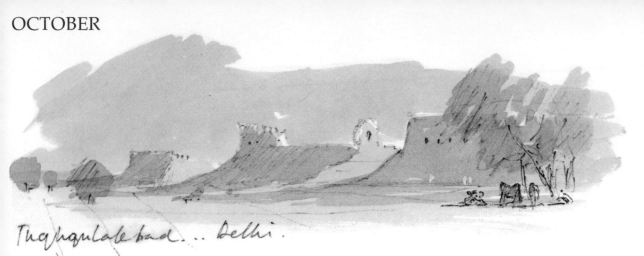

Thghqulahebad ... Delhi.

bathe. Black, silver-necked crows, beaks ajar and jumping up and down as if on pogo-sticks, haunt the surf's edge for mini-crabs – so small and light they are propelled over the sand by the wind rather than by their legs. Bills are paid, tickets checked, the bus boarded, the ferry awaited for nearly an hour (secret perks, I suppose, of the usual kind) . . . but on arrival our Delhi flight is announced as two hours late. Sad we have no time to visit Bombay. Twenty years ago or so it gave me my first sight of India. Buffaloes, goats, shanties, wirescape, shrouded bodies lying like dropped dusters on the pavements, the colours bleached and dusty (grey, white, biscuit, yellow), a sweet, damp, unplaceable smell. The slap-tinkle and whine of the India radio from café doors, the flailing shadows of great fans from upper windows, a grey, sulky sea, every ledge, step and parapet carrying a snowdrift of white sleeping figures.

Later, I was to discover the architecture: St Thomas' Cathedral (1718), its original mother-of-pearl windows long ago gone but still with its poignant parade of 18th-century monuments . . . the Prince of Wales Museum (Shannon, Glyn Philpot and Lavery fighting for their lives with cracked and pitted skins) . . . the Taj Mahal Hotel with its Parisian stone staircase . . . the Art School where Rudyard Kipling's father was Principal . . . the magnificent Blois-Baronial Railway Station (I was taken up on the roof to watch the commuter trains arrive in the rush-hour and opening an access door to a tiny decorative turret disturbed somebody who had made it his home, with an old sack to sleep on, a couple of pots, a marigold). Today all this lies out of sight and reach.

Next morning, New Delhi from our skyscraper window looks green, spacious and empty and – if pushed – I would say French in style. Odd 'modern', flash villas in working class areas I'm told are owned by workers – bricklayers, plumbers, clerks – from the Gulf returning flush and ready to spend extravagantly. Byzantine bureaucracy at airport: tickets (handwritten) to admit your bags into concourse; $1\frac{1}{2}$ hour wait; boarding card stamped three times by separate officials. Newspapers carry familiar stories – marriage ads . . . a train crash . . . a Minister impeached . . . a vulture has brought down a helicopter, a Vice Chancellor has been stoned . . . one unexpected scoop (an Indian film com-

142

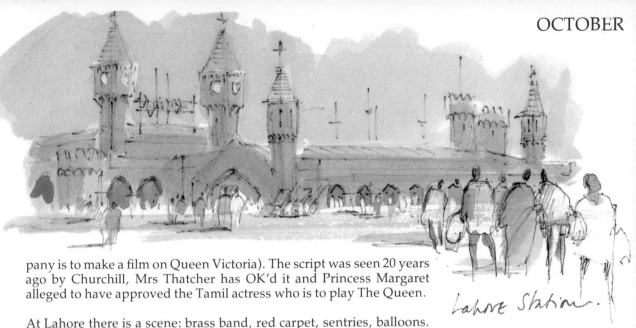

Lahore Station.

pany is to make a film on Queen Victoria). The script was seen 20 years ago by Churchill, Mrs Thatcher has OK'd it and Princess Margaret alleged to have approved the Tamil actress who is to play The Queen.

At Lahore there is a scene: brass band, red carpet, sentries, balloons. The President arrives (turbo-prop white aircraft) and drives off to cheers. We are taken to huge suite at Hotel Intercontinental – sitting room, bar (plus sit-up stools) pantry, two bathrooms. Bath, change and take bus to Governor-General's mansion for banquet. It is an old house, British-designed in Regent's Park-Classical, floodlit, with tables dotted around the lawn. There are 500 guests; since men and women are separated, M disappears into the darkness. Then with 30 outriders and two Cadillacs of police, General Zia arrives, and HH. Temperature drops from 80 to around 40. M, I am to learn later, is so frozen her teeth begin to chatter and when I go to search for her later I'm told she's been taken home unwell, in fact paralysed and trembling with cold. Luckily it's dark and the hotel is only ten minutes' walk. A hot bath and whiskey and she recovers.

Wednesday 22nd
Seminar starts at 9 am. General Zia and HH open – both speak well and forcefully. Panel of jurors then address us. Break at 12 after my one tiny contribution to the discussion, that architects are not welfare workers but artists. We break for steering committee/jurors' lunch and a brief press conference – wives elsewhere. Hotel packed with faithful waiting to see HH as he leaves. M and I and three wives go sightseeing in old city. There's lots to see, for Lahore is the chief centre of Muslim culture in Pakistan. I am glad to be surrounded by Mogul architecture; through laziness of mind and an English nanny approach to mysticism and ecstasy ('now that's enough of that come in and have your tea now'), I have always found Hindu mythology labyrinthine and unsympathetic, many of its doctrines and ceremonies unattractive, the representation of their gods – blue-fleshed, multi-armed, elephant-headed – repulsive, their temples oppressive. The missionary Abbé Dubois, writing 150 years ago on Hindu manners and customs, was even less complimentary – he found 'their customs odious or cruel, their mental faculties as feeble as their physique, their vegetables tasteless, their flowers without scent, the air unhealthy and the water

Aitchison College Lahore.

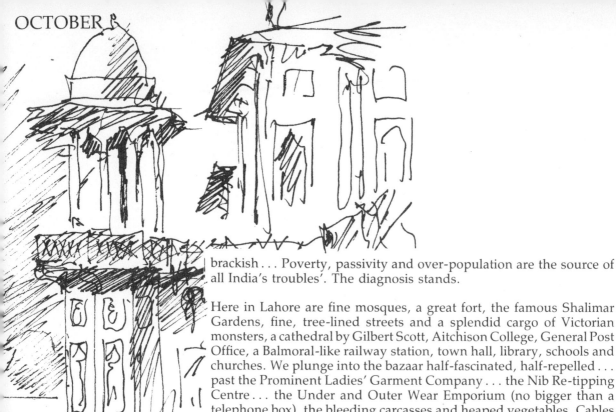

Aitchison College.
Lahore

brackish... Poverty, passivity and over-population are the source of all India's troubles'. The diagnosis stands.

Here in Lahore are fine mosques, a great fort, the famous Shalimar Gardens, fine, tree-lined streets and a splendid cargo of Victorian monsters, a cathedral by Gilbert Scott, Aitchison College, General Post Office, a Balmoral-like railway station, town hall, library, schools and churches. We plunge into the bazaar half-fascinated, half-repelled... past the Prominent Ladies' Garment Company... the Nib Re-tipping Centre... the Under and Outer Wear Emporium (no bigger than a telephone box), the bleeding carcasses and heaped vegetables. Cables and wires scribble overhead, blistered shutters hang hingeless over Japanese transistors. An ancient pyjama-clad figure approaches me as I sketch – 'Are you', he says, 'writing a poem?' – but we have to hurry back for the prizegiving ceremony.

It's pitch-dark except for fairylights down the long water canals, orchestra playing on marble island, centre pavilion floodlit. We sit on platform. Speeches from HH and Zia again. Move off to dinner-tables dotted on terraces and lawns. A great success.

Thursday 23rd: Islamabad
Lunch at State Guest House with HH (11 am) plus Steering Committee meeting. Finished at three. Join Sherban Cantacuzino[8] and M for tour of Aitchison College. It is a spendid Victorian Butterfieldish public school, red brick and turretted, looking like Rugby on its plate of green lawns. The headmaster shows us round. It's half-term and deserted. In the dark, shuttered assembly hall the honours boards – gold lettering on black – hang like monuments in a forgotten church. Aziz Khan has won the silver cup for debating. A three-wheel rickshaw draws up: anxious mother, agonised little boy, roped-up suitcase. How well one remembers that trapped feeling. We catch the evening flight (small turbo-prop) to Islamabad.

Friday 24th
Curtains drawn back disclose fir-clad foothills and a faint rim of mountains. Clear, clear sunny day. Work starts at 9 am. There are about 30 of us – local administrators, planners and architects. Brief

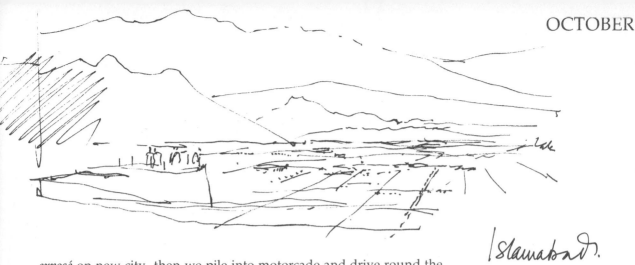

Islamabad.

exposé on new city, then we pile into motorcade and drive round the city, finishing in a picnic on top of a small mountain with Himalayan foothills behind us and the great plain in front and below us. Discussion 'till 4. At sunset we go for a walk by the lake. Colours turn from brown to lilac, the night falls like a lid, fires wink in distant villages. At dinner Mr Catezi, our host, the chairman of the CDA (plus two Indian colleagues, two Swiss architects and ourselves) places his problems before us.

Like Chandighar, Islamabad is a new city – not 20 years old – built, like Delhi, parallel with an old one, Rawalpindi. The choice of site seems to have been a personal presidential one at the time – a river, flat plain, a backdrop of wooded mountains. The plan (by Doxiadis) is a formal grid (justified by the traditional walled-compound plan of local housing, and perhaps familiar through the 19th-century British cantonment and civil lines layout) zoned in the usual way – administration, diplomatic, ceremonial, commercial, housing – round a beautiful artificial lake, the whole heavily tree'd and landscaped, so that from the air it looks a green city. The quality of architecture (if not of maintenance) is remarkably high – both private and public design – and though, like all new cities, the great straight avenues are largely empty except for cyclists and buses at rush hours, the place is attractive. An incomplete new town with its air of desperate optimism, its empty stretching boulevards and isolated pockets of housing makes great demand on the imagination. We know that it is sensible, far-sighted, logical (why on a flat featureless plain try to escape from the rational grid?) but every building is the same age (and will die at the same time) and the fact that most people doing the same job (government service) makes it basically an army camp. Mr Catezi, the chairman, feels the place has reached a moment of decision: to expand? . . . to accept more industry? . . . to pull-up the drawbridge? . . . to take up the role of a white-collar suburb to a regional development plan? Bill Porter (who worked three years in Caracas on a similar scheme) argues for a change, perhaps changing the CDA into a management company or even disbanding it. Some of the private architects complain of bureaucracy and domination by engineers (not unfamiliar). I plead for more of the passion and the courage that set the place up – the jump in the dark, so to speak.

145

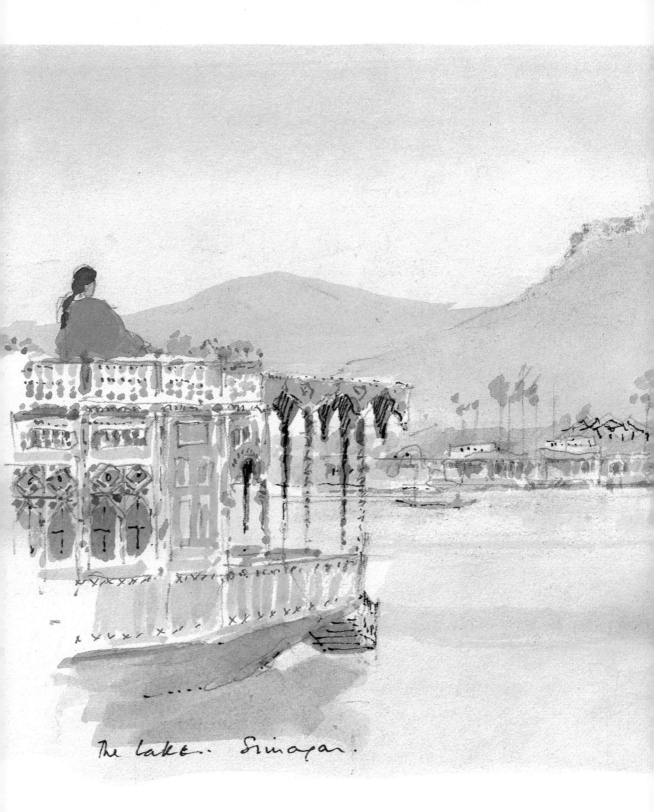

The Lake. Srinagar.

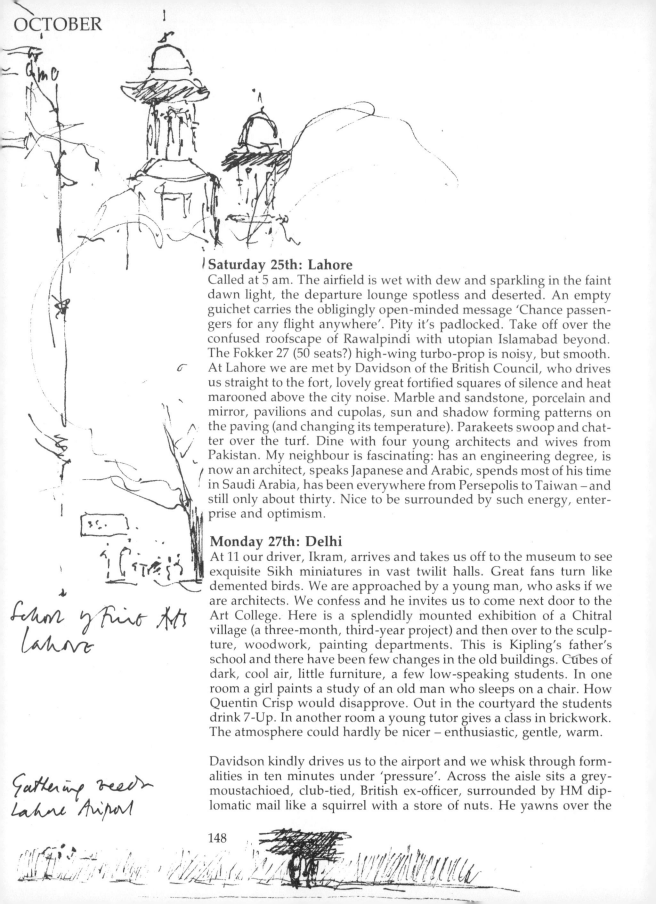

Saturday 25th: Lahore

Called at 5 am. The airfield is wet with dew and sparkling in the faint dawn light, the departure lounge spotless and deserted. An empty guichet carries the obligingly open-minded message 'Chance passengers for any flight anywhere'. Pity it's padlocked. Take off over the confused roofscape of Rawalpindi with utopian Islamabad beyond. The Fokker 27 (50 seats?) high-wing turbo-prop is noisy, but smooth. At Lahore we are met by Davidson of the British Council, who drives us straight to the fort, lovely great fortified squares of silence and heat marooned above the city noise. Marble and sandstone, porcelain and mirror, pavilions and cupolas, sun and shadow forming patterns on the paving (and changing its temperature). Parakeets swoop and chatter over the turf. Dine with four young architects and wives from Pakistan. My neighbour is fascinating: has an engineering degree, is now an architect, speaks Japanese and Arabic, spends most of his time in Saudi Arabia, has been everywhere from Persepolis to Taiwan – and still only about thirty. Nice to be surrounded by such energy, enterprise and optimism.

Monday 27th: Delhi

At 11 our driver, Ikram, arrives and takes us off to the museum to see exquisite Sikh miniatures in vast twilit halls. Great fans turn like demented birds. We are approached by a young man, who asks if we are architects. We confess and he invites us to come next door to the Art College. Here is a splendidly mounted exhibition of a Chitral village (a three-month, third-year project) and then over to the sculpture, woodwork, painting departments. This is Kipling's father's school and there have been few changes in the old buildings. Cubes of dark, cool air, little furniture, a few low-speaking students. In one room a girl paints a study of an old man who sleeps on a chair. How Quentin Crisp would disapprove. Out in the courtyard the students drink 7-Up. In another room a young tutor gives a class in brickwork. The atmosphere could hardly be nicer – enthusiastic, gentle, warm.

Davidson kindly drives us to the airport and we whisk through formalities in ten minutes under 'pressure'. Across the aisle sits a grey-moustachioed, club-tied, British ex-officer, surrounded by HM diplomatic mail like a squirrel with a store of nuts. He yawns over the

School of Fine Arts Lahore

Gathering reeds Lahore Airport

High Commissioner's
Residence
New Delhi

Financial Times. The landscape below is sallow and indecisive, dust from dried-up river-beds drifting across the plain. We brood over the last two days. Pakistan has been a delight from start to finish, though admittedly only seen from the stalls. With climate, population, ecology, poverty ranged against them, they grapple with issues without – it seems – being swamped by them. The afterglow of British influences still seems to persist but determination to be independent prevails. Even the Abbé Dubois might grant them an encouraging word. Formalities at Delhi are endless but outside – bliss– the grey High Commission Rolls and the familiar smiling driver. We roll off, noses in the air, waving dismissively at the Porters. Our hosts, the Thomsons, are in the midst of their normal 18-hour day but warm and welcoming as always. Dinner party guests include Professor Jhabvala, architect husband of novelist Ruth, the Ures (British Council) and Mrs Jaykar, the doughty Gordon Russell of India.

Tuesday 28th: Kashmir

Breakfast at 8 on the verandah. Leave for airport at 10. The landscape around Delhi is littered with old abandoned cities, palaces and forts, into the ruins of which the new suburbs are filtering, crawling like bright-coloured fungus over the ancient tumbled stones. Aircraft on time, nice seats by exit. Milk-chocolate midriffs sway past, offering orange juice and coffee. Mountains, snow-tipped on their northern flanks, appear through clouds. Villages with tiny shiny roofs. We are 600 feet above a valley when the runway rears up suddenly under our wheels. It's like landing on a dining room table. Cloudy outside, temperature around 60. Looks as if we were unwise to leave our macs behind. We are met and taxi'd to the lake landing stage. There is no railway to Srinagar and the main road into India is choked with convoys of trucks. The vale is barely 100 miles by 20 miles in size, flat-bottomed (it once was a lake), patched with paddy fields and pricked with poplars, streams, willows and glacier-smooth boulders. The mudbrick villages are roofed today in shining aluminium.

We embark on a tiny pavilioned gondola (they are called *Super-fast*, *Honolo-loo*) and are paddled to our respective houseboats. The famous European houseboats date back about 100 years, providing a solution to the edict that no European could own land in Kashmir. They are

Watchman's Hut on Saffron Field.

standard in size – about 150 foot long and 12 foot wide – moored side by side, stern to the bank, and built of unpainted wood. The gondola delivers you to the bow steps that lead to the verandah, thence through double doors to sitting room, dining room, past the pantry to the bedroom and bathroom. (The service quarters are usually ashore.) The furnishings are Indianised Waring and Gillow – armchairs like sucked toffees upholstered in velour, plenty of occasional tables carrying small bunches of bright flowers. Carved, fretted, elaborately furnished with chandeliers and polished pine, they line the banks of the lake like Oxford barges – which they closely resemble.

We are shown our quarters and introduced to our captain, Rashi. He is at once captain, houseboy and cook and is anxious that we approve of everything. He brings us coffee and slices of bread and butter and honey. We leave again for a tour of the lakeside and the Shalimar Gardens. Despite grey skies and brooding mountains the lake is beautiful, mirror calm, with waterlilies and tiny mud islands. The gardens themselves are a disappointment – formal and terraced, but the tanks and canals are empty and muddy, the fountains dead, the flowerbeds a hideous blaze of purple and orange. The pavilion roofs are painted apple green. We walk briskly round to comfort the dignity of our guide – a small brown man in a brown suit with sad brown eyes. On round the lake past paddy fields and through villages, brushing geese and piglets and children from our path, we step outside a collapsed shed. 'Come', says sad-eyes, and we are led into a darkened barn filled with timber structures of mediaeval scale and grandeur. At the feet of these machines squat the weavers – some children – working at high speed in the near-dark on carpets.

We are next driven, at our request, to the Handicraft Centre, once the old British Residence – gabled and half-timbered like a Shakespearian cuckoo clock in a Bournemouth glade. The vast staircase is guarded by two stuffed white tigers, the goods are a mixture – pretty lacquer boxes, hideously carved furniture, undistinguished silverware, woollen shawls of delicate pale colour and texture. Back to houseboat as it's now five o'clock and freezing cold. We ask for the stove to be lit. It is newly painted and smoky but after ten minutes the room is cosy as a nest. While waiting for supper I leaf through a magazine of coloured

150

Jain Temple. Srinagar.

Srinagar.

reproductions of Indian paintings with pleasantly misprinted captions. 'Note', one reads, 'the atmosphere of clam. The husband is woking in a dream and his wife is restless' . . .

Our American colleague Gail N is rowed over for dinner. She admires a lampshade, parchment coloured like a gourd. 'That', says Rashi proudly, 'is a camel's stomach'. What do you reply? 'Fancy that'? . . . 'Well done'? . . . 'You'd never guess'? Dinner – mulligatawny, chicken and stewed apple – is served formally to us in our high-backed Cromwellian chairs. Over coffee there is a knock on the French window and in bounces a bare-footed, woollen-hatted, miniature pirate, like a clown in a panto. 'I am Crocodile', he declares, sitting suddenly cross-legged on the floor, 'and I have brought you some super-duper suede coats. How often do you come to Srinagar? Well, then, buy when you see, not when you want' . . . The patter is continuous. At a flick of fingers an attendant appears with bundles, and they sit round the stove with white gleaming teeth and pleading eyes. M orders a beautiful, soft, natural suede jacket which we all find irresistible – and cheap. It will be made by tomorrow evening, he says. Gail rows off into the night alive with distant firecrackers (it is the season for weddings). Rashi doffs his white coat and retires after taking orders for dinner tomorrow night and we prepare for our berth in an icy room . . . but find hot water bottles.

Wednesday 29th
Beautiful pink dawn over the hills. Opposite are houseboats, *Aristotle*, *Miss America*, *Sea Palace*, *Egypt*, *Cosmo* and *Arqunut*, faintly floodlit in the rising sun and balanced on their reflections. The stove is lit and breakfast under way. It's dead quiet. The sitting room – fretted carved ceiling and jalousies, pale panelling left treated – is pink-carpeted, lace-curtained. There are 12 lights (Bauhaus wall brackets, pleated and tasselled floor lamps and the camel's stomach), six occasional tables, a three-piece suite, a desk and a revolving bookcase containing the *AA Handbook* for 1971, *King Henry IV*, part I, and *Homilies and Pensées* by Dostoievsky.

We leave at 9.30 with a picnic basket. Long, pretty (if uncomfy) drive

Houseboat Interior.

Houseboats
in Gulmarg –

through rice beds, lilac-coloured fields of saffron and white-stemmed poplars. Once we stop and walk through a bazaar whose donkeys, clamour, sheepsheads and tin kettles can hardly have changed in 100 years. We turn up a valley and climb for 20 miles by the side of a shallow, clear, fast-flowing river in a wide, stony bed. It finishes in a resort village . . . a street of souvenir shops, a group of hotels, pony-trekking agencies. We picnic by the stream on cheese sandwiches, beer, macaroons, fruit, coffee, all on a table-cloth spread on the grass by our courier. It's chilly but very pleasant and quiet. Four huge dogs and a dozen ravens encircle us, growing closer with courage. A fifth dog that approaches is seen off by the others. They are scarred but healthy-looking and gentle-eyed. We walk for about half-an-hour in the woods to see another valley stretching away up to the snow peaks.

Long drive home interrupted by a colossal traffic jam. Sixty trucks queuing for diesel and the other two lanes nose to nose, fighting it out with 'macho'. We are in despair, since nobody will give way. At last an army officer arrives and NCO and in ten minutes it's solved. We call in at a jeweller's for a browse then gondola home for a snooze before dinner. Crocodile interrupts us with his suede coat for M. We don't think it's a good enough fit so, with cries of 'no problem', he vanishes into the night to bring it back tomorrow. Gail joins us for dinner.

Thursday 30th: Delhi

Disconsolate dawn, rain pattering on the deck and dimpling the surface of the lake. At 9 Gail arrives under tarpaulins for a half-hour lake tour. Swathed in borrowed macs, we join her on the soaking cushions. Rain drops from the eaves of *Mother of Parliament*. *Artistotle* is 'To Let', *Rolex* is half-sunk, *Happy England*'s balcony carries a load of dispirited guests. Round the corner half a dozen sheep wait in the rain to be slaughtered beneath a string of carcasses of their earlier colleagues. The wedding barge is taking on a load of cauliflowers. Frozen, we return to *Lone Ranger* for coffee, money calculations and usual travel *angst*. At 12.30 the gondola arrives, then the taxi. By the time we reach the airport the rain is pelting down, the roads are slippery, filmed with mud, and seething with cows and buses and trucks and goats, their horns apparently wedged down with matches. An old man bicycles past, a flowering rose tree 6 feet high strapped to his back wheel.

The old Fort
Srinagar.

We have 1½ hours to wait. I go to change some money. He sends me back for my passport – luckily – for our agent has got us onto an earlier flight. We roar through everything (as the aircraft is already boarding) and are jeep'd out to the air bus. Blue sky and sun within five minutes of a bumpy take-off. Lovely to look forward to heat again. We miss the car sent to meet us and taxi to the house. A lovely swim watched by a group of tiny squirrels and (more menacingly) a vulture. Tea on the balcony; snooze 'till 7. Elizabeth T takes M off to some Indian dancing. I chicken out for whiskey and John, who arrives and gossip 'till a four-piece supper in the sitting room. John is very optimistic about India though finds Mrs Gandhi curiously, low-key. His normal load is increased by Prince Charles' visit and by the Festival of India for 1982.

Friday 31st: To London

Called at 4. Rolls to airport. Although it is still dark we ask our driver to seek out the house where Lutyens lived while designing New Delhi (it was all shrouded in shrubs and invisible), and thus to remind us of that astonishing architectural drama which at times approached farce. Lutyens used to call it 'Bedlampore'... the first survey party, elephant-mounted, pounding over the plains and arguing so hotly that at one moment Mr Brodie, the City Engineer of Leeds, slid down the elephant's back leg and walked crossly off into the heat (117 degrees at the time)... Lutyens' arguments with Hardinge and King George V, with his colleague Herbert Baker and with other rivals, critics and experts... the changes of plan, the shortage of money... But in the end there it stands, a masterpiece, witty (who but Lutyens would put fountains on a roof?), aristocratic, confident, inventive.

Usual nightmare formalities, airport tax, check-in, customs, passport, security. We take off late into a beige-pink sky and almost at once into an hour-long storm – too bumpy to serve coffee – which clears suddenly to reveal the Arabian Sea and a tiny bare island like a dropped almond. We come in over the dust-coloured coast and moored tankers to Dubai airport (good clean design, beautifully kept). Whiskey is £1 a bottle. The passenger bus is made, I notice, in Portsmouth, the aircraft steps in Basingstoke. We take off after half-an-hour ashore. At Heathrow the luggage is on the carousel before we reach it ourselves. Dinah and tinies there to meet us and drive us home to rest, dinner and bed.

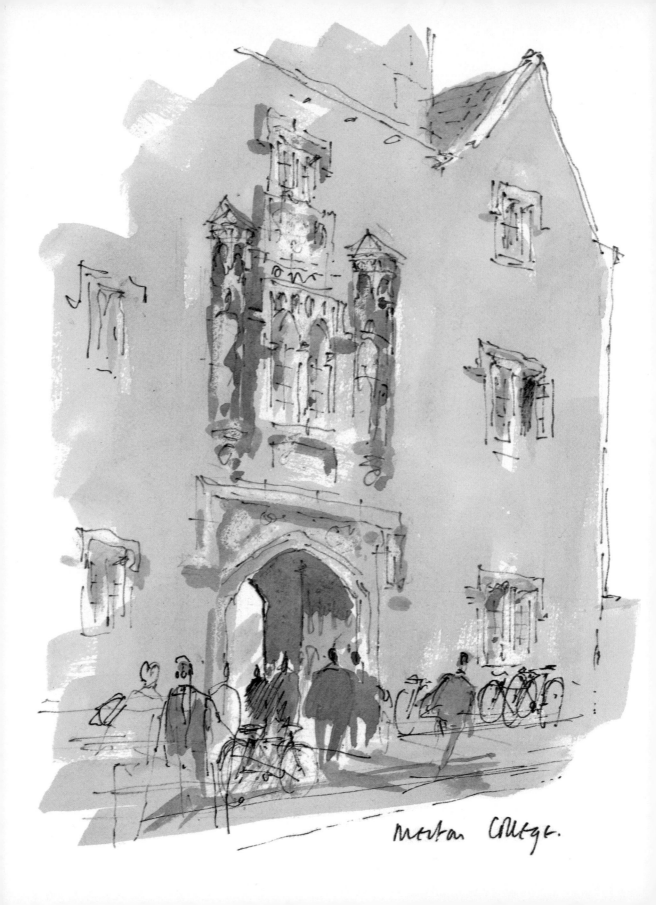

Merton College.

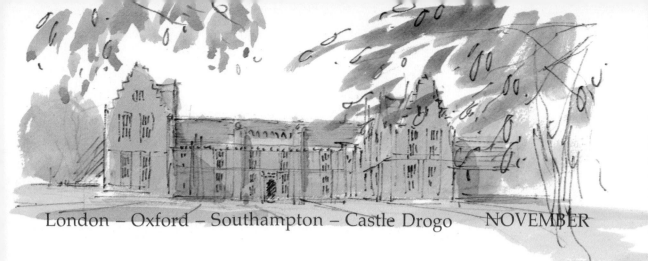

Saturday 1st: London

Fiddly day. Take M shopping locally. How difficult and time-consuming it is. By ill-luck we need a broom-head, some bananas, batteries, bulbs, bacon and elastoplast – all from different shops. It takes ages and quickly ruffles the temper. How sheltered are the lives of most married men; and would shopping centres be different if we shopped more often?

Sunday 2nd

M in bed with temperature. I spend morning doing a watercolour of Burlington House for a retiring member of staff. Odd chores at RA and Thurloe Place and am given dinner upstairs by children.

Monday 3rd

A crisis meeting at RA at 9 am on our Modern Painting exhibition. The pictures are chosen and ready to be sent from Europe and America. The catalogue printers are poised. (If not allowed to start they say no catalogues guaranteed in time.) The press conference has been held, and the publicity machine is already under way. But . . . not a single penny of support certain from anybody and the estimated deficit is so awful as almost to be funny. Council is naturally restless: their instructions were to proceed only subject to sponsorship. This has not materialised despite desperate searches in Europe and the USA, yet time has brought us to the starting line. The administration is cautiously alarmed, Norman Rosenthal – the principal organiser – is clay-faced with anxiety.

I leave at 2 pm with Mrs Midgley, to discuss Orangery at Sutton Place. Shall it be glassy, spidery, Paxtonesque? Or murky, tithe barn, Arts and Crafts Lutyenesque? Sparkle or mystery? Space frame or Tudor-scale timbers? Stanley Seeger agrees either approach tenable but admits to disliking a swim under a glass toplight. (I, with memories of prep school swimming baths, agree.) We withdraw to consider.

Straight to BBC to help judge *Blue Peter* poster competition for Natural History Museum Centenary. Sixteen thousand entries mercifully

Sutton Place.

Law Library. Oxford.

reduced to a few hundred. The judges work briskly and in three hours we have our agreed results – as so often one of the youngest competitors and by chance also mentally retarded, who has come up with a magnificently simple and attractive image.

Tuesday 4th
British Council Estimates Meeting – Byzantine in their complexity. I emerge with ill-informed prejudices.

Farewell lunch at RA to Dorothy Laidman of the Artists' General Benevolent Institution. Touched by the loyalty of distinguished artists – including Bill Coldstream and Henry Moore – who have turned up for the occasion. Fiddle about all afternoon, fuss-potting.

Wednesday 5th: Oxford
Sleep badly and feel depleted, so scrub morning appointments. Jo P arrives to drive me down to Oxford in semi-sleet for lecture to the University Architectural Society. (I accepted this invitation because I had once been secretary of its equivalent in Cambridge and know the agony of obtaining speakers and/or for that matter audiences.) Sherry with the Society's Officers in Merton, followed by dinner in hall. Oh the gloom of High Table, the black gowns, dark panelling, subdued cross-talk, but perhaps they are all happy enough.

On to Leslie Martin's Law Library for the lecture. Fine building but disappointing lecture room, inadequately equipped. I remember Bernard Ashmole's story of lecturing in an over-equipped theatre in America. He inadvertently pressed a lectern button, there was a secret whirring noise and a dance floor descended slowly in sections over his audience. I need two projectors – only one can be found and the second has to be sent for. Both are propped on telephone directories. Who worries except me? My hosts are charming and polite. The room is full and sympathetic, the talk (Victorian Venice again) seems to be appreciated – as a change from art history or architects talking about their own work – and we drive off home relieved and tired.

Thursday 6th: London
Enjoyably provocative day – non-stop argument from 10 am to 11 pm.

High Table.

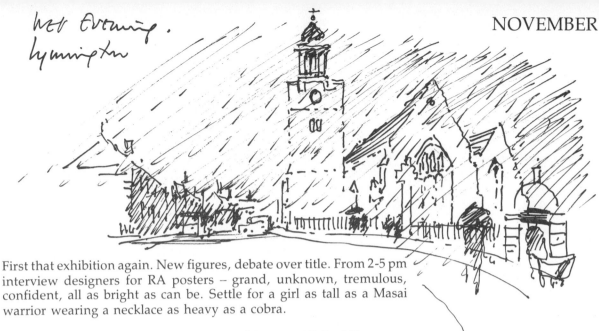

Wet Evening. Lymington

First that exhibition again. New figures, debate over title. From 2-5 pm interview designers for RA posters – grand, unknown, tremulous, confident, all as bright as can be. Settle for a girl as tall as a Masai warrior wearing a necklace as heavy as a cobra.

Dinner at Lancaster House in honour of Simone Weil of European Parliament. Company of about thirty, Lord Hailsham in chair. M next to French Ambassador, me between his handsome wife and a tiny blonde, who reveals herself as the Irish-born PA to Mme Weil, married to a Frenchman and living in Luxembourg. She claims to enjoy it, but to me it sounds an unrelieved nightmare. Discourteously, I refuse to speak French, unlike Lord Hailsham, who in a splendid Churchillian accent ('Quoi je toujours dis est . . .'), has a brave go, unafraid too of oratory, rolling out – unashamedly and touchingly – phrases like 'grim spectre of war stalking across Europe', as if nothing had happened. Luckily diplomatic parties never last long, and after I have learned from my neighbour the French for hot water bottle, we leave.

Friday 7th: Lymington
To Lymington with M in an icy drizzle to open an exhibition of water-colours – mostly of India and many of the same subjects I had myself attempted a few weeks ago.

Saturday 8th: Southampton
Isle of Wight invisible behind slicing rain-rods. To Southampton for AGM of Solent Protection Society. A constructive and lively debate, and usual problems. As always, I am amazed by the professionalism, selfless hard work and minor successes of pressure groups such as this.

At lunch I sit beside a Mr Lewis who, with the help of volunteer trainees, has just completed the reconstruction of the tide-mill at Eling Creek! He was originally a shipwright with the Union Castle Line – serving on the Capetown Castle, the flagship in which M and I returned to England in 1940. It was an eerie voyage: a huge, blacked-out liner zig-zagging at high speed up the West Coast of Africa with a full crew complement and only about a dozen passengers, huddled nightly for company in the first class lounge to listen to the ship's orchestra (which seemed to outnumber us) playing Grand Hotel airs.

Graphic Designer

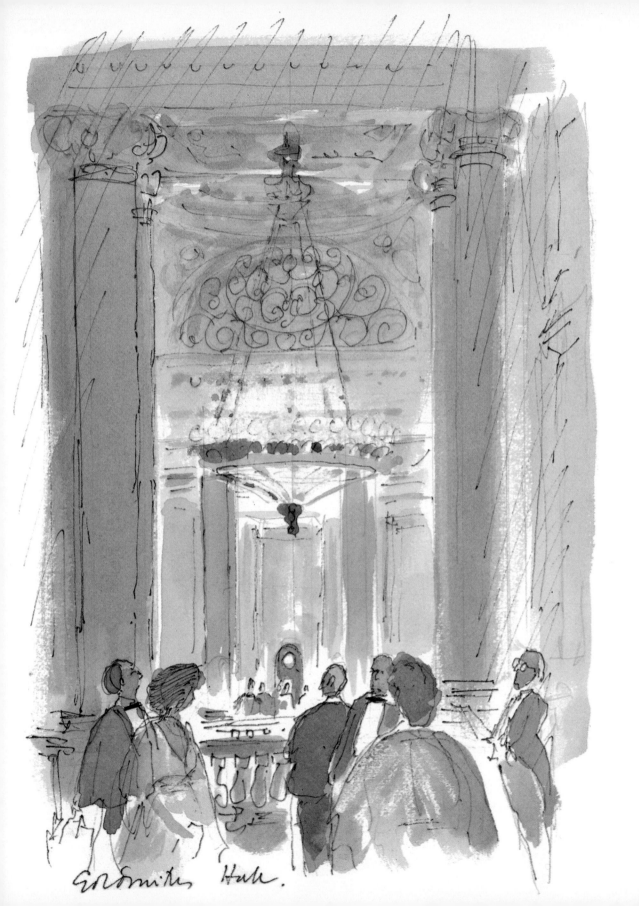

Goldsmiths Hall.

Solent Race.

Mr Lewis is the craftsman of the story books – carved out of wood, with thick white hair, slow-speaking, wise, humorous and pithy.

Sunday 9th: London

Twenty yachts racing round the buoy this morning . . . unthinkable twenty years ago. New designs in protective clothing and handling gear have achieved this, I suspect, more than a new physical endurance. Return to London to find a dismembered thrush under the piano and enough feathers to stuff a pillow.

Monday 10th

All morning at the Temple over the Hounslow Inquiry. (Strange how barristers have achieved a tradition that clients always go to them instead of the other way round.) So, as usual, 20 people cram into a tiny, linen-cupboard-sized room like prefects summoned by a housemaster. Lunch with Lord Lever to discuss our proposed RA Trust. He is as helpful and voluble as always.

Tuesday 11th

I meet an anxious parent, job-hunting for her landscape architect daughter. I can't be encouraging. Next a student with a portfolio of magical drawings of the Watts Chapel at Compton. Speak on conservation at a Mayfair Society lunch – too fast as usual – and then to my first meeting of Council at the Royal College of Music. Everybody agog about Sir Robert Mayer's wedding. The agenda is almost identical with the RA's and so is the debate.

Wednesday 12th

Royal Fine Art Commission all day.

Thursday 13th

National Portrait Gallery. (This is obviously institution week.) Normally an amiable not to say jokey lot, today we are in a rather scratchy mood. We question the eligibility of subject, the quality of painting and the price of nearly everything, and only warm up over a Thornhill panel cut from a ceiling and possibly, thinks the Director, re-adjusted in its new frame, since the weave of the canvas goes diagonally. We nod thoughtfully. 'This morning', says Lawrence Gowing, 'I gave a

Royal College of Music

159

Old Town Hall
Hounslow.

PhD to a girl who has spent two years studying the weaving of canvases used in the 18th century and she proved that a diagonal weave was frequently preferred'. Game, set and match to Gowing.

Pilgrim Trust dinner at the Goldsmiths' Hall. Splendid evening – good speeches, food, company and architecture.

Friday 14th

To BBC to see rough-cut of the Watts film and record some missing bits. Anne J has caught the strange, dozy, Edwardian feel of the place, but sad there was no time to talk more about this extraordinary man, his lifelong industry (he was working on *Physical Energy* at the age of 80), his bewildering attraction for women. Certainly he was Byron-ically beautiful as a young man, but perhaps because he seems to have been under-sexed (and therefore no threat to husbands or wives) all his life he never lacked somebody to cosset him. Sad, too, that Mrs Watts spent so much of her energy in heating up his milk, so to speak, and not in painting, for such few works of hers as survive are remark-ably sensitive.

Saturday 15th

All day catching up on the drawing board – an illustration for a Frank Muir miscellany, a perspective of Suite 240 at Windsor Castle, some watercolours of the Lake District. Mostly failures and discarded; a lifelong struggle continues to achieve the structural simplicity of an Edward Lear landscape.

Sunday 16th: Hounslow

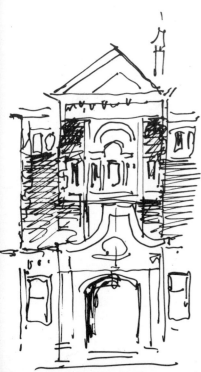

All morning driving round Hounslow and Brentford in search of buildings by Nowell Parr, the late Victorian architect of the Old Town Hall – the demolition of which is the subject of a public inquiry. Parr's pubs are lively and pleasantly horrific enough, like an assembly of domed overmantels built in puce and bottle-green terracotta, but nowhere does he approach the competence or quality of his better contemporaries Robson or Winmill or Smith and Brewer. I retain my view that his Town Hall is not worth keeping. The Victorian Society will be cross with me again.

Public Library. Hounslow

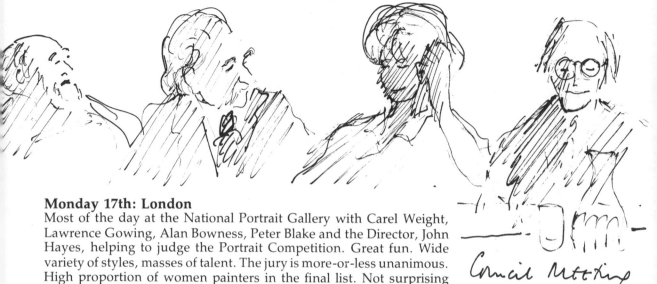

Council Meeting

Monday 17th: London

Most of the day at the National Portrait Gallery with Carel Weight, Lawrence Gowing, Alan Bowness, Peter Blake and the Director, John Hayes, helping to judge the Portrait Competition. Great fun. Wide variety of styles, masses of talent. The jury is more-or-less unanimous. High proportion of women painters in the final list. Not surprising perhaps, since women have always, allegedly anyway, been more interested in people than in abstract ideas, but it's strange how few women portrait painters are today remembered. Was it due perhaps simply to problems of chaperonage? When Kate Terry sat to Watts for her portrait – a marriage plot by Mrs Prinsep – she brought her 17-year-old sister Ellen along as a chaperon, and Watts (by design, or through fatigue or absentmindedness) proposed to Ellen instead.

Tuesday 18th

A rough day, not to be remembered with pleasure, starting with the doctor, continuing with an RA meeting entirely on finance, followed by a depressing requiem mass at Farm Street – hideous church, virtually no music, chilly priest – which leaves me angry and miserable. After lunch a very long and rather ill-tempered council meeting, mostly on the subject of our New Spirit in Painting Exhibition, which new members of Council in particular feel has not been well or even properly handled.

Wednesday 19th

Wedding anniversary: I give M a moonstone ring from Kashmir; she gives me a silver medal. Somehow this agreeable exchange makes me late for everything all day . . . at Gray's Inn for a meeting on Liverpool Street . . . at the London Electricity Board lunch . . . at a jury session for the design of a RA silk scarf to be sold in our bookshop. A bad or boring day is always saved by seeing an original piece of work really well done. Some lovely designs. Leave in high spirits for celebratory supper at home.

Thursday 20th

Breakfastless to the Clinic in Bryanston Square. Blood drawn at half-hour intervals all morning. In between sessions I watch the Queen's Troop of the Royal Horse Artillery assemble outside for some state

LIVERPOOL STREET

161

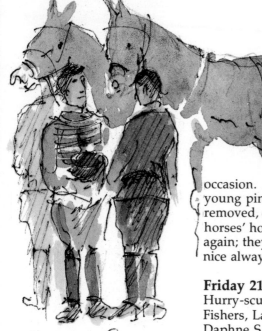

The King's Troop
R.H.A.

occasion. Frogged uniforms, glittering spurs, gold enrichments, young pink faces. A bugle, all dismount. A bugle, and shakoes are removed, cigarettes extracted and lit. A groom goes round painting the horses' hooves with varnish(?) oil(?) paint(?). At 11 the bugle sounds again; they mount and jingle off, pursued by a veterinary van. How nice always to be followed by solicitude.

Friday 21st
Hurry-scurry day. Odd meetings. Give an enjoyable lunch party – Fishers, Larsens, Astors, Blackmores, Summersons, Plumb, Jo P and Daphne S.

Saturday 22nd: Castle Drogo
Train to Exeter for Castle Drogo, (sadly) my last BBC assignment. All the way down I read Mary Lutyens' sensitive study of her architect father. An extraordinary, complicated man packed to the brim with paradox. He worked almost entirely for the rich and the titled, yet all his life seemed socially insecure (no school or university). He was a sparkling conversationalist at dinner parties, yet was tongue-tied in public and silent at his own table. He was a lover of children but could happily communicate with them only through letters and drawings. He was vulnerable yet capable of drawing blood from others with a casual remark, childlike yet driven on by the radical ruthlessness that all great artists must possess. How great a man he was we are only now beginning to appreciate. In my student days – we were a priggish lot – he seemed to us to stand for elitism in patronage and reaction in design, an image-monger without integrity. We ignored (for we were taught to look the other way) his fantastic skill in playing with space as opposed to just handling it; his love of geometry – 'by measure', he used to say, 'we must live'; his insistence on good craftsmanship and fine materials; above all we ignored the products – a procession of great buildings as harmonious, intricate, controlled and witty as some great musical symphony and at times equally exalting.

Almost the last (and perhaps the oddest) of these was Castle Drogo, to which I am now on my way, built for a fellow romantic who wanted to live in a real, strong castle on a crag – a serious folly, so to speak. He got what he wanted, though he had to wait twenty years while it was

the Library
Castle Drogo

building and died within a year of its completion. (Perhaps, like many clients, he had enjoyed the designing/building period more than the finished house.) Certainly it went through lots of changes – many of them almost as drastic as the decision to reduce its size by more than half. Lutyens, as always, seized every time the opportunities presented by change, transforming the study into a two-storey staircase, the basement of an unbuilt Great Hall into a chapel, cranking the plans round the ball-joint of a vaulted staircase that works through inventively placed half-landings horizontally as well as vertically.

It is a house in fact where the stairs and landings and corridors and approaches are more subtle, inventive and throat-catching than the rooms, and where granite is everywhere – inside and out (if only as a reminder in a nursery skirting or a dining room frieze) – sharpened to a razor-edged blade of masonry, pared down to essentials, carved and burrowed into so that the house is more like a simple sculptured block than an assembly of rooms. How would this massive, austere, bony place look in film, I wonder? Would it look tyrannical and unfriendly (which it certainly is not) instead of as lively and sparkling as the stone from which it was cut? Anne J caught it on our preliminary visit . . . can her camera crew respond with equal enthusiasm? Tomorrow will show.

A long dark taxi-ride to the hotel crouching behind a wall at the foot of a hillside. I join Anne J and the crew in the dark little bar – where, says our host, Evelyn Waugh wrote *Brideshead Revisited*.

Sunday 23rd
Grey misty day, just right for granite and battlements. Castle Drogo grips the hill top like an old ironclad aground on a reef. All day spent in walking round, deciding on locations, drafting scripts while the crew investigate acoustics and lights. Nothing on film today.

Monday 24th
Drogo glistening again in the mist as though salt-encrusted. Most of the morning spent in lighting the vaulted staircase. The camera man is a perfectionist and it's slow work. By midday I've descended the stairs five times and spoken 60 words. By 3 pm the light is gone and we have

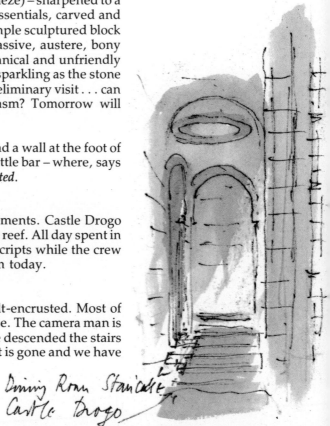

Dining Room Staircase
Castle Drogo

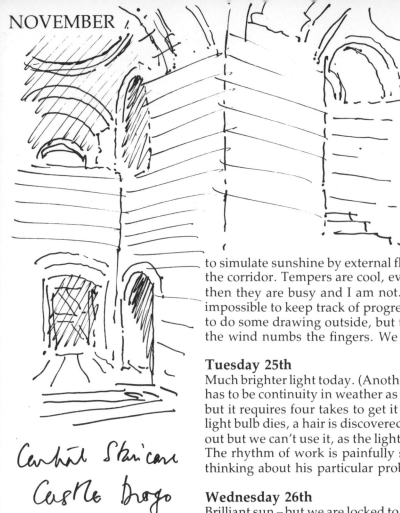

Central Staircase
Castle Drogo

to simulate sunshine by external floods. Another hour goes in lighting the corridor. Tempers are cool, everybody's patience exemplary. (But then they are busy and I am not.) As we shoot out of sequence it is impossible to keep track of progress. Before darkness sets in, I escape to do some drawing outside, but the Castle frowns on my efforts and the wind numbs the fingers. We break at 5.30.

Tuesday 25th
Much brighter light today. (Another problem for the cameras and there has to be continuity in weather as well as in clothes.) I learn 500 words but it requires four takes to get it done (a log explodes in the grate, a light bulb dies, a hair is discovered in the camera gate). The sun comes out but we can't use it, as the lights are there and must be put to work. The rhythm of work is painfully slow but everybody is working and thinking about his particular problem.

Wednesday 26th
Brilliant sun – but we are locked to our electricians and must stay inside – and anyway the generator truck is parked outside and would inter-fere with any external shooting. 'Sod's Law' rules as usual. At tea time we have a foray to the roof, but the sun is setting so fast that by the time everybody's ready we've lost the light. Back to the dining room – a beastly room like the smoke room of a 1920s Cunarder – what *was* Lutyens about here? – and manage two sentences before we break. (Not a productive day.)

Thursday 27th
Thin rain and watery gleams of sun. At breakfast Anne J – no surprise – says we are behind schedule and asks for two more days. I can manage one. The delays spring from the architecture. It's a very difficult house to light, and the sun goes in and out at the wrong moments, visually disturbing to viewers who cannot see its source. Nevertheless, shor-tage of time quickens the pace. We deal smartly with the kitchen, and after lunch I speak the final three-minute summing up from the arm-chair – word-perfect first go. General euphoria 'till another hair is discovered on the gate. We have a difficult session with a recalcitrant portcullis (one of Lutyens' less successful jokes) and spend a final hour recording footsteps on stone, carpet and oak. At Television Centre, I'm

Sir Edwin Lutyens (after Dulac)

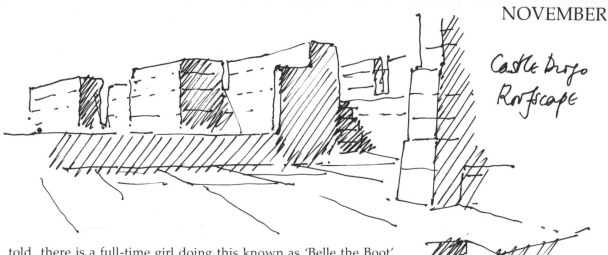

Castle Drogo
Roofscape

told, there is a full-time girl doing this known as 'Belle the Boot'.

Friday 28th

Driving snow – and the camera crew car has a flat. But within an hour the sun is out and most of the snow gone, though requiring continuity care when we get near windows. We lunch –as every day – at the local pub, often with Anthony Drewe, grandson of Drogo client, a courteous, stooping figure in a scarlet woollen hat, brimful of tiny family anecdotes. (He still remembers the most terrifying moment of his life when, at the age of four, digging in his parents' garden in Tunbridge Wells, he unearthed a gas main, black, sinister, stiff, coming from he knew not where and disappearing he knew not whence.) After lunch the bathroom, Mrs Drewe's bedroom, and the chapel. (Last chance as the electricians leave tonight.) The undercroft is a *tour de force* – massive, contained strength as if all carved from living rock.

Saturday 29th: To London

A diamond of a day. Blue sky, crisp shadows, blades of grass snapping underfoot like twigs. We spend an hour on the flat roof – designed in a series of courts and steps as carefully as a Moghul garden. The chimneys, usually a Lutyens trademark, have vanished into the battlements and turrets, and the parapets are pared down to inches to show simultaneously the strength of granite and the insubstantiality of this make-believe. A few hurried external shots by the front door before the taxi arrives to take me to the station.

As the train rattles off back to London I reflect on the week's work. We have lived – almost – in Castle Drogo, at first intimidated by its austerity and a little nervous of those masterly spaces and surfaces, to which it seemed nobody else could be allowed to add a personal touch. (No question as to who is in charge there.) But as the days passed and the light ebbed and flowed, glancing off stone edges, illuminating softly plastered vaults, highlighting the affectionate details of door latches and plate racks and handrails, the magic and mystery of the place began to take command and we had, all of us, capitulated. There are times, as here at Castle Drogo, when, in the presence of a masterpiece, something of the artist's intention seems to pass into one's possession.

Anthony Drewe

165

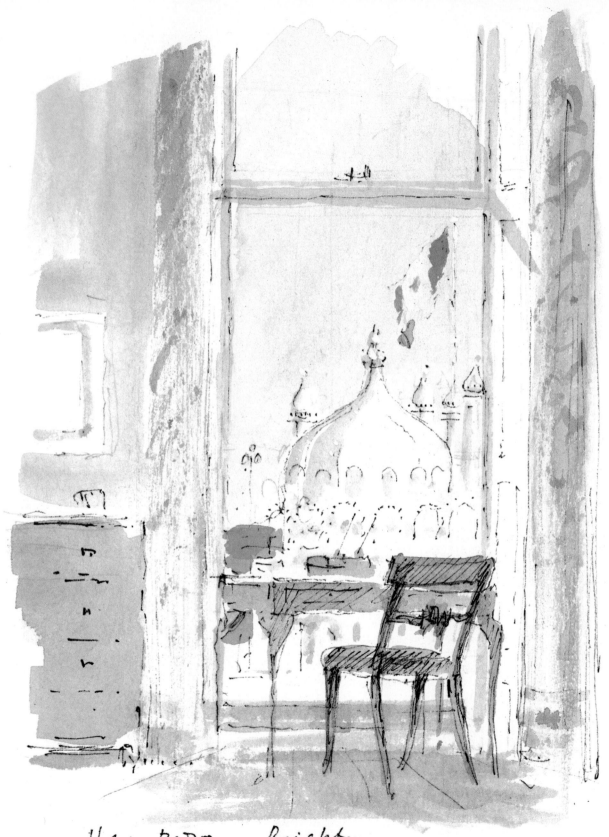

Hotel Bedroom. Brighton.

Brighton Beach.

London – Brighton – Windsor – Preston DECEMBER

Monday 1st: London

Evening Finance Committee at RA. Lord Lever, Sir Jasper Hollom[1], Michael Verey[2], Nicholas Goodison. I am helplessly in the chair, much of the money talk . . . liquidity . . . gilts . . . preference shares . . . going over my head as elusively as silver-fish. But our advisers are firm, practical, helpful and critical. Harold Lever crackling as usual like a Chinese firework with gossip and common sense. His stories are unrancorous, hilarious and irresistibly diversionary . . . and it's hard to keep the company on the subject, our miserable finances.

These are fast becoming a public bore as well as a private one. The RA receives no government grant. Unlike the national museums, it receives no insurance indemnity for its great exhibitions – this has to be applied for each time, and not always successfully – and while many of its exhibitions, on the face of it, pay for themselves, when the over-heads are included (as they quite properly are) only three exhibitions in the last 20 years have made a profit: Goya, Chinese Art and Post-Impressionism. It's no comfort either to be told that nobody makes a living out of showing the visual arts – last year the Arts Council's published 'loss' on exhibitions was over a million pounds – so clearly if we are to survive something (or more likely somebody) must give.

Tuesday 2nd: Brighton

Liverpool Street again, this time at BR HQ. Long difficult debate. The basis of the argument is do you establish the new station as a 'presence' (like King's Cross or Waterloo) or as no more than a horizontal 'passenger-slot' beneath offices (like Holborn Viaduct)? Romantics are for the former, commercial interests the latter. The planners (as usual) want both – a distinguished building with a recognisable identity, but designed to give the impression that there has been no change at all. The debate opens up all sorts of side-alleys: 75% of station users arrive and depart on foot . . . it's no good planting trees on the forecourt as they will be cut down by vandals within 48 hours . . . as the boundary between Hackney and the City of London cuts through the site it's important to get office entrance doors (and thus rents) on the City side.

Forsake the arguments reluctantly to go to Brighton for a university public lecture on the Festival of Britain. My old *Observer* film breaks

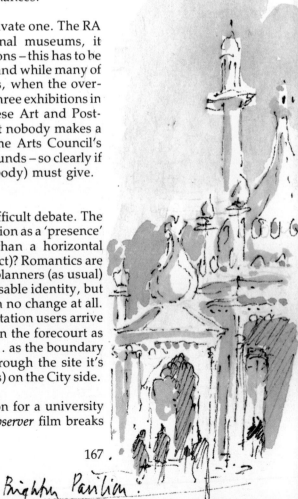

Brighton Pavilion.

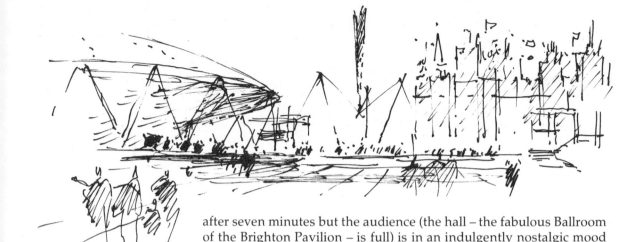

South Bank
Exhibition 1951.

after seven minutes but the audience (the hall – the fabulous Ballroom of the Brighton Pavilion – is full) is in an indulgently nostalgic mood and sits out the mending period.

It's nice to sense how warmly the South Bank Exhibition is still remembered, how quickly people forget it started in 1948 (it seemed) with a recipe for failure: conceived by a Hampstead herbivore (Gerald Barry), backed against a unitedly opposed press by an ambitious left-wing politican (Herbert Morrison), designed by a bunch of young and totally inexperienced architects, built during a time of desperate national shortage (rationing was worse than in wartime) . . . and yet it opened on time, kept within respectable reach of its budget, and was seen and enjoyed by over eight million visitors. For me it was perhaps almost the happiest time of my life.

Everybody seemed against it. The establishment thought it was a smoke-screen for advancing socialism; the left that it was elitist; the academics that it was populist. Thomas Beecham said it was imbecilic, Evelyn Waugh that it was pathetic. How and by what agency would such a spontaneous national outburst be allowed to erupt today? By herbivores or carnivores? Lew Grade or Jonathan Miller? Would people – as they did on the South Bank – again dance in overcoats, in the open air, in the rain? It was a remakable achievement, but was it anything else? Was it – as Gerald Barry used to claim, a tonic for the nation, or as the critics suspected, a national tranquilliser, a political device to distract us from our discomforts? Was it an architectural milestone . . . or just a rehash of Stockholm and Paris? Certainly it was a bit priggish, there was a whiff of WEA paternalism about . . . yet it was not boastful, not noisily nationalistic. It was popular, relaxed, delightful, witty and human in scale – and everybody enjoyed themselves.

Wednesday 3rd: London

British Council 'till lunch when Norman St John Stevas, in his usual humorous fettle, opens the NPG Competition Exhibition. (Nice that the first two winners are from the RA Schools). After lunch give a sitting to another ex-RA student, a Mrs White, beautiful, hare-faced, sudden, disconcertingly sweet smile. She draws elegantly with red and blue biro pens.

Shot Tower!

The Great Barn
Gawthorpe

Talkative and inconclusive meeting at the Arts Council on the Festival of India – so many ideas, so many plans, so few halls and hotels booked, so little money – but the co-ordinator, Tom Petzal, is cheerfully confident. Evening at the RSA for medal award by Prince Philip to William Clark, who accepts it on behalf of poor Lady Jackson, seriously ill in hospital. Supper with Bill Coldstream[3] and Keith Grant[4] in one of M's newly re-decorated rooms, for which – with the architect, Sam Lloyd – she is rightly showered with compliments.

Thursday 4th: Windsor

To Windsor with Pamela R (from the office) and bags of samples to meet Bill Nash, the Superintendent, to discuss practicalities and estimates. Another cheerful – and I hope rewarding – RA lunch with Harold Lever, Robin Leigh-Pemberton (NatWest chairman) and Sir Jules Thorn, a sharp-eyed and diminutive 82-year-old. Dinner for ten at the Goetzs. I wear a shirt Walter gave me six years ago when he was plumper. Now as he is thinner he eyes it enviously . . . but in vain.

Friday 5th: Preston

To Preston early and thence to Gawthorpe Manor, a dark-stoned, Wuthering Heightish, 16-century home, mercilessly modernised by Barry in 1850 and now National Trust. It stands grimly commanding a circle of trees wildly waving their bare black branches in a force 8 gale. The meeting, chaired by the ex-owner Lord Shuttleworth (curly red hair), is called to discuss a competition for the remodelling of the magnificent tithe barn adjoining the house. The view from the windows is peaceful and romantic, revealing graceful watermeadows through which a stream meanders, but Shuttleworth tells us that in his childhood days it was a huge, clamorous, open-cast coal pit. He and his sister who were placed to play behind rabbit wire on the lawn which quickly resembled a chicken run, could hardly hear themselves speak for the grinding of bull-dozers. He is a good chairman, so catch a tea-time train home.

Saturday 6th: London

Watch Quentin Crisp on tele talking about his experiences as an artists' model. He believes in heroic 'Italian' poses which test the drawing of anatomy but the students tend to giggle and fail to recognise the

Gawthorpe Hall

169

DECEMBER

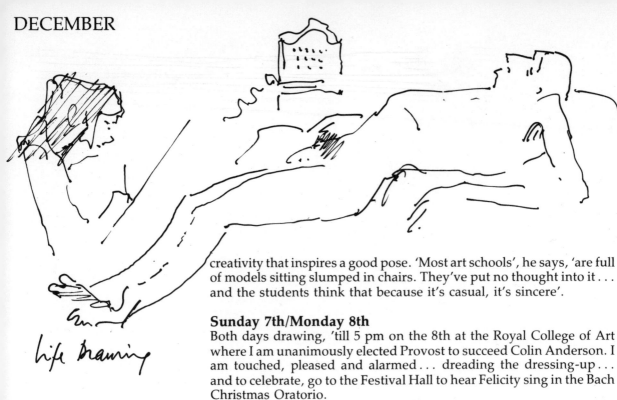

life drawing

witness reading

creativity that inspires a good pose. 'Most art schools', he says, 'are full of models sitting slumped in chairs. They've put no thought into it . . . and the students think that because it's casual, it's sincere'.

Sunday 7th/Monday 8th
Both days drawing, 'till 5 pm on the 8th at the Royal College of Art where I am unanimously elected Provost to succeed Colin Anderson. I am touched, pleased and alarmed . . . dreading the dressing-up . . . and to celebrate, go to the Festival Hall to hear Felicity sing in the Bach Christmas Oratorio.

Tuesday 9th
Another Council Meeting, indecisive but better tempered. We are marvellously old-fashioned here, no student representative from the Schools or the manual staff. Would they come if asked?

Wednesday 10th
Natural History Museum Trustees. Despite a public inquiry finding in our favour, opposition to our building plans is being drummed up and we are obviously in for a scratchy time. (One correspondent describes our Biology Exhibition as Marxist.) A tonic dinner in Chelsea; most of the fellow guests young, sparkly and optimistic.

Thursday 11th: Hounslow
To Hounslow for the Town Hall Inquiry. It's been going a few days already and only those immediately concerned are now sitting it out. The usual paper-handling and courteous back-biting and reading of interminable statements. A sudden glimpse of real life is opened up when a Mrs Williams rises to say that her parents (aged 80 and over) are being evicted to make way for the new shopping centre, and that while they have been offered alternative accommodation they don't want to move. 'They've worked hard', she says, 'and my father was awarded the Imperial Service Order'. She reads the citation tremulously. We all look down our noses at this brush with reality. Our expert talk of retail movement, compulsory purchase, shopping malls and the like turns suddenly sour.

When my turn comes to discuss the merits of the Town Hall, I become

Christmas shopping

engaged in an enjoyable philosophical debate with a bright young man from the Victorian Society. His defence – put over-simply – is that, while it is only a Grade II building, you must keep second-rate buildings sometimes because they are so gawkily characteristic of their period. I see exactly what he means and if the building were gawkier and funnier I would be on his side. But Nowell Parr's architectural joke – unintended of course by him – is in my view a leaden one, and perhaps even unfair of us to laugh at. The debate is interesting but the inspector looks impatient and I am released.

A General Assembly after lunch. Initially hot-tempered in its questioning of our exhibition policy, but the defenders rally strongly. By the time we go to dinner all is peaceful . . . and I am generously re-elected PRA for another year.

Friday 12th
Another financial lunch at RA – this time Arnold Goodman, Peter Vanneck, Courteney Blackmore. Some good ideas and enthusiastic support.

Saturday 13th
Shopped all day . . . and luckily, unlike Angela, not sick in afternoon.

Sunday 14th
Evening carol service in the Hall at Burlington House. We take the grandchildren to join a company about 200 strong. A great success.

Monday 15th
Executive Committee Royal College of Music. John Redcliffe-Maud reveals, to our consternation, that some local education authorities have, for economy reasons, closed down their instrumental teaching in schools, leaving students stranded, expensive instruments unused and people like the RCM short of students in future. We discuss what's the best method and place to make our protest – music is not something that can be stopped and started again – and return to the usual agenda of all teaching institutions: staff changes, cafeteria prices, cycle sheds, raising fees.

DECEMBER

Frogmore Cottage

After lunch I cross the road to the AGM of the British School at Rome. Princess Alexandra presides over a dull meeting. The presence of Royalty, sadly for them, seems to remove all items of dispute from any agenda . . . and there's plenty of dispute about. Is the idea of painters going to Rome (as opposed to Los Angeles or Tokyo) an absurd anachronism? If the idea of the scholarship founders was as stated 'to improve design', why do we not send industrial designers instead of sculptors? Should design be taught and practised under the same roof as the fine arts when these (in their present state) are perverse, wilful, inexplicable, undisciplined? (I remember Mr Maldonado – head of the famous design school at Ulm – visiting the RCA and castigating us for this fundamental error.) None of this debate surfaces and we break for tea as if all were calm.

Tuesday 16th

At 2.30 the Queen – hatless in a Rover – arrives to see the Chatsworth Exhibition. Andrew Devonshire takes her round (she stays an hour) the other visitors behave well, neither staring nor pushing. Princess Alexandra arrives at 5.30 for the same circuit. Torchlight carol party at St James's Palace.

Wednesday 17th: Windsor, London

To Windsor to draw Frogmore for a royal christmas card. Continue to be fascinated by what Queen Victoria called 'this dear mausoleum'. Gruesomely planned by the Queen and Albert when they were only 24 years old, designed by Professor Gruner of Dresden, erected under the supervision of A J Humbert (later to design Sandringham), and paid for entirely by the Queen, it was completed in 1871. Granite, marble, bronze, mosaics, stained glass (on an inner wall is a modest tablet to the memory of John Brown). It's not nearly so visually exciting as Destailleur's mausoleum for the Empress Eugénie at Farnborough – now there's a knock-out, which curiously enough also contains a tiny tablet to a personal servant – but Frogmore rules the gardens and lake with a ponderous melancholy which is undeniably both touching and dignified.

The Victorians weren't so daft about the treatment of death as later generations suppose. Now that it is treated as no more than refuse

Fire Truck Windsor

disposal, we miss the ceremony and ritual which made it bearable and death is deprived of the dignity to which it is entitled.

Draw with freezing fingers by the emptied lake (a footbridge is being re-built) and return to London. Then with M to Rennie Maudslay's farewell party at Buckingham Palace. Masses of people – chauffeurs and footmen as well as courtiers and staff. Good speeches and nice, if sad, occasion.

Thursday 18th
I am sent a vast coffee table book of erotic paintings by famous artists – Courbet, Degas, Watteau and others – and asked to write a foreword. I ask for time to consider (ie look at the pictures) and then refuse. I am neither a painter nor an art critic and could think of nothing to say. Spend rest of the morning discussing plans with the architects for the new RCA building – my first new Provost chore. It seems to have got jammed into somebody's in-tray and we plod away at devices to release it. It's no good college departments giving us lists of what they want until we discover what the local planning authorities will permit us to have.

Friday 19th
Architect son-in-law's office party in a converted 19th-century factory near Smithfield. How magnificent is the solidity of Victorian industrial building – two-inch treads on the stairs, roof trusses like a tithe barn, electric light switches that in weight might control the street lamps of a whole city. Nice to see so many old students there from the 'fifties and 'sixties . . . all surviving and busy.

Saturday 20th
Christmas shopping. 'I walk about', in Beckett's phrase, 'not to and from'.

Sunday 21st: Windsor
To Windsor Castle with M (plus drawings and samples). Self-service lunch with HM and an hour of discussion after. We pack up pleased the main decisions are made.

Stable Block

DECEMBER

Monday 22nd
All-day tests at the cardiac clinic: white-coated girls ... humming machinery ... wires attached everywhere ... treadmill ... injections ... X-rays. At 4 pm I'm attached to a recording cassette (for 24 hours' wear) and sent home. The doctor is young and powerful. Does he, I ask, like all doctors, play rugger? Of course he does. And lady doctors, I ask? 'The ones I know', he says, 'play lacrosse'. Where does this tradition of team games and medicine originate? Ancient Greece or Dr Arnold?

Tuesday 23rd
Unstrap and deliver my recorder to the clinic, clear my desk at the RA. Spend all afternoon drawing my local parish church for a charity auction.

Wednesday 24th
Christmas Eve party at the Mosers – more literary than musical in membership – but many old friends. Start a promising conversation with handsome stranger who stops in mid-sentence. Excuse me', she says, 'but do you mind if I take off your glasses and clean them?' Take some time to regain confidence after this – or should I take it as a compliment?

Thursday 25th-Tuesday 30th: London, Windsor
Domestic family days: writing thank-you letters ... emptying waste paper baskets ... reading new books. Gain the distinction of a half-page attack in *Private Eye* because of Hounslow, and accompany party of grandchildren to *Toad of Toad Hall* at the Old Vic. Not as good as it should be – only one character (Badger) has taken the trouble to wear an animal's head, and Ratty merely wears jeans and a T-shirt. As his face is particularly un-snouty as well, this is a major laziness. Theatre full, enthusiastic audience. Annual post-Christmas lunch with Johnstons at Adelaide Cottage. Rest of the days spent in completing this diary and re-writing most of it. Like Larkin, I have picked up bad habits of expectancy: almost for the first time in my life I am glad to welcome New Year's Day.

174

NOTES

Throughout the diary, the context of a meeting or of a social occasion makes the role, if not always the identity, of the participants clear. Brief biographical clues have, however, been added where it has been thought helpful.

JANUARY

1 Pamela Tudor Craig, mediaeval historian
2 David Wilson: Director, British Museum
3 Lawrence Gowing: Slade Professor of Fine Art, University College London
4 Moran Caplat: General Administrator, Glyndebourne Festival Opera
5 David McKenna: Member of British Railways Board, former Chairman of Southern Railway Board
6 Plunket Memorial Trust: set up to commemorate the life in royal service of Lord Plunket

FEBRUARY

1 Gordon Russell: Sir Gordon Russell (d 1980), furniture designer and former Director of the Design Council
2 Ove Arup: Sir Ove Arup, senior partner of Ove Arup and Partners, Consulting Engineers, and of Arup Associates
3 Aga Khan Award: triennial award for excellence in architecture designed in the spirit of Islam and within the context of modern life; founded by HH Aga Khan
4 Garr Campbell: landscape architect on the staff of HH Aga Khan
5 Sir Anthony Wagner: Garter Principal King of Arms
6 Thelma Cazalet: Mrs Thelma Cazalet-Keir, former MP
7 Sir John Balfour: former member of HM Diplomatic Service
8 Mediaeval Exhibition: discussed for 1984-5 at the Royal Academy and elsewhere

MARCH

1 Job Mill: The Marquess of Bath's private residence near Longleat
2 Joanna Drew: Art Director, Arts Council
3 Bill Mather: Sir William Mather, Chairman of Mather and Platt Limited, Manchester
4 Edward Montagu: Lord Montagu of Beaulieu
5 Marina Vaizey: art critic of *The Sunday Times*
6 Caccia: Lord Caccia, former head of HM Diplomatic Service
7 Inglefield: Sir Gilbert Inglefield, former Lord Mayor of London

8 Adeane: Lord Adeane, former Private Secretary to HM The Queen
9 Robert Armstrong: Sir Robert Armstrong, Secretary to the Cabinet
10 Peter Scott: Sir Peter Scott, artist and International Chairman of the World Wildlife Fund

APRIL
1 Edward James: philanthropist and collector of surrealist art
2 John Skeaping (d 1980): sculptor and former Professor of Sculpture, Royal College of Art

MAY
1 Ambrose Congreve: industrialist

JULY
1 Colin Anderson: Sir Colin Anderson (d 1980), former Provost of the Royal College of Art and Chairman, Royal Fine Art Commission
2 Dick Guyatt: Professor Richard Guyatt, Pro-Rector and Professor of Graphic Arts, Royal College of Art
3 Nicholas Goodison: Chairman, Stock Exchange
4 Macleans: the Lord Chamberlain, Lord Maclean, and Lady Maclean
5 William Scott: painter and Associate of the Royal Academy
6 Jo Pattrick: interior designer and widow of Michael Pattrick (d 1980), who was Principal of the Central School of Art and Design

AUGUST
1 Bill Nash: William Nash, Superintendent of Windsor Castle

OCTOBER
1 Milner Gray: founder partner and senior consultant, Design Research Unit
2 Alan Bowness: Director, Tate Gallery
3 Margaret Weston: Director, Science Museum
4 Brian Organ: painter
5 Diana Reader Harris: Dame Diana Reader Harris, President of the Royal Society of Arts
6 Bill Barlow: Sir William Barlow, Chairman of the Design Council and former Chairman of the Post Office
7 James Cousins: Director of Design, British Rail
8 Sherban Cantacuzino: Secretary, Royal Fine Art Commission

DECEMBER
1 Sir Jasper Hollom: Deputy Governor, Bank of England
2 Michael Verey: Chairman of Trustees, Charities Official Investment Fund
3 Bill Coldstream: Sir William Coldstream, painter and former Slade Professor of Fine Art, University College London
4 Keith Grant: Director, Design Council